SUCCESS
LEAVES CLUES

PRACTICAL TOOLS FOR EFFECTIVE SALES AND MARKETING

JOHN STANTON
RICHARD GEORGE

SILVER LAKE PUBLISHING
LOS ANGELES, CALIFORNIA

REVISED EDITION

Success Leaves Clues
An Entrepreneurial Guide to Building Brand Recognition and Effective Marketing
Strategies
Second edition, 1999
Copyright © 1999 by John Stanton and Richard George

Silver Lake Publishing
2025 Hyperion Avenue
Los Angeles, CA 90027

Success Leaves Clues is the latest title in Silver Lake Publishing's "Taking Control" series for business owners. For a list of other publications or for more information from Silver Lake Publishing, please call (888) 663-3091.

Library of Congress Catalog Number: pending

Stanton, John and Richard George
Success Leaves Clues
An Entrepreneurial Guide to Building Brand Recognition and Effective Marketing
Strategies
Includes index
Pages: 356

ISBN: 1-56343-161-0
Printed in the United States of America.

To our parents
John and Emma Stanton
Joseph and Margaret George

SUCCESS LEAVES CLUES

TABLE OF CONTENTS

iv

ABOUT THE AUTHORS

John L. Stanton, Ph.D.

John Stanton is a consultant, author, practitioner and teacher of marketing research. He is currently professor of marketing at Saint Joseph's University in Philadelphia. As a consultant, Dr. Stanton includes among his many clients Campbell Soup Co., Frito-Lay, Kellogg, Miles Laboratories, PepsiCo and Procter & Gamble. Dr. Stanton is the editor of the *Journal of Food Products Marketing.*

A graduate of Syracuse University (B.S. and Ph.D.), he has taught at Temple University, Philadelphia; University of Dar es Salaam, Tanzania; Federal University of Rio de Janeiro, Brazil; and Syracuse University, New York. A prolific author, Dr. Stanton has written articles on data analysis techniques, advertising research, brand preference, segmentation and positioning research, which have appeared in the *Journal of Advertising, Marketing Intelligence and Planning, Journal of Marketing Research, American Journal of Clinical Nutrition* and *Marketing News.*

Recently, Dr. Stanton spent two years as vice president of marketing of Melitta North America while on leave from Saint Joseph's University. Prior to joining Melitta, he spent eight months in Germany analyzing retail food store strategies in the European Community for Tengelmann, the world's largest food retailer, whose chains include A&P and Super Fresh in the United States. *Making Niche Marketing Work* (McGraw-Hill, 1992), which Dr. Stanton wrote with Dr. Robert Linneman, was *Business Week*'s Book Club's first choice and has been published in three languages.

Richard J. George, Ph.D.

Richard George is an entrepreneur, author, teacher and former Fortune 500 marketing research and marketing management executive. He is presently professor of food marketing at Saint Joseph's University in Philadelphia. He has been recognized for his teaching excellence on many occasions and is the recipient of the Christian R. and Mary F. Lindback Award for Distinguished Teaching. As a consultant, Dr. George includes among his clients AT&T, Campbell Soup, Commonwealth of Pennsylvania, SmithKline-Beecham, Island Marine, Wyeth-Ayerst, Herr Foods and Tastykake.

A graduate of Saint Joseph's University (B.S.), Harvard University (M.B.A.) and Temple University (Ph.D.), he has taught at the University of Florida; University of London, England; and University College Cork, Ireland. Dr. George has published research on the subjects of marketing strategy, consumer behavior, technological innovations in marketing and business ethics. Articles emanating from his research have appeared in the *Journal of Consumer Marketing, Journal of Food Products Marketing, Marketing News* and *Journal of Business Ethics*.

In addition to his position as professor of marketing, Dr. George gets to practice what he preaches by running his own corporation, Cruisn 1 Inc., which operates tour boats offering dolphin-watching and eco-tours off the coast of New Jersey.

Delight Me ... The Ten Commandments of Customer Service (Raphel Publishing, 1997), which Dr. George also co-authored with Dr. Stanton, is considered one of the best books for taking customer service from rhetoric to reality.

PREFACE:

LEARNING FROM OTHERS' SUCCESS

In the first edition of *Success Leaves Clues* we identified the common elements of successful marketing strategies. We examined thousands of articles and cases and interviewed executives to find out what the successful marketers were doing that the not-so-successful executives didn't do.

We created 10 rules based on the clues left by the successful companies—not on what we thought was good marketing practice. We wanted the successful marketers to leave their mark on others. And we wanted to let others facing similar problems see that it was possible to achieve success by following sound principles.

In this edition, we looked to see if there were more clues left since our first activities. There were, and we documented these new clues in this book. We also looked to see whether the successful executives were still following the same basic principles or rules we found before.

In addition to the 250 updates and new examples, we developed a series of worksheets to help you take the rules from concept to action. To get the most out of this book, in addition to reading and highlighting key concepts, complete as many of the provided worksheets as necessary to bring the words to life. These worksheets are designed to help you critically assess where your organization

is, relative to developing a winning marketing strategy. Also, completing appropriate worksheets will enable you to put the rules you've learned into action. The results: satisfied customers and increased profits.

This book is dedicated to helping the lifelong learner become a more effective and efficient marketer, not simply a more educated marketer. After reading this book, you should be in a position to change your approach to strategy to better enable you to achieve your objectives.

We still believe that by observing, examining and borrowing the techniques that made others successful, you can be successful. Keep in mind that failure leaves clues, as well, and you can learn as much from the failures of others as from their successes.

What you will find is that successful marketers don't just get lucky or serendipitously find success. They tend to follow rules—rules of strategy that transcend all competitive situations, from business and sports to war. All these scenarios are used to show the clues of success.

Success Leaves Clues is not just a compilation of war stories. Instead, the examples we use represent illustrations of documented, tried-and-true rules and strategies that have resulted in success consistently—for centuries. However, as time passes, some of the companies and individuals described in the ensuing chapters will perform better or worse than depicted by us. That's because—while the rules are universal—the examples of success or failure are situationally relevant and must be evaluated within the referenced context.

Success Leaves Clues is based on the premise that it is not that history repeats itself, but that it is the failure to learn from history that repeats itself. Take the clues from the past and make them the guidelines for success in the future.

THE RULES

1) Be a Leader

2) Know What Is Under Your Umbrella

3) Get Close and Stay Close to Your Customer

4) Know Your Playing Field

5) Know Your Real Rivals

6) Use the Element of Surprise

7) Focus, Focus, Focus

8) Concentrate Your Resources

9) Be Mobile

10) Advance and Secure

x

Chapter 1:

WHY ANOTHER BOOK ON MARKETING STRATEGY?

Hundreds of books on marketing strategy have been written over the past 10 years. For the most part, however, there is little evidence that middle-level marketing and brand managers have changed their styles after exposure to these books.

Most managers have studied strategy either in university classrooms or in executive education programs, but little is put to daily use. Most of their time is spent either in implementation, which is tactically focused, or in putting out fires.

Ask a marketing manager how often he or she refers to the company's marketing strategy document in the course of a week. The usual response is "infrequently" or "not at all." In many cases, it is only during the "rite of spring"—when the document is written—that it is ever referred to.

No doubt there are countless reasons why marketing and brand managers spend so much time on tactics and ignore strategy, even though strategy is the source of market success. For example, it is clear that the American penchant for short-run profits and sales, especially at the end of a quarter, leads many managers to trade future profits and sales for more immediately recognized and rewarded financial objectives. This is a systematic problem that affects most middle managers.

The lack of in-depth marketing knowledge is yet another reason for the tactical approach. Many of

The basic question: Tactics or strategy?

the brand managers in American companies just haven't had significant practical marketing education or experience. Whereas most professions have internships, practicums and even certification, these practices are unknown to marketers. Engineers must be licensed. Physicians must be licensed and serve an internship. Lawyers must pass state bar examinations. Professional accountants must be certified. Marketers must speak English!

The "fast-track" syndrome may be another reason for choosing a tactical orientation over a strategic one. Most brand managers spend so little time at one position or with one brand that they have little interest in developing a major future strategy at the cost of reporting a minor tactical success.

Still another reason is that the strategy taught in most business schools is corporate strategy: "How should the corporation proceed in the future?" For example, "Should our company move from being a food processor to being a food distributor?" While this decision has a profound effect on the entire company, it offers little strategic help to the marketing brand manager of one of the processed foods (except for serving notice that he or she might be out of a job in the future). Notice where most universities house the responsibility for teaching their strategy courses: in the management department. And look at the curriculum focus: It is almost always corporate strategy.

This in no way should suggest that corporate strategy is not an important component of a marketing education. It is mandatory. But strategy is as important to the line marketing managers in the middle of the organization as it is to the "chosen few" at the top who set the course for the company.

Strategy is about competition, about customers and consumers, and about the marketing environment. Most importantly, it is about winning marketing wars using the fewest resources. These concepts are just as important to the line marketing managers as to those in the rarefied air of the

boardroom.

This book is concerned with developing a successful strategy for the middle line marketing, brand or customer manager. A successful strategy enables a manager not to work harder, but to work smarter. A successful strategy empowers the manager not only to fight the battle, but also to decide how the battle should be fought.

This concept is certainly not new. For centuries, the military has understood that strategy is important at the point of battle, as well as in the halls of the joint chiefs of staff. Military men and women are taught how to use their fists, their guns and whatever weapon is in vogue. But to win wars, officers also must understand and apply battlefield strategy, as well as tactics.

Although we will draw frequently from ancient and recent military history for examples of good strategy, we do not always agree with military leaders. For example, England recently erected a monument to "Bomber" Harris, the general who developed the strategy for the air war on Germany. While the Allies won the air war, it was at such a great cost that we wonder whether it was brilliant strategy or a massive waste of resources. The loss of Allied pilots' and flight crews' lives—and the loss of German civilian lives and property—suggest that a better strategy would have had the same result with fewer losses of resources, property and human lives on both sides. It would have been more appropriate to follow the advice of Sun Tzu: The best battle won is the battle never fought.

Changing Battlefields

Despite the shortcomings associated with Bomber Harris' efforts, it is generally strategy and not tactics that have brought about the major successes in today's markets. It is the ability to adapt strategically to the changing battlefield and the changing weapons of battle that will determine a company's long-term success in the marketplace.

Consider ConAgra's Healthy Choice brand of lun-

Decide how the battle should be fought

Facts change the weapons of battle

cheon meats. For years, three or four regional and national companies fought for shelf space in the deli case of convenience stores and supermarkets. The sales and marketing staffs of those companies could not have worked any harder or any longer hours. But they used the same tactical weapons—such as trade discounts, cooperative advertising, promotions and lower prices—to secure a little more shelf space and a little larger share of the market. Hard-fought battles were waged in the supermarket buyers' offices. There were winners and losers.

When ConAgra introduced its new concept on a national scale—Healthy Choice luncheon meats— the buyers made room in the deli cases. The new product was not like any other on the market and was introduced with significant national support. A low-fat, low-sodium product was just what many Americans were waiting for.

ConAgra didn't just fight a hand-to-hand tactical battle with the other combatants—it changed the battleground and the weapons of battle.

This is really a paradox. Everyone in the other deli meat firms would say, after the fact, "This was not a new idea. We could have introduced this new low-fat product."

Of course, the other firms were scrambling to get into the new battle. The other companies also would introduce a low-fat product. And they would get into the low-fat, low-sodium luncheon meat market by offering trade discounts, cooperative advertising, promotions and reduced prices to get just a little more space on the shelf and a little larger share of the market.

By the time the other deli meat firms have made inroads into that market, still another company will change the battlefield, and the battle will rage anew.

Another example of changing the competitive playing field is Staples. Prior to the introduction of this new chain, stationery stores serviced both retail and commercial accounts. The stationery stores

primarily stocked volume items and ordered other items from distributors. They offered "service," but usually the customer had to wait to get an order filled. Walk-in customers often were treated with disdain, as they were not really part of the profit base of the company. Everything was just great in this industry, with only an occasional market share shift.

Then Staples entered the market and provided everything a company could want at a much lower price, without the "service." Instead, Staples serviced everyone who wandered through the warehouse-format stores by having everything in stock and immediately available for sale.

While the stationery stores fought to keep the profitable commercial accounts, Staples established a beachhead in the private market, school market, home office market and small business market. The company took more and more share from the traditional stores. Soon, flush with success, Staples started to add "services" for a fee that competed with the traditional stores, such as delivery, credit accounts, etc. Commercial accounts that wanted the service for a fee could still get the low prices on products and the immediate availability offered at Staples, and businesses that could afford to send a person to pick up the order did not have to pay the service charge. In short, Staples changed the face of the office supply industry, while the traditional stationery stores beat their heads against the wall—or went out of business.

Probably the best example of an organization changing the field of play comes from Southwest Airlines under the leadership of CEO Herbert D. Kelleher. Southwest recognized that the traditional approach to running an airline usually resulted in excessive costs and disastrous price wars—with the resulting sea of red ink that has become the hallmark of the industry. Kelleher understood the economic concept of having a functional cost advantage. For example, during 1996, USAir spent 12.6 cents to fly one seat one mile, compared with just 7.5 cents per seat-mile at Southwest—the lowest of any major U.S. airline.

Staples established a beachhead

Having a functional cost advantage

How did Southwest accomplish this? By changing the rules of engagement. Southwest holds down expenses with one-size-fits-all seating. It also flies only one type of plane, the Boeing 737, and even installs older, basic cockpit equipment in new jets, so all pilots can fly all planes. It keeps its jets unusually productive—typically spending only 20 minutes on the ground between hops—and its non-unionized work force is unusually gung-ho.

While Southwest has changed the playing field with regard to cost structure, it has been even more innovative in its perspective. It sees as its competition not just other air carriers, but cars and buses, as well. It claims that it is not an airline, but mass transportation. In fact, when it entered the short-haul market in California, air traffic increased 60 percent.

Southwest breaks some other traditional paradigms. For example, it includes customers on teams to interview job applicants. Kelleher's cry is, "We must constantly and consistently dignify the customer."

While Southwest appears to be very market-focused, does this approach reap financial benefits? You be the judge. It is the only airline with an A credit rating, and it plans to pay cash for three-quarters of the 106 Boeing 737s scheduled for delivery in the next five years. Even though it has almost doubled its fleet in the past five years, long-term debt is up only 6 percent—to $655.7 million from $617 million at the end of 1991. Unlike other major U.S. lines, Southwest has been profitable for more than 20 years in a row. "We're fit. We're trim. We're mean," says Kelleher.[1]

The ConAgra, Staples and Southwest Airlines stories are not unique. These kinds of changes happen every week, every month and every year. We have seen a number of companies spend thousands of dollars developing the weapons of the marketing war, only to have the battlefield and weapons of war change.

Winning Means Profits

This book also takes the position that winning the market share or sales war isn't enough. You can't spend share points; you can only spend profits. Winning means profits.

Winning means increasing sales without sacrificing profit margins. It doesn't take a lot of strategy to achieve higher sales with lower profit margins. Yet look at the way so many companies' marketing groups perform. Lower profits and higher sales usually are justified on the basis that higher volume contributes to unit cost reduction. But what sense does it make to manufacture a less expensive product if you are simply going to turn back all the savings in the form of lower prices?

Our approach is to have satisfied customers as the primary objective. If you really satisfy your customers, they will reward you with profitable sales. And winning in marketing terms simply means higher long-term profits.

Don't misconstrue the relationship between profit and customer satisfaction. Profit is the reward for creating a satisfied customer. Profit cannot be considered the objective. The objective must be creating a satisfied customer.

Looking for Clues

Why the title *Success Leaves Clues*? You can learn from studying marketing success stories. You can see what has worked and what hasn't. You can learn how competitors react, how consumers respond and how distribution channels adapt to successful strategies.

Failures also provide learning opportunities. What did companies fail to do? Why did they fail to recognize or react to a competitive move?

Looking for the clues of success will enable marketing strategists to use their time wisely. Military strategists have an advantage over marketing strategists because wars generally are fought at intervals. Between the wars, the generals study what

Military strategists seek an advantage

happened. They have time to prepare for the next war. But the marketing strategist must fight every day with no armistice or truce. This leaves precious little time for reflection or learning. Therefore, marketing strategists must use their time wisely and look for the clues of success.

This book details the marketing wars and documents the lessons to be learned from the winners and losers. It puts between these covers lessons that a manager could spend years trying accumulate. For those with spare time on their hands, we recommend a firsthand study. For the rest of you, read on.

A Preview of the Rest of the Book

Those who continue reading will find *Success Leaves Clues* divided into three parts. The first part (including this chapter) provides background information. Chapter 2 describes the marketing concept, while Chapter 3 explains the evolution of marketing and strategy. Chapter 4 concludes the first section by distinguishing between strategy and tactics. Individuals with considerable knowledge or experience in marketing may not feel the need to give much attention to these chapters. However, our experience has been that a refresher of the philosophy underlying the marketing function will enhance the subsequent learning.

Chapters 5 through 12 detail our rules of strategy. Chapter 5 begins the process by discussing the philosophies that govern strategy. This chapter also highlights some basic heuristics that marketers should follow. Finally, Chapter 5 concludes with the introduction of the rules of strategy.

Chapter 6 discusses the only rule listed in order of importance: Be a Leader. Using our definition of a leader—"a preacher of vision and a lover of change"—we identify some of today's great leaders and provide characteristics and examples of their leadership. Chapter 7 commands marketers to know what business you are in. Business will no longer be defined in terms of what product or

service you offer for sale. Rather, your success will be judged in terms of what problems you solve for the customer.

Chapter 8 demands that you get and stay close to the customer. Detailed and intimate knowledge of your customer is essential if you are to answer the question, "What business are you in?" Chapter 9 covers three related rules. The chapter begins with a discussion of the importance of knowing your environment. A technique for environmental scanning is presented. Next, the chapter addresses the issue of competitive analysis. Finally, the chapter discusses the element of surprise from a secrecy—as well as from a doing the unexpected—perspective.

Chapter 10 urges marketers to maintain your objective. While not totally minimizing "opportunism," you are reminded not to lose sight of your target. Chapter 11 introduces a complementary rule: Concentrate your resources. Concentration of resources is best done at the point of attack and most successful when you concentrate your strengths against your competitors' weaknesses.

Chapter 12 concludes the rules, as well as the second part of the book, by introducing the concept of mobility, followed by the directive: Advance and secure. To win in strategy, you have to take the offensive at some time—and to avoid being ambushed, you have to keep moving. Likewise, whenever you move forward, it is important to have a fall-back position where you can find safety or a haven, should the new strategy meet with failure or even strong resistance.

The final section identifies the various strategies you can consider, once you understand and apply the rules. Chapters 13 through 15 detail the offensive strategies—from pure offensive (straight at the competition) to broadening (line extensions) and flanking. Multiple examples of successful (and unsuccessful) applications taken from a variety of industries are introduced for clarity and completeness.

You have to take the offensive

Avoid the trap of "ad hocracy"

Chapters 16 and 17 provide you with a number of strategic options, if your objective is to defend against competitive intrusions into your markets. Many of the alternatives introduced under the rubric of offensive strategies are recast as efforts to repel or discourage marketers who may aspire to take your business.

Chapters 18 and 19 conclude the strategies by presenting options for marketers who believe that the best battle won is the battle never fought. A variety of avoidance alternatives are identified, with a separate chapter on niche marketing.

Chapter 20 brings *Success Leaves Clues* to a close by urging you to adopt some set of rules or standards to guide your marketing strategy decision-making. As the title of the last chapter states, "If not our rules, what rules?" We urge you to avoid the "ad hocracy" that appears to govern much of today's strategic formulation. Please read on, and we believe you will agree with us that *Success Leaves Clues.*

Chapter 1 Clues

- Stop, look and listen for success in all arenas.

- Take time to learn from successes (and failures).

- Borrow, copy and adopt.

- Be flexible and open to change.

- Keep a journal or notebook and make daily entries of successes and failures observed.

Chapter 2:

DO YOU REALLY KNOW WHAT MARKETING IS?

There is no better place to begin a discussion of marketing strategy than with the term *marketing*. This may seem rather elementary. But based on the poor performance of many so-called "marketing-oriented" companies, a real understanding of the marketing concept is suspect.

Why does it appear that so many managers are unable to design and implement a successful marketing strategy? Perhaps some marketers have only been trained to devise the annual marketing plan (and by that we mean which forms to fill out and when) or to prepare a budget request for a new advertising campaign, without being given any instruction in what marketing really is. Maybe others have learned key marketing tasks (tactics) on the job, by working in advertising or marketing research departments, and then were promoted to a position requiring a strategic focus. Such seemingly pragmatic experiences do not guarantee that the real meaning of marketing strategy is understood, appreciated and, most importantly, used properly.

University education programs should fill that gap—and some do. But, for the most part, a recent graduate is more prepared to be the president of General Foods than to be a brand manager. Similarly, most graduate business programs seem to focus on statistics, financial statements, economic analysis and organizational behavior. Few have the foggiest idea who the consumer is or what he or she wants. Some MBAs still think their consumers are no different from stocks and

Marketing has two distinct meanings

use the same methods of dealing with stocks and bonds that they do with their consumers. Some even go so far as to refer to their consumers as cash cows or dogs! Even the most market-oriented brand managers talk in terms of market share points, failing to recognize that goods and services are sold one at a time to real people.

Customer Satisfaction Is the Key

Marketing is the process of understanding and satisfying customer needs at a profit.

Managers must first understand exactly what the market wants, and then satisfy the needs of those segments of the market that can be profitably served.

Before presenting our definition of marketing, a clarification is in order. *Marketing*—as it is used today—has two distinct meanings: one as a philosophy of doing business, the other as a set of activities. Before we discuss marketing as a philosophy, we will address the issue of marketing as a set of activities, such as advertising, promoting, pricing and distributing goods and services. These are simply a few of the many tasks that someone in a marketing department does on a regular and routine basis. The types of activities undertaken by someone in the marketing department are analogous to the day-to-day tasks performed by one's counterparts in accounting, finance, production, human resources, etc. While these so-called "marketing" activities are necessary, they are not sufficient to ensure success in the marketplace. To realize such success, the meaning of *marketing as a philosophy* must be understood, and it must permeate the entire organization.

Marketing is a philosophy of how a company deals with its customers and consumers. Our definition of marketing—and this book—is predicated on this very simple philosophy.

Throughout *Success Leaves Clues*, we will use the terms *customer* and *consumer*. By *customer* we mean anyone who purchases the product or ser-

vice for resale or for use. By *consumer* we mean the end user, the person who actually uses or consumes the product or service. It should be clear that a customer also may play the role of a consumer. For example, mothers who purchase breakfast cereal for their families are customers, but when they eat it they become consumers.

Be advised that although we use the term *satisfy*, we mean more than simply meeting customer expectations. The concept of satisfaction that we would like our readers to strive for may better be described as *delight*—that is, not meeting customer needs or expectations, but exceeding them.

Marketing is more than just a bag of tricks used to get people to buy your company's product over a competitor's. Marketing begins long before the sales process; it ends only when the consumer is satisfied and your offering becomes the only choice on the next purchase occasion. Marketing isn't advertising, but advertising is an important part of marketing. Similarly, marketing isn't selling, but selling is an important part of marketing.

Since marketing is an approach to doing business, all aspects of the firm must be directed toward satisfying the customer. Marketing is what a firm does, not simply what a department does. Marketing is a firm organizing itself to satisfy the customer—as opposed to establishing policies and programs for the convenience of the firm.

A customer-driven firm is one in which the finance department sends invoices at times when it is convenient for the customer, the distribution department delivers the product when the customer can best accept it, and the customer service department communicates to a dissatisfied consumer that it is the company's—and not the consumer's or customer's—problem.

Marketing is a philosophy which emphasizes that, in the long run, success results from creating a satisfied customer, because satisfied customers lead to higher profits. Most short-run-oriented brand managers believe that the objective should

It's more than just a bag of tricks

Money is the risk; profits are the reward

be higher sales or profits, and a way to accomplish this objective may be by creating a satisfied customer.

Our approach to marketing states that creating a satisfied customer is our primary objective and profits are the reward for achieving that objective. Keep in mind the words attributed to management guru Peter Drucker. There is only one valid definition of business purpose: to create a satisfied customer. It is the customer who determines what the business is.

Because the purpose of a firm is to create a customer, any business enterprise has two—and only two—basic functions: marketing and innovation.

Understanding Customers

The first part of the definition of marketing is *understanding customers and consumers*. Before you can satisfy them, you have to know what they want. That should come as no surprise. In fact, implied in understanding is not only learning what the consumer wants today, but also anticipating tomorrow's needs.

You probably would be surprised how few brand or marketing managers know their customers or consumers and their real needs in the present, let alone the future. Most brand managers spend more time with paper than they do with people. The people they spend the most time with are their co-workers in meetings. When we ask line marketing managers how much time they spend with consumers, they almost all say, "Virtually no time."

Equally surprising was a report by Tom Peters in his video *Speed* that 95 percent to 99.5 percent of all business activity does not add value to the product or service.[1] Think about this statistic for a moment: Less than 5 percent of all of our efforts devoted to producing a good or service results in giving more to the customer. Many brand managers spend time with their customers only to sell or to call on them to correct a pressing problem. When things are going well with the trade, no

one goes near them.

But more and more companies are developing a market- or customer-driven approach and are forcing their marketing managers to get closer to the customer. The most celebrated case of getting out and listening to the customer is the Wal-Mart organization. This company, long before it was fashionable, began sending its vice presidents out to hundreds of stores each and every week, leaving the corporate headquarters (described as "early Greyhound bus terminal") on Monday morning and returning Friday morning. Based on their observations and discussions with customers and store personnel, they seek to answer three simple questions: What's working? What's not working? And what needs to be changed?

Who would have guessed that this company from Bentonville, Arkansas, would displace Sears as the No. 1 retailer in the country and cause Sears to restructure its business?

Does success leave clues? Ask Jack Welch, CEO of America's extremely successful giant General Electric Corp. He is attempting to model GE after Wal-Mart. Jack Welch recognizes that you do not have to be sick to get better, and he intends to model Wal-Mart's approach to knowing the customer, as well as its speed in decision-making and implementation.

Likewise, Stew Leonard showed major food retailers that making the customer No. 1 has made Stew Leonard's one of the most profitable food stores in the country. Stew claims that he is not in the food business serving people, but in the people business serving food.

Nordstrom is to department stores what Stew Leonard is to supermarkets. The customer comes first. This doesn't require complicated policy manuals. Nordstrom's policy manual is revered for its single directive: Use your best judgment. Remember, a customer is the only component that is absolutely required to have a business.

Another example of a successful company that lis-

What needs to be changed?

Customers tend to speak in code

tens to its customers is Whirlpool. When customers talk, Whirlpool listens. Each year, the company mails 180,000 surveys asking people to rate their appliances against the competition's.[2] When a competitor's product ranks higher than Whirlpool's, engineers tear the competitive product apart to find out why. They also have created a usability lab with product simulations for consumers to "fiddle with."

Whirlpool has discovered something very important by listening carefully to its customers: Customers speak in code. For example, people said they wanted clean refrigerators. Whirlpool decoded this to mean that they wanted them to *look clean*, not just be *easy to clean*. So Whirlpool introduced a model with a stucco-like exterior, which prevents fingerprints from showing up.

In listening to customers, Whirlpool realized consumers were being forced to compromise when buying and using appliances. For example, by observing directly, Whirlpool managers found that cleanup after meals was taking more time than necessary. Why? Because the person who originally designed the traditional stove top obviously was spared the daily responsibility of keeping it clean. Now, the top of Whirlpool's CleanTop stove is completely flat, eliminating all the grease traps of the old design. By listening to and observing customers, Whirlpool identified a number of growth opportunities.

Does listening work? Whirlpool has tripled in size since 1982. How many other appliance companies can make this claim?[3]

You must get close to and listen to the customer personally—not have someone else do it for you. Fergal Quinn, president of one of Ireland's leading supermarket chains (humbly named Super-Quinn's), said, "Listening is something you can't do secondhand."[4] Many people we have interviewed said that although they don't get into the market much themselves, they have a great market research department that keeps them posted. Non-

sense! The market research department cannot substitute for brand management's contact with the market. Why do so many ideas from the corporate marketing staff become an instant laughingstock for the field staff? The field staff knows it's a bad idea before one unit is sold—and often predicts with some certainty how few units will be sold. That's because the field staff is closer to the customer.

Some brand managers are so far removed from the market that they require the market research staff to present the "bottom line." They want a 30-minute meeting on everything the research department can tell them about their customers or consumers. Most of the research reports to brand management we've sat through had more time and resources devoted to the quality of the slides or overheads than to the quality of the analysis.

The Japanese understand the necessity of getting close to the market. Most Japanese firms don't even have a market research department. The line management and the research and development staffs are expected to do their own research. One Japanese company wanted information on changes necessary to the heavy construction equipment it produced for the U.S. market. It sent the design engineers to the United States to ride with the tractor drivers for six months, so they would understand completely the specific problems and unique needs of their market.

Don't Play Whisper Down the Alley

When too many intermediaries get involved in listening to or observing the customer, the message becomes garbled. Even children understand the effect that a long chain of people, each interpreting a message, has on the final outcome. They have a party game called "Telegraph," "Telephone" or "Whisper Down the Alley," in which one child passes along a secret to another child. By the time the secret is passed down to each child, it no longer resembles the original message. It usually gets lots of laughs.

Ask an 8-year-old how much sense that makes

When a brand manager asks the market research director to find out something about the company's customers, the market research director asks a project director who asks a supplier's sales representative who asks a field supervisor who in turn has a minimum-wage data collector ask the consumer a question. Then the response is passed back to the field supervisor, then to the sales representative, the market research project director, the research director and, finally, the brand manager. Then the brand manager feels as if he or she has an in-depth understanding of the market. Maybe he should ask an 8-year-old how much sense that makes. Why is it that we as adults believe that delegating listening responsibilities in this fashion will generate an accurate assessment of the customer's true needs?

The whisper-down-the-alley syndrome is better than the "all knowledgeable" syndrome. For example, in talking with a number of upper and middle managers in both food processing and food retailing organizations, we found that male managers seldom—if ever—food shop for their families and don't prepare family meals on a regular basis. On those few occasions when they do cook, it is an orchestrated production in which everything is already planned and purchased by the spouse or other family members. Cleanup? Forget it! In fact, these men are so busy that they eat very few meals at home.

How can these people really understand the problems and issues of the American household when it comes to in-home appetite satisfaction? We found that the "all knowledgeable" manager usually bases his decisions on either his mother's behavior (experiences from many years earlier) or what he hopes or wishes to be true. And this criticism is not limited to consumer packaged products personnel. The same can be said for marketers of durable goods.

This phenomenon is not the exclusive purview of U.S. marketers. In Germany, we conducted a series of interviews with store managers of the world's

largest supermarket chain in order to determine how the typical German shopper cooks. All the store managers were young men. In every case but one, the store managers responded that German women like to cook, that the main meal is eaten midday at home, and that a smaller meal is eaten later in the evening. We then asked each person in the room if he had eaten this way in the past week. In every case, the answer was, "No, we are different!" We then tried to find someone in the store with these supposedly typical German habits, someone who eats like the "typical German." We asked store clerks, shoppers and delivery people. After about 20 people, we found a woman who described her eating habits as the "typical German." The store manager smiled and said, "I guess you see now that I was correct." What we witnessed was that "typical German" behavior was anything but typical. By the way, in these same stores, more and more prepared foods—both frozen and fresh—were being sold.

An even more distressing example comes to us from the U.S. telecommunications industry. In discussions with one of the regional Bell operating companies (RBOCs), we learned that product managers were not allowed to talk with customers. It was against policy. Furthermore, engineers who were researching and developing new products were not allowed to talk with customers. Yes, there was a policy against that, too. This particular RBOC had a market research department to talk with customers and report to management. In defense of its non-direct-contact approach, the RBOC personnel cited one of their reports, which claims that the company enjoys a 99 percent satisfied rating among its customers. Hard to believe!

Most managers are so involved in the details of the business—the crises, the memos, the meetings, the internal politics, etc.—that they have become almost totally detached from their customers. Yet understanding the needs of the target market is what marketing is all about. How to stay in touch with customers will be discussed

Supposedly typical German habits

Listening only to your current customers

later, but keep in mind that this is where marketing starts and ends—with the consumer. The marketer, not someone else, must maintain the contact and gain the understanding. This is the last responsibility ever delegated.

A note of caution here. When we say *get to know the customer*, we mean not only *your* customer, but also others in the market for your product who currently fail to see you as a source of satisfaction. You can fall into a trap of listening to your current customers only. Look at what was reported to have happened to International Business Machines. When PCs entered the market, IBM asked its mainframe customers about the importance of PCs. Of course, since they were current mainframe users, they thought mainframes represented the future. After a short period (while the PC market was growing), IBM again asked its customers. At this point, some of the original customers had switched to PCs, and the remaining people were even more convinced of the value of mainframes. The message to IBM was clear: mainframes. This research scenario was repeated frequently. Each time, the only remaining customers were even more diehard mainframe users, and their message was even clearer: mainframes.

IBM was not listening to the market. Instead, it was hearing only from its (shrinking) mainframe customer base. Be sure to listen to the whole market—that is, anyone whose problems you have the capability of solving.

Listening to customers often takes courage and requires respect for their opinions. Sam Johnson, CEO of S.C. Johnson and Sons, discovered that his customers were concerned with chlorofluorocarbons (CFCs) in aerosol cans three years before they were banned by the FDA. While other companies were fighting the threat of the ban, Johnson, to satisfy his customers, stopped using CFCs. He recognized that he worked for his customers, not the FDA. He did what his customers wanted.[5]

Customer satisfaction (delight) represents the primary function, purpose or objective of any organi-

zation espousing marketing as a philosophy. It is the reason anyone would decide to risk his or her resources (time and money) to start a business. Too often, entrepreneurs confuse the purpose of business with the reward for delighting customers. Profit is the reward for achieving your objectives.

Satisfying Customers

The second part of the definition of marketing is *satisfying the customer*. When you look at how many companies work, you see an almost trial-and-error approach to satisfying the customer. This is often because the marketing department didn't understand what the customer really wanted. Satisfying means giving the customer what he or she wants—not what the company wants to give. Satisfying means making what can be sold—not selling what can be made. The better you understand your customers, the better able you are to satisfy them.

We worked with Tastykake, a company in the baking business, which has produced a small snack food cake for the past hundred years. It was the regional icon and, for years, it was the preferred baked snack. But sales declined, and top management decided that the product was just too expensive, so they cut cost wherever possible and lowered the price. Soon sales were going up a little, but more than 70 percent of all sales were on a deal or promotion (and usually a significant deal). Soon, customers waited for the product to come on deal and stocked up at the lower price. The deal price became the regular price, and profits declined significantly.

In all the discussions of what to do, no one at the company suggested that perhaps people no longer wanted this product. There are no longer markets for products or services that everyone likes a little. However, there are only markets for products that some people like a lot.[6] Perhaps the product was wanted only by the baking company and its employees, who wouldn't believe that the great prod-

Focus: Making things that can be sold

Give the marketplace what it wants

uct which once made them famous was now history.

Finally, a new president came on board and said the unsayable. The gist: People no longer wanted the sacred cow that management revered and consumers once salivated over. Let's make new products that they want. In less than 18 months, the company's stock price almost doubled. The lesson: When you produce what people want, they usually buy it.

Keep this in mind. Give people what they need and you can make money. Give people what they want and you will become very rich.

At a Profit

This, of course, is where the challenge is. The definition of marketing is not simply understanding and satisfying customers, but accomplishing this while realizing the organization's objectives—which, in business (versus the not-for-profit sectors), is to make a profit. As we said earlier, if you can satisfy the customer, you have a better chance of making a profit. Profit is both the result of and the reward for delighting customers. It is neither the objective nor the right of any business. Never forget this!

The key to this part of the definition is identifying the market segments and market niches that offer the most potential. Need we remind you that before you can pick the markets, you must understand the markets.

There are many companies either not in business today or almost out of business because of failure to satisfy. However, we can't think of any companies that satisfied the customers, gave them what they wanted, provided value-added and did not make a profit. Can you?

The Genesis of Marketing

Where did the concept of marketing originate? It is the result of changes in the society, culture and economy—which, in turn, influenced man-

age-ment's varying approaches to the market.

The Production Era

In the United States after World War II, there was tremendous pent-up demand for consumer goods. Soldiers were returning home and starting families, buying homes, furniture, cars, etc. Those who had not been overseas or in the military had faced years of limited supply and even no availability of some goods. They were buying, too.

The objective of business was to produce in volume—quickly and cheaply. The stars of the companies were the engineers and operations people who developed systems to produce in quantity and to reduce the unit cost. This led to even higher profits for the companies, since prices generally were high from lack of competition and strong demand. There was no sales department to speak of. There were order-taking departments, since the retailers were desperate for products to meet the seemingly unquenchable demand.

This period has been called the *production era*. The primary unit of measure for success was cost—specifically low cost.

The large chain retailers at that time were on a parallel track. They targeted the mom-and-pop stores as the competition. They focused on operational efficiency to reduce costs and provide a combination of lower prices to the consumer and higher margins to the owners. By increasing size, they could offer the traditional American family almost any product it wanted. Furthermore, they brought more stores to the new "suburbs." Location became a primary factor.

But two changes occurred. First, the unquenchable demand became quenched. Families purchased their first TV sets, dining room chairs and cars. Now, customers could be choosier and shop around. Second, more competition meant consumers had a choice of products in many categories, and factors other than price entered the picture. Consumers asked about quality, color, style and

The unit of measure for success was cost

Television advertising grew to new levels

other factors as more products became available.

The Sales Era

Sales for the manufacturers slowed considerably, and some companies decided they could not wait for people to call them. Instead, they would have to make a concerted effort to call on the retailers. This began the selling era. Salesmen from the manufacturers called on the retailers and persuaded them to buy more of their product.

Some companies stimulated primary demand by advertising directly to the consumer. Television advertising grew to new levels, as almost every household watched TV. Some companies selling household products, such as soap, thought so highly of this new medium that they acquired the production companies for daytime television, which targeted women at home. Today, we still refer to these shows as soap operas.

During the sales era, the primary unit of measure for success shifted from costs to unit sales.

The retailers realized that the only link manufacturers had with consumers was through them, and they welcomed the new sales and promotion efforts by manufacturers. The deals, discounts, promotions, off-invoice prices and games eventually led to slotting allowances, diverting, new product charges, return allowances—all of which contributed to the retailer's bottom line. Retailers made money without even thinking seriously about their customers' needs. Their rationale was to make bigger stores with more room for products (which meant more money from manufacturers). If retailers did this, they reasoned, there would be something on the shelf that the people would want.

Again, two things happened. First, the cost of selling increased. Getting the incremental sale was more and more expensive. The manufacturer's sales personnel might call on 50 stores, and the first 30 quickly accepted the product. But to get the next store to buy was more time-consuming and more expensive. That store (the 31st) had al-

ready declined the offers made to and accepted by the first 30 stores. When manufacturers put new products on the market, the initial sales were to people who wanted the product. However, persuading the additional customers took more and more effort and resources. Therefore, more had to be offered and, as a result, while sales grew, the cost of sales also went up, producing flat—and, in many cases, falling—profits.

Second, at the same time, more money was spent on building consumer demand. As you can imagine, the best shows had already sold all their advertising time. Consequently, new dollars were spent on less popular, less effective TV shows, and the sales effort became less effective and less efficient, as well.

The initial response of manufacturers was predictable. If sales are up and profits are down, then the solution is simple: Cut costs. So the operations people were directed to make the product cheaper. And they did—cheaper in price and lower in quality. One food manufacturer continually reduced the quality of its product in order to cut production costs. It should come as no surprise that as product quality dropped, this particular manufacturer experienced a decade-long decline in sales. Every other department was cut, as well. Spend less money on telephone. Why call on our customers? Spend less time on the road. Why visit our customers? Spend less on research. Why improve our products so often?

Retailers were doing exactly the same things. As profits declined, they cut costs. Where? From labor. The stores offered less service, which meant fewer checkout stands with longer lines. Less labor also meant dirtier stores and little customer assistance. Stores resorted to lower prices to get customers; this, in turn, reduced the profit margins, which led to more cost cutting and less labor. And the vicious cycle continued. The more costs were cut, the more difficult it was to satisfy the customer, and sales plummeted.

The Marketing Era

Surprise! The cost of sales went up

Different groups of people with different needs

Finally, someone realized that a company must first determine what customers want and then produce it—not the reverse. The first major finding was that consumers have different needs and wants. In fact, the reason for the high cost of sales was that companies were trying to convince people to buy something that was exactly what the company made.

Consider our example of the bakery that produced great-tasting snacks. Suppose you were hungry for a snack. You were a little conscious of your weight and preferred fruit tastes over super-sweet tastes. How much effort do you think it would take to convince you to buy a high-calorie, tasty cupcake? Would it take more or less effort to convince you to buy a low-calorie fruit pie?

So, the companies discovered different groups of people with different needs—called market segments. Market segmentation became the hallmark of the third era: the marketing era. Companies finally recognized that by determining what consumers want and finding enough of them who have this particular need (a segment), they would be able to sell to that segment profitably.

What's Next?

What is likely to happen next? It would be naive to believe that the evolution of business will end because we are now "marketing-oriented." In fact, we believe the next step will be a system of business that brings companies closer to consumers. This might be called one-to-one marketing.

In traditional mass marketing, the company tries to find as many consumers as it can for its limited range of products. In one-to-one marketing, the company tries to find a consumer and sell that person a wide range of products. The catalog companies are good examples of one-to-one marketing. Lands' End uses a general clothes catalog to gain initial contact with a customer, and then provides specialized catalogs, such as a sporting clothes catalog, to gain additional sales. Lillian

Vernon generates initial sales through a general catalog and then uses that purchase information to send specialized catalogs, such as a "grandparents" or "home furnishings" catalog.

More recently, such companies as Abercrombie & Fitch began offering catalogs that sell more than clothing. Abercrombie & Fitch's 130-page book, dubbed *A&F Quarterly*, sells the Abercrombie lifestyle, offering articles and advice.[7]

Another example would be the supermarkets' use of frequent shopper cards. They can analyze the purchase history of shoppers and develop promotional pieces specifically for a particular shopper. For example, if a consumer seems to buy all groceries but not meat, a special letter can be sent discussing the meat section and even providing a coupon for that department. Each customer can be dealt with on a one-to-one basis.

There are thousands of companies out there that are still in the production era, and just as many in the sales mode. But some companies have truly shifted to a philosophy of delighting customers, and they will be the ones to initiate one-to-one marketing. Although its adoption is slow, it will be here for the successful companies.

Change From Inside-Out to Outside-In

Marketing strategy means changing the company's focus from inside-out to outside-in. To achieve this, you must turn the organization chart upside down. Front-line fighters must provide information on the market, the customers, the competition and the environment. Management also must collect its own information and assess the situation. Management then evaluates all the relevant market data and creates a strategy. This strategy is relayed to the front-line people, who are responsible for executing it. From that point on, the staff's job is to help the front-line people carry out the strategy.

Make no mistake about it—front-line people are not in a position to create strategy. They are too close to the fighting to have the "big picture." One

Turn the organization chart upside down

Lack of respect for the sales force

classic example of this is when the sales force is asked what the price strategy should be. The response is almost always, "Cut the price!" Why? Cutting price makes the sales job easier—but it may not be in the best interest of the company. Key information on the best strategy comes from those closest to the fight, but the decisions must be made in bunkers that are distanced from the heat of battle.

One of the best examples of not seeing the war while in battle is the boxing match between Marvis Frazier, the son of Smokin' Joe Frazier, and another heavyweight. Marvis was losing badly, his eyes were almost closed, and blood was coming from his mouth. At the end of the round, he sat on the stool, looked up to his father, and asked, "How am I doing, Pop?" The boxer was the only one in the arena who didn't know how he was doing.

It is also important to be sure the front-liners know what the strategy is. They must know that their behavior and actions are part of the overall strategy. Again, a big problem is often the strategists' lack of respect for the sales force—the fighters of their elaborately designed battles. However, you can't expect the sales force to fight in the dark.

For example, a European drug store chain decided to change its strategy to include greater customer service in a test store. The strategy involved increasing the number of employees in the store, so that more time could be spent with customers. While the appropriate budget increase was transferred to the test store, the new strategy was not communicated to the store manager or the staff. They were elated that they had more personnel in the store than before—to do such tasks as restock the shelves, clean the back room and do other details that had previously been left undone. Needless to say, after six months, headquarters concluded that an increase in customer service does not increase sales. The plan was not rolled out to the other stores.

Most manufacturers have shifted their focus from

inside the company to outside—to the consumer. Even General Motors has gotten the message, after paying heavily for its neglect of the customer. Its U.S. market share has been declining for decades. Since 1991 alone, it has fallen from 35 percent to less than 32 percent. Now GM's brand managers will work closely with the engineering teams on new-model designs, to ensure they're giving customers what they want. While that may sound like Marketing 101, remember: GM traditionally has been run by executives more interested in accounting than marketing. And engineers thought more about the competition than the customer.[8]

Unfortunately, this approach is not yet commonplace for most retailers. Retailers are promotion junkies—they can't get off the stuff. Without too much effort, retailers could continue to extort more money from manufacturers (through various promotional programs), rather than focus on what consumers want. One critic within the food retailing industry told us that marketing in his supermarket chain (among the Top 10 in the country) amounted to simply opening the door for business each morning.

Another critic told us that supermarkets and mass merchandisers behave like the son of a rich man. The son never goes to work and just constantly asks the father for more money. Why work if someone will pay you to sit around? The father threatens, but each time gives in and pays the lazy son. Retailers are like the lazy son. So long as the manufacturers continue to subsidize them, retailers don't need to work—i.e., market their retail stores.

Why the Resistance to Marketing?

Certainly you'd think that this new approach called "marketing" would be greeted with choruses of "Hallelujah." In fact, just the opposite occurred. This meant a significant change in the way companies did business. The new boss was the consumer, and everyone would take marching orders

Marketing was just a fancy name for advertising

from him or her. As a result, marketing research grew in importance for many companies, since this department provided their only contact with the consumer.

But, for most companies, marketing was just a fancy name for advertising, and it was just another way to spend money. Many company executives lamented that if they didn't have to spend so much on marketing, they would have higher profits. Many "marketing executives" of major consumer products companies couldn't even explain the difference between the functions of marketing and sales.

So, you see, many key executives in leading organizations did not really know what marketing was or did. Actually, many who claimed understanding, in fact, were reactive—they were task- or tactically-oriented, not strategically oriented. If you want to become more proactive, or if you aspire to become a better marketing strategist, read on.

Chapter 2 Clues

* Focus on making what you can sell, rather than selling what you can make.

* Make listening to and understanding the customer a priority for everyone in your organization.

* Never be too busy to listen to the customer.

* Satisfy the customer and you will be rewarded with profit.

Chapter 3:

THE GENESIS OF MARKETING STRATEGY

There are as many definitions of *strategy* as there are of *marketing*. Using strategy in a marketing context demands more than a definition; it must be completely understood not only by the practitioners, but by the entire organization above them. Many the well-thought-out strategy was laid to waste by a manager who wanted immediate tactical success at any cost.

Strategy comes from the Greek word *stratigki*, meaning "art of the general." Strategy was the practice of outsmarting the opposing forces. While the lieutenants prepared the troops for hand-to-hand combat, making them better fighters, the generals decided where and how the battle would be fought. In fact, there has been a clear distinction in the military between fighting battles and deciding how battles will be fought.

Throughout this book, we will draw heavily on military examples to demonstrate marketing strategy. We don't condone war, nor do we think that fighting and violence are good. But we do believe that for thousands of years, the military has studied how to win battles, and we want to use that knowledge wherever possible. We also will draw heavily on sports analogies, because sports teams and players have addressed the issue of beating a competitor by employing strategy, not just brute force.

Planning— by itself—is not strategy

Managers often confuse planning with strategy. Usually, planning is the articulation of a series of steps the firm intends to carry out. Planning brings the future to the present. Typical planning documents include a media advertising schedule showing exactly when and how much is expected to be spent on various media, or a product development plan that details each step before a product can "hit the market." Make no mistake about it: These are important marketing documents and no firm should be without them, but planning documents are not strategic documents. Planning is not strategy.

Strategy is how a business intends to compete in the market it chooses to serve. It is the conceptual glue that makes sense out of all the various actions and activities taking place in the marketing. It answers the questions of *what* and *why*.

Here's the definition of *strategy* to which we subscribe:

> Strategy is the way in which a corporation endeavors to differentiate itself positively from its competitors, using its relative corporate strengths to better satisfy customer needs.[1]

Key to the topic of strategy is understanding the competition—or, more specifically, gaining competitive advantage. Understanding the strengths and weaknesses of the competition—as well as your own strengths and weaknesses—provides the basis for developing a method of beating the competition. Naturally, you want to pit your strengths against the competition's weaknesses—and protect against your weaknesses.

Planning implies satisfying customers; strategy means satisfying them better than the competition does. Keep in mind that there are many bankrupt firms out there that satisfied their customers, but the competition satisfied them better. Competition is so important that it will be discussed in detail later.

But one caution must be offered here with respect to beating competition: Successful marketing en-

tails developing a market strategy that focuses on customer needs within the context of alternative competitive realities. Beating the competition isn't enough; you must satisfy the customer. Beating the competition isn't the measure of success. Success comes when the consumer buys and continues to buy your product.

Think of a basketball game. When bringing the ball up court, you must keep one eye on the defense and the other eye on the basket. If you are successful in getting by the defense (competition), you still haven't won. You still must make a basket (satisfy the customer). All basketball players can remember at least one time when they made a great move, faked the defense out of their socks, ran undefended to the basket and missed. They didn't get cheers for the great move. They may even have been booed for having the chance and not taking advantage of it.

More than once, "great minds" have laid to rest a plan in the meeting room of the corporate office, closing the book with, "Well, I guess that wraps it up." You still have to play the game. You still have to execute the strategy, you still have to make customers happy, and you have to keep them happier than they would be with the competition's offering.

Doing What Comes Naturally

One point should be made before a strategic adventure is begun: Most business people do not naturally tend to be strategic. As a matter of fact, most people are more likely to be tactical. That means if you expect either your staff or yourself to be more strategic, you will have to be very explicit about the process. Don't assume you or your staff will do it naturally.

Reasons for this tactical orientation have been hypothesized. One is that most people start their business careers at the lowest sales level. The successful salesperson usually is very tactical, good at hand-to-hand combat and able to win in the trenches. He or she can make a sale!

"Quarter-itis" should get some of the blame

The reward for that success is a promotion—leading others at hand-to-hand combat and helping when the situation calls for assisting another salesperson in closing a sale or making inroads with a new account.

The reward for tactical leadership is often a promotion out of the field into headquarters. Here, a new task is demanded: deciding how battles should be fought, not fighting them. A major problem arises, because the promotion was the result of successful tactics. Naturally, the approaches and techniques that brought about the promotion are employed. Unfortunately, this actually may be counterproductive.

Obviously, businesses are not fortunate enough to have the War College of the Military, where officers are sent to learn how to make wars winnable, as opposed to how to fight.

Some businesses do send people to traditional MBA programs and read *Fortune, Business Week* or other business publications. Others send executives to advanced management seminars at the Ivy League schools. However, this learning experience usually is reserved for top management who are planning the corporate future, not middle-level marketing executives who must chart the market and their products' futures.

Additionally, the "quarter-itis" that is blamed for everything else bad about the American economy should receive some of the blame here. It is very difficult to develop a multi-year strategic plan when the company demands short-term returns.

Consider the situation in which a company noticed a new competitor moving into its market. While the new company had only a few share points in the outside fringes of the market, the marketing staff recognized that the new competitor was the leader in most of the other markets it had entered.

The marketing staff put together a proposal to create a new product to attack the competitor head on. The strategy was to block channel access by

offering the retailers the same product with similar trade margins, thus precluding the trade from having to deal with a new supplier. The project would have some startup costs, but the real hang-up was that the margin on this new product would have been lower than the company wanted.

Top management viewed the competition as insignificant. After all, the competition had a low market share, and the new product did not meet the company's margin objectives. Consequently, management decided not to proceed with the project.

Think about this for a second. The reason the new competitor entered the market was that it had a product that was not available to the market, and people seemed to want this new product. The company's plan was to try to convince people they really didn't want the new product, rather than being the first to give it to them.

You can guess the results. The company had good earnings for a few years, while the new competitor made small but constant market share gains. Soon, it had almost 15 percent of the total market and almost 100 percent of the market for the new product. The new company had invested in new product development and created products to compete with the full line of the original company.

It was then in a position to approach the retailers and offer them the full line of products from one supplier. Guess what happened? The "old" company fired the marketing manager, because he had not generated sales, and felt that the best approach was to lower prices to generate sales. Sound familiar?

Strategy Is More Than Price Cutting

There is a natural inclination for companies to use price as the first line of defense in any serious battle for customers. Our hypothesis is that marketers didn't pay close enough attention in their introductory economics class. They remember only something about if you lower prices, sales go up,

Never give customers equal choices

all else being equal. It is the "all else being equal" that they forget. In the marketplace, all else is never equal, and when you lower prices you are probably getting yourself into deeper trouble. Remember, anyone can give away product. It takes brains to sell it.

Think about it. If you offer the customer two identical products (equal choices) at different prices, you would expect the customer to select the lower-priced alternative. Our job as marketers is to never give customers equal choices—thus avoiding the devastating price wars associated with a commodity products mentality. We believe there are no such things as commodity products, only commodity marketers.

Using a tactical price reduction to solve a strategic problem is very common and usually fails. Now, we are not talking about using strategic price changes to solve long-term problems. This is as reasonable as any other strategic weapon and will be discussed in a later chapter.

An example of a tactical price response to a strategic issue can be found in the airline industry. During the Gulf War, the airlines had a serious problem because people were not flying. They were afraid of terrorism and other acts of violence at the airports, in the air and even in hotels. They wanted to avoid the hassle of three-hour advance check-in, which was warranted by security checks.

Of course, people who did fly really had to. They had no choice because of professional commitment. Also, some just were not afraid.

How did the airlines try to increase air travel? They lowered price. Think just for one minute. Would someone who was afraid to fly to Europe for $3,000 per person really decide that he would risk it all for $2,500 per person? Not likely. You know it, we know it, but why didn't the airlines know it?

What other ideas should have been studied? An effort should have been made to solve the customers' problems—not the airlines'. If people were afraid, increased security should have been very

visual. More interviews of passengers, more searches, airline-paid security at selected hotels and other services for security should have been provided. If people don't feel safe, make them feel safe. If it's not convenient to check in, make it easier to do so—for example, pick up their bags at home and put the luggage through the exhausting pre-departure security check, but spare the passenger. Don't tell them: "You may not feel safe, but at least it's cheaper."

Why didn't the airlines do this? We can only hypothesize, since they won't discuss this for the record. One possible reason is money. That's easy.

Let's look at the effect of a price drop on revenues. Clearly, there would be a loss in revenue. In fact, the loss would be—at the minimum—the difference between the number who would have traveled without the war at the old price minus that same number at the lower price. That is the minimum, because it assumes that the tactic is 100 percent effective in bringing the scared travelers back to the airlines. That lost pool of money could have been used for increased security.

What if that isn't enough money? Why not increase price, rather than decrease it? First, the travelers who had to travel are most likely price inelastic—i.e., insensitive to price changes. Second, everyone would have seen some visible evidence that, for the higher price, their concerns were being addressed.

Why else might they not take the visual security route? They didn't want to draw travelers' attention to the potential security problems. Why make them think this was a problem if they didn't already think it? This would have been a reasonable explanation—if the travelers didn't watch any television, read newspapers, talk with friends or do just about anything but live in a cave. It was a solution totally outside an awareness of customers' real situations.

This "why create a problem?" mentality was exactly the logic that went into Campbell Soup's de-

The world's-safest-airline approach

cision not to address the salt issue head on. We were told directly that it would draw customers' attention to the sodium content of the soup. What?

At that time, salt was one of the issues consumers thought was most serious, and they identified soup—homemade, as well as commercially prepared—as high in salt. Rather than make a good low-salt soup, which was considered a threat to the original soup, Campbell's waited for a major player, such as ConAgra, to introduce Healthy Choice soup. Campbell's might argue that it introduced a low-sodium product before Healthy Choice, but it was a half-hearted effort by the company.

Who was right in the airline example? We will never know, because our assessment was a hypothesis, and all the airlines lowered prices. But that was a record year for losses for the airline industry. In all fairness, during the war, there were also many other problems for the industry, such as much higher fuel costs and a sluggish economy.

Who was correct in the soup example? At one time, Campbell's literally owned the soup business. Ten years ago, Healthy Choice was not even in the marketplace, let alone the major competitor it is today. Who do you think better addressed the strategic issue?

One very special warning must be given to the marketer at this point. Many times, marketing programs are developed that are financed by small price increases. However, once the new price is set, the marketer has a difficult time doing what was proposed in the plan, because the money originally targeted for marketing efforts is used for other purposes.

It was claimed that Pan Am had developed a plan to be the safest airline in the air and, for that advantage, a small surcharge of only a couple dollars was added to the ticket. When the security planners tried to implement the world's-safest-airline plan, management questioned where the funding would come from. From the security surcharge, of course, the planners responded. How-

ever, that money had already been allocated to solve other operating problems. Naturally, the marketing managers couldn't fulfill their promise to make Pan Am the safest airline in the world, and it eventually went bankrupt. This is a common problem. Beware. Beware.

Let's look at an example from the food industry, where lowering prices seems to be a natural reaction. Each year, the food marketing department at Saint Joseph's University holds a seminar for food retailing executives throughout Europe, and the closing exercise is to present plans for the supermarket for the 21st century. Each year, American supermarket executives act as the judges. And each year, the students present a plan that offers a significant number of customer services in the supermarket.

In general, these services are matched to the desires of the targeted consumers. In the markets studied, the findings indicate that better service is the preferred strategic keystone, not price.

However, each year, at least one executive asks how those services can be offered with a low-price policy. The students' response is, "We try to do the best job of providing what the targeted consumers want at a fair price, not necessarily the lowest price."

Claiming that consumers desire only the lowest price, the executives are doubtful of the proposal's potential success.

We are not trying to pick on our soup or supermarket friends (we hope they still are friends) or the airlines. Our point is that when you examine a strategic situation, your natural reaction is to concentrate on tactical solutions—with a heavy emphasis on pricing as the most expedient remedy. Beware!

Heed the words of John Weston, chairman and CEO of Automatic Data Processing Inc., who said, "We will never try to develop a strategy that wins on price. There is nothing unique about pricing."[2]

Better service is the strategic keystone

Chapter 3 Clues

- Make sure that everyone in your organization who needs to know the strategy knows it.

- Train managers to be strategists.

- Make every manager read *Success Leaves Clues*.

- Make no tactical decision without considering its strategic implications.

- Unless you have a functional cost advantage, avoid price wars.

Chapter 4:

STRATEGY IS HOW YOU USE A COMPETITIVE ADVANTAGE

Strategy is how your company will use a competitive advantage to win customers to your products or services. It suggests the approach that must take place to make this happen. Quite simply, strategy is how you will get from where you are to where you want to be. The most important aspect of strategy is that it is planning and deploying resources *before* the battle takes place.

Strategy is stacking the odds in your favor before you begin your activities. It is determining how the firm will allocate its scarce resources before the battle takes place, so the objectives surely will be realized if and when a battle occurs. It states everything that must happen for the battle to be won.

Strategy is finalized in the boardroom, not in the field. It ends at the boardroom door, and tactics begin at the customer's door. Just think of it as what must be done to reach your objective. It is the reason you advertise, promote and call on certain customers. It provides the direction for R&D. It even spells out how you will bill your customers.

Strategy sets the point where the battle will take place (what type of customer or what type of retail store), the time when the battle will take place (when you make your sales call or introduce the new product) and the force with which the battle

The critical question: "Is it on strategy?"

will be fought (how much money for advertising and promotion and how many people in the sales force).

Strategy is the conceptual glue that makes sense out of all the tactical actions that will follow.

Let's look at an example. At a recent meeting of a multinational pharmaceutical company, an executive lamented that he couldn't decide what price to charge for a new breakthrough product. He asked our opinion on the matter, and we responded with, "What is the strategy?" He explained—and quickly realized that, given the strategy, he had innumerable options beyond just setting the initial price. Heretofore, issues such as the company financing customer purchases of the product, return policies and warranties were not considered under a strict pricing decision. Now, all were possible, given the strategy. Also, he learned that some of the tactical options he was considering did not fit the strategy.

Strategy is what gives you license or permission to act tactically. For every tactical decision, ask yourself a very simple question: "Is it on strategy?" If yes, consider doing it. If no, don't do it or reconsider the strategy. There are absolutely no other alternatives if you want to stay in business. No idea is a good idea if it's not on strategy. Think we believe strategy is important?

The importance of strategy was stated best by B.H. Liddell Hart, "The true aim [of strategy] is not so much to seek battle as to seek a strategic situation so advantageous that if it does not of itself produce the decision, its continuation by a battle is sure to achieve this [victory]."[1]

Think of a boxer's strategy. He knows his opponent's strengths and weaknesses, as well as his own. He works with his trainer to decide how each round will be fought before the bout ever takes place. The fighter plans to throw jabs early to exhaust the opponent, move around the ring to keep him off balance and finally hit him with a hook in the late rounds to knock him out. If all this hap-

pens, he will win. And the job of the trainer is to tell him what to do so he will win.

Keep in mind that strategy has various levels. The overall marketing strategy of the firm should be simple and easy, so all employees can see exactly where the firm wants to be in the future.

Consider Domino's strategy: "Pizza fast, pizza hot." With this simple statement, all the operating units and staff functions have direction as to what they must do and not do. Each operational unit must develop its own strategy to accomplish the corporate strategy. For example, the real estate department must search for locations that have easy access to highways and are close to residential centers. Locations conducive to walk-in or drive-in business are not needed. The store designers must be concerned with making pizzas faster, not with seating. None of the restaurants have tables, because eat-in customers would interfere with the goal of speedy delivery. Product developers need to make few sizes, few toppings and packaging that keeps pizza hot. For example, crush-proof boxes and insulated pouches keep pizzas "hot," while routes are pre-planned to deliver "fast." Even R&D would look to microwave dough or even mobile ovens that go to the houses.

Beyond the "simple" strategy statement, a comprehensive strategy includes the mission, the objectives, the target consumers, the specific competitors, the competitive advantage statement and the time frame for the strategy.

Once a strategy is articulated, another plan, a tactical one, must be developed. The tactical plan delineates exactly how strategy will be carried out. Who will do what and when and with what force?

Tactics

Tactics represent the execution or carrying out of the strategy. All the planning and strategy in the world don't win marketing wars; they only make them winnable. The wars are won in the trenches, in the field, in the customers' offices or in front of

A billion-dollar strategy: "Pizza fast, pizza hot"

Tactics must support the strategy

the shelves.

The product manager decides what product customers might buy, but the sales force sells it. The advertising manager decides what appeals to make in the ad, but the sales force sells it. The buyer decides what the store assortment should be, but the store manager sells it.

Some argue that the sales manager has one of the most difficult jobs, since he or she must deal with both the strategy and the tactics. In the manager's office, the strategy is converted into tactics for his salespeople.

Winning the Race

Make no mistake about it: You need both strategy and tactics to be successful in business today. But tactics follow strategy, and tactics must support the strategy.

Think of strategy and tactics in terms of a boat race. The rudder is the strategy, which sets the course, and the engine is the tactics. If you have a boat with no rudder and a fully engaged engine, then you travel fast but could quickly run onto the rocks and sink. Just going somewhere fast is not sufficient.

But a boat with a rudder and no engine or horsepower is not much better. The boat just sits still in the water with everyone onboard knowing exactly where they want to go, only they aren't getting there.

Success requires both the rudder to be set to the appropriate heading and the engines to be throttled at cruising speed. One without the other is sure to bring failure in the short or long run.

More products and businesses fail because of poor strategy than poor tactics. Corporate planners have sent their sales force into the field with the odds stacked against them. Retail executives have asked their store managers to run stores that have little or no chance of success.

But because tactics follow strategy, it should not be construed that strategy can be developed without intimate knowledge of the market. As we will discuss later, we believe in a "bottom up" approach to strategy. Because tactics follow strategy, the corporate planners often think they can sit in their offices and create the ultimate plan, then simply send it down to the troops for execution. Nonsense! The strategy must be conceived in the context of the marketplace and executed in the market.

How Does It All Fit Together?

One question we are asked frequently is: What is the relationship between the vision, strategy and tactics? We have found it useful to think of the building trades for an analogy. When an architect is planning a new building, he creates a rendering that shows everyone what the final project will look like. It is the overall image, the result of years of construction. The vision of the corporation should be like the architect's rendering. It should show one and all what the company will be like if the plan is achieved.

The architect then creates blueprints, which describe how the building must be built. It explains in excruciating detail what must be done. The strategy is like the blueprint. It explains what must happen if the vision is to be achieved. It explains how the pieces go together, specifies the materials and takes into account the terrain.

The next step happens at the job site: the actual construction. The blueprint is brought to life by the carpenters, electricians and plumbers. Anyone in the building trades knows that once the blueprint is brought to the job site, things are changed. Products may not be available and substitutes are used. The terrain may have changed, or the labor pool may have shrunk. The plans are modified with the single objective of making the building look like the rendering.

The job site is analogous to the tactical stage. It is where the vision is realized. But, in any business,

A pyramid:
Vision,
strategy and
then tactics

Clear strategy, basic order: "Go out and win"

changes must be made. Everything will not go exactly as expected. It is corporate vision that provides the basis on which to decide how to modify or correct the plan.

So, as you can see, it is a continuous circle of vision, strategy, tactics, vision, etc. Where is the beginning of a circle?

Another question often asked is: What role does profit play in this analogy, if the vision is the objective? Think about how the architect is rewarded if, after the building is built, it closely resembles the rendering. He gets paid. He gets paid because he achieved the vision. The same is true in business. If you achieve your vision, you get paid in the form of profit. But all of your daily decisions must be about the vision, not about the profits. Seeking profits does not give you guidance as to how to achieve the vision.

Another analogy also may help. Suppose you are the coach of a basketball team that is losing a game with 30 seconds left to play. You call a timeout and have the team circle you. You give them the winning theme. What if you said, "Here's what we do, boys: Go out and win"? Each player would look at you with no idea what he needs to do to get the team a victory. That's why the coach will tell each team member exactly where they should be, who should get the ball and when. If the players do everything exactly as he says, they will win.

In business, we often act as if we are the coach giving the advice to go out and win. So often, you hear executives say the objective of business is profit. Let's all go out and make profits. Like bewildered basketball players, the company's executives have no idea what to do when you say, "Make profits." They have no idea how to get closer to the vision.

Business is about delighting customers. Do that and you will make a profit.

Why Strategy Now?

American corporations have only recently discovered the value of customer-driven strategy, and many are still learning. The world of old was a reactive one, where most companies just "did their thing" and occasionally reacted to a new competitor, a new product or changes in society or the culture. For the most part, this worked, as the world changed slowly and the companies reacted without losing too much in terms of sales, market share or profits.

As an example, it was gospel in the retailing industry that there were three important things—location, location and location. This was a marketer's nightmare. Nothing had to be special about the store, what it sold or how it was sold. Success came from being where the customers were.

However, as the best locations became occupied by the competition and good locations were harder to find, marketers again looked for one-word solutions. The new solution was price. Their rationale: Since they had fewer good locations available and competition was all around, then it must be lower prices that would bring in customers.

This approach is interesting, since the same store operators could see that higher-priced, branded merchandise outsold the much less expensive private labels 3 to 1 or even 4 to 1. Yet major retailers printed three- and four-page circulars that never mentioned any customer-related store-differentiating attributes, only the prices of the products sold.

Changes in the past 10 years have helped make this thinking obsolete. These changes exert their impact on manufacturers, wholesalers and distributors, and retailers.

One major change is the blurring of the boundaries within an industry. For example, it used to be that people went to supermarkets to buy ingredients or groceries that they stored, then later prepared or changed into meals. They also occasionally went to restaurants for meals prepared away

Location, location and location

Meal-satisfying opportunities

from home. They went to department stores or discounters for health and beauty products, hard goods and clothes.

But think about the market today. More than 50 percent of the food we eat does not come from food stores, either convenience or traditional stores. People are eating more food in transit, and more food is being sold by non-traditional sources. For example, hospitals sell dinners to staff to take home, and schools prepare breakfast, lunch and dinner for latchkey kids and their parents. Supermarkets are trying not to be left out. More and more are competing by offering prepared and cooked meals. Convenience stores sell so many sandwiches and other prepared meals that many view McDonald's as a more significant competitor than supermarkets.

Restaurants are fighting back by offering larger portions, which are routinely wrapped, taken home and consumed a day later. This phenomenon is referred as "planned-overs"—as opposed to "leftovers."

Talk about a double whammy for the supermarkets. It used to be that when a person dined in a restaurant, the supermarket lost the sale of one meal. In many cases now, with the planned doggy bags, it loses two or three meal-satisfying opportunities.

Add to these changes the fact that department stores and discounters are selling more food. Today, sales of Frito Lay snack foods are as important at Wal-Mart and K-Mart as they are in any supermarket chain. In 1992, snacks gained only 0.9 percent in supermarket dollar sales, compared with a 66.6 percent gain in warehouse clubs and an 18 percent increase in mass merchandisers.[2] Likewise, supermarkets themselves are contributing to the blurring by selling and promoting more and more non-food items.

Don't Be Complacent

One last point about marketing strategy: You will

never get it perfect. Just when you think it's right, something changes—competition, customers, channels of distribution, something. Marketing is a race with no finish line.

The problem occurs when a company achieves some measure of success, possibly with good strategy, and believes it can't fail. Success breeds complacency, and complacency leads to failure.

We cannot warn you enough about staying vigilant. Current success does not guarantee future success. Remember the old adage, "Whom the gods want to destroy, they send 40 years of success."[3] Or, in the words attributed to the late Malcolm Forbes, "The toughest business obstacle to overcome is success."

Every business might become complacent, and the more successful it is, the greater the chance of complacency. Just look at Nike, the athletic shoe manufacturer. A great success in the late 1970s, it thought the "world stopped and started in the lab and everything revolved around the product. Nike managers were blinded by their own success."[4] It took years for them to overcome disastrous errors. It was under the guidance of CEO Phil Knight that Nike came back. Chapter 6 (on leadership) will cite the reasons for Knight's success.

In reviewing the sneaker wars, one might understand why Nike became complacent. It had a complacency role model to follow: Reebok. Imagine, as recently as 1987, Reebok dominated Nike. In fact, some people talked about the Nike/Reebok battles the way they discuss Coke/Pepsi and Budweiser/Miller. But no longer. In 1995, Nike's market share soared to 37 percent from 31 percent a year earlier. At the same time, Reebok continued to slide, down to 20 percent in 1995 from 22 percent in 1994. In the mid-'80s, Reebok was the market leader and almost torpedoed Nike. Today, Reebok is struggling to stay in the contest.[5]

"Blip on the screen" is how top management at Kellogg Co. describes the upheaval in America's

A strategic trap: Success breeds complacency

"Management is blowing it"

breakfast nooks. Hardly. Kellogg's share in breakfast cereals fell from 41 percent in 1988 to 33 percent in 1996. Similarly, operating margins dropped from 18 percent in 1995 to 10.6 percent in the second quarter of 1996. Kellogg was slow to react to the private-label onslaught. Even after taking such a beating, Kellogg's response prompted *Forbes* magazine to write a story titled "Denial in Battle Creek." Kellogg's complacent demeanor has been compared with IBM in the 1980s and the U.S. auto industry before the Japanese invaded.[6]

Kellogg's problems continue, as net income decreased 23 percent in 1996. According to a prominent investor, "Kellogg has a great name and franchise, but management is blowing it. The company lacks vision and focus."[7]

Even the world's largest manufacturer of jeans, Levi Strauss, was misled by its success. After years of double-digit growth in the casual wear business, Levi went after the classic wool suit business with a sense of invincibility. Read Rule 2 (Know What Is Under Your Umbrella, Chapter 7) and you'll understand why.

In the food and drug industry, the assault on nationally branded merchandise continues. We recommend that you read a humorous and insightful article titled "The Day the Last National Brand Died" in *New Product News*.[8]

In the retailing industry, they call it the Taj Mahal Effect. It happens when a retailer erects a glitzy flagship store in Manhattan. It appears to be a combination ego and "we figured it out" phenomena. According to analyst David Childe of Salomon Brothers, "When they build a monument to themselves, it's time to get out."[9]

Many companies let success blind them. F.W. Woolworth, S.S. Kresge, W.T. Grant, E.J. Korvette, Eastern Airlines, Pan Am, Allied Supermarkets, Grandway, Jamesway, Wang, Smith Corona, Silo and Best. Just look at this list of once-successful companies and ask: Where are they today?

After visiting companies on consulting assignments, we often comment on the closed minds of the marketing managers. When a change is suggested, they smirk and say, "We don't do things that way." They usually aren't smirking when they are unemployed and looking for a new position.

Don't be complacent. It will mean the end of your success.

Chapter 4 Clues

- Be just as vigilant during periods of success as you are when things are not going well.

- Don't enter a boat race with either a bad rudder or a defective engine.

- Conceive your strategy in the context of the marketplace, not in the context of the boardroom.

Chapter 5:

STRATEGIC PHILOSOPHIES AND RULES

Before we introduce the various strategic alternatives, the concept of strategic philosophy needs some attention. Great generals don't just sit around and talk about the rules of strategy. Rather, they develop strategies that do not violate the rules. They decide whether they should take the offensive and go straight at the enemy—or develop a defense to protect the ground recently gained—or look for uncontested ground.

In general, the particular strategy selected by the leader reflects his or her philosophical orientation: offensive, defensive or avoidance-driven. If the prevailing philosophy of the organization is offensive, then the thrust will be to attack the competition (the enemy). If, however, the organization's governing philosophy is defensive, then the objective will be to stop the attack. An avoidance philosophy dictates refraining from any direct engagement of the competition.

Each of these basic approaches to strategy has some advantages and disadvantages. Some are more appropriate under certain conditions, while not appropriate under other conditions. The advantages and disadvantages, as well as the appropriate conditions for use of each of the strategies, will be detailed in ensuing chapters. This chapter

Achieving a strategic victory

will identify the philosophies governing the development and deployment of these so-called "classical strategies," while pointing out pitfalls to avoid and suggestions to improve the probability of achieving a strategic victory.

As the particular strategies are identified, you will see that some may be employed only with a particular philosophy. For example, launching an attack directly at the enemy's strength—a frontal assault—may be used only with an offensively oriented philosophy. On the other hand, a flanking strategy may be used offensively to attack the enemy's weakness or defensively to protect your own weakness. Even a guerrilla strategy, primarily employed under the avoidance philosophy, may be initiated for offensive purposes (to attack the competition's fringe business), defensive purposes (to stop the enemy from attacking your core business) and avoidance purposes (to compete in the target market without directly engaging the stronger competitor).

The Offensive

An organization or leader with an offensive philosophy may employ any one or more of the following strategies, depending on the circumstances of the market, organization, environment and competition:

- Frontal Attack (Pure Offensive);

- Offensive Flanking;

- Encirclement;

- Preemptive; and

- Broadening.

The Defensive

Like the strategist who is offensively minded, the defensive philosopher has a number of strategies at his disposal. Some of these strategies are similar to those noted under an offensive philosophy.

They include the following:

- Defend, Defend, Defend (Pure Defensive);

- Defensive Flanking;

- Encirclement;

- Preemptive;

- Broadening; and

- Counteroffensive.

Avoidance

Finally, there are organizations whose philosophies are more in line with those of Sun Tzu, who believed that the best battle won is the battle never fought. These individuals would consider implementing the following strategies:

- Retreat;

- Bypass;

- Lull to Sleep; and

- Guerrilla and Diversionary.

- Niche

Identifying strategies according to these competitive engagement philosophies is done to simplify the presentation of these classical strategies. We are not really concerned with strategy typology—i.e., the correct labeling or classification of a particular strategy. Rather, the focus of the remainder of the text will be on understanding the nature of these classical strategies, identifying the context in which each should be considered, giving examples of the successful implementation of these strategies and providing strategic guidelines for success. Regardless of the strategy employed, a few basic heuristics should be pointed out.

Competitive engagement philosophies

Big companies destroy small companies

Rules of Thumb to Save Your Limbs

Big Fish Eat Little Fish. This is probably the most important of the three heuristics. We refer to it simply as the "Big Rule." Expressed in military terms, big armies conquer small armies. In the corporate world, big companies destroy small companies.

Many of you are probably wondering about David and Goliath. In other words, "Doesn't the little guy sometimes win?" Yes, remember a few years ago when Duke, the decided underdog, beat previously undefeated UNLV in the NCAA basketball tournament?

Sometimes Lady Luck smiles on the little guy. Let's face it—David had some additional help from above. Keep in mind that UNLV had already beaten at least 60 consecutive "Davids," before finally losing. In the long run, would you rather have 60 wins and 1 loss, like UNLV, or 50 wins and 11 losses, like Duke?

What about the small Japanese cars that beat General Motors? In the small-car market, the Japanese were the big guys. In fact, they were the only guys in the small-car market. This is the difference between absolute strength and relative strength. GM was bigger overall. That is absolute strength. But in the small-car battlefield, the Japanese were bigger. That is relative strength.

Marketers seem to ignore the law of superiority of force, while the military almost never ignores it. Carl Von Clausewitz said in his book *On War*, "The superiority of numbers is the *most* important factor in the result of a combat."[1]

We can again see how inviolate the military hold this law. Before the Joint Allied Forces attacked Iraq, months were spent building up resources in Saudi Arabia. In fact, General Norman Schwarzkopf was under great political pressure to begin the attack. The Washington politicians wanted to get the Gulf War started. Even though the result

56

of the war was determined before the first shot was fired, Schwarzkopf refused to begin until he had amassed a superior force at the point of attack. He knew that even though the United States had many more troops than Iraq—more planes, more armor, more ships, more rockets, more artillery, more troop carriers and more politicians—it mattered only when he had more on the battlefield. And congratulations to the general!

But how many times have we sent the sales force out to a specific market, when we knew they were totally outnumbered by the competition? How many times have we spent significantly less on advertising than the competition spends, and expected to get their customers to switch to our product? How many strategists have entered the market, expecting to win with half the promotional support or half the targeted distribution of the competition?

The distressing fact is that these same under-resourced companies usually are shocked when their objectives are not realized. However, the rule holds that the biggest companies in a particular market usually have the biggest share in this market.

Two additional fallacies are commonly held by today's executives. These were best articulated by Al Reis and Jack Trout, who identified the fallacy of better people and the fallacy of better products.[2] These two major marketing fallacies are that you can overcome superior competitive offerings with either better people or with better products.

More People Are Better Than Better People. Why do so many marketing strategists ignore this rule? We think they fall into two groups—those who fall into the trap of believing these marketing fallacies and those who are too stupid to understand.

Have you been to marketing meetings where the VP gets up and claims that even though the company is small and does not have much money, it will take over the market because it has better people? "We will outsell, outwork and outthink the competition."

Building a better mouse-trap

In 1856, the British had some of the finest soldiers in the world, well-trained, well-led and very professional. But when these 600 "better" troops of the light brigade charged more than 27,000 Russians, they didn't stand a chance. Lord Tennyson documented this rush into the jaws of death, so that managers can think about it every time they consider sending their "better" and outnumbered troops into the marketing wars. Unfortunately, it appears very few have read and understood Tennyson's "Charge of the Light Brigade."

Imagine if these same managers who fight head-to-head battles and expect to win are asked to coach a basketball team. One team has the starting five of the Olympic "Dream Team"; the other consists of 15 of the next best NBA players. Most would select the Dream Team (better people).

What if we modified the rules so that there was no limit to the number of players on the court during the game, and then we pitted the 15 "next best" players against the five "better or best" players? In all likelihood, most managers would change the team that they want to coach. Yet, off the court, in the marketing jungle, they think their outmanned team of better workers can beat the better-resourced competition.

Don't get us wrong. We would rather have better trained, better educated, more experienced employees. But they don't make up for having significantly fewer dispatched to engage the enemy or competition.

Building a Better Mousetrap Is Not Sufficient. "Build a better mousetrap, and the world will beat a path to your door" was good advice during the manufacturing era of the 1950s. However, as we enter the 21st century, this advice is as useful as last week's news. Many times, entrepreneurs of fledgling businesses—as well as managers of big companies—approach us with the claim that they have invented or discovered a great product. In fact, they contend that their great product is analogous to the better mousetrap and are confident that once consumers are aware of it, surely they will buy it.

A colleague of ours, an accounting professor, couldn't understand what marketing was all about. He believed that people will automatically buy the better product. This also must be the opinion of many American managers, who enter the market armed with a better product, only to be totally outgunned.

Just look at the situation with the clone personal computers. Most "techies" say that clones are just as good as—if not better than—branded computers, such as IBM PCs. As a matter of fact, their components are almost exactly the same. But the better product cannot compensate for the hundreds of thousands of IBM employees and dollars. As of this writing, IBM still has the largest share of the market.

If the big guy usually wins when the little guy goes head-to-head with him, how does the little guy ever win? How did Dell get into the PC market? How did Domino's get ahead of Pizza Hut? How did Nissin soup pull so many share points from Campbell? They didn't go head-to-head against the competition. They chose their battlefield, and they followed the rules. The clues to their success will be detailed later.

Corollary: Do Post-Mortems

Only the most naive executive would ever expect to achieve success without some failures. But, in most cases, the marketing failures are hidden or ignored—or, in the words of Ross Perot, "kept in the attic like some crazy aunt."

However, today's marketing strategist uses those failures as enriching learning opportunities—no matter how painful or unpleasant the task of conducting the autopsy. While marketers don't have the advantage of time between wars—like their military or athletic counterparts—nonetheless, a post-mortem still is an activity crucial to strategic success. Keep in mind that past successes—and conversely, failures—must be completely understood before any constructive change can be made.

They chose their battlefield

Why a strategy failed

(Apparently, based on Mr. Perot's performance in the 1996 presidential election, he must have kept his 1992 experience in the closet with his crazy aunt. So much for advice not followed.)

Don't rely on others to tell you why certain strategies failed and others succeeded. Do your own analysis. Never assume that the next battle will be fought like the last. Conduct a post-mortem.

Marketing histories tend to focus on *what* happened, rather than on *why* things happened. The only time the why is discussed is when there is a marketing success. In this case, marketers are quick to share with their colleagues why their strategy was a success.

When was the last time you were in a meeting for the express purpose of determining why a strategy failed? Often, the names of a failed strategy and its designer are not even whispered in the halls of corporate headquarters. The infamous losers are referred to only when someone suggests something new. A colleague may be quick to silence the initiative by reminding the group about "such and such" a strategy initiated by "so and so" that failed miserably.

The Rules of Strategy

Before we examine in detail the different types of strategies, it would help to ask if there are any common threads or rules that may be applied to all strategies. If common threads exist and are followed, will success be achieved?

As you might guess because we asked, there are such rules. They are, for the most part, empirically derived, the results of thousands of years of competition in war, sports, business and other aspects of life that have been constant over time.

We should point out at the outset that the rules are guidelines to help the strategist in formulating plans, in problem solving and in decision making. They are not intended to shackle him or her. Baseball fans know that most managers "stick to the book" because they know it usually pays off to

do so. The fan is also aware that knowingly violating the rules often surprises the opposition, which is expecting things to go by the book. Sometimes, the manager's team is overpowered by the opposition, and the unexpected may be the best strategy. On occasion, you should do the inconceivable. The perceived greatest-risk strategy is often the best strategy because no one expects it.

What has been most interesting is that while sports or military strategists know the rules and follow them to a fault, very few managers even know the rules—let alone follow them in strategy development and execution. When asked about the basic rules of strategy, many managers go to great lengths to explain why it makes sense not to follow them or claim that political reasons keep them from following the rules.

Not everyone is without rules. If you read the biographies of Sam Walton (founder of Wal-Mart), Helmut Maucher (chairman and CEO of Nestle) or John Bogel (CEO of Vanguard Financial), you will see that they all include principles that have guided their businesses. These are some successful companies, by any standard you apply.

Some will argue that you cannot really use universal rules of strategy or, in effect, learn from others. Instead, you must rely on your own practical experience. To them, we offer the words of the German General Bismarck, who said, "Fools say they learn from experience. I prefer to learn by others' experience."[3] *Success Leaves Clues* gives you the opportunity to learn from the experience of others.

"I prefer to learn by others' experience"

The 10 Rules in Brief

1) **Be a Leader**. Without a doubt, this is the most important rule. You must be a leader or have a leader who is a preacher of vision and a lover of change.

2) **Know What Is Under Your Umbrella**. Know what business you are in. Know the differ-

61

Distracted by quick profits

ence between what you make and what problems you solve.

3) **Get and Stay Close to Your Customer**. If you expect to understand your customers, you must become intimate with them.

4) **Know Your Playing Field**. Be aware of the forces in the environment that impact your success.

5) **Know Your Real Rivals**. Know your competitors as intimately as you know your customers.

6) **Use the Element of Surprise**. When they think you are beaten, surprise them.

7) **Focus, Focus, Focus**. Maintain your objective. Marketers often are distracted by quick profits that may not be part of the strategy.

8) **Concentrate Your Resources**. Organize resources at the point of attack. Put your money where it will have an impact.

9) **Be Mobile**. The world doesn't stand still. The competition doesn't stand still. You can't stand still.

10) **Advance and Secure**. You can't win by defending. But when you go forward, be sure you have a safe haven to return to if you fail.

Each of these rules must be considered each and every time your company begins a strategic planning session, and each and every time you finish one.

Ask yourself the following 10 questions:

1) Are we exhibiting leadership?

2) Are we still operating under our umbrella?

3) Do we really understand our customers' problems?

4) Have we considered the relevant external forces?

5) Do we know the strengths and weaknesses of our competitors?

6) Will anyone besides us be surprised?

7) Have we focused on our objectives?

8) Are our resources concentrated where they will make a difference?

9) Are we a sitting duck, or can we fly to where the action is?

10) At some point, does our strategy takes us forward, but not out on a limb?

In the next few chapters, we will provide details on each of the rules.

Chapter 5 Clues

- Don't try to take a giant head-on.

- Better people are necessary—but not sufficient—for success.

- Ditto better products.

- Be sure to make our rules of strategy your rules of strategy.

- Understand the rules.

- Follow the rules.

Chapter 6:

RULE 1—

BE A LEADER

If it were possible to prioritize the rules of strategy, certainly "Be a Leader" would stand at the top of the list. All the meetings, reports, plans, discussions and objectives are for nil if there isn't a leader to make it happen. The operative words, however, are "make it happen," as much in the bad times as in the good times.

A leader can make winners of losers and can achieve progress in the face of retreat. Leadership is an activity, not a position.

Many companies have good managers who can carry out the orders, but there are few who know what orders to give and have the courage to give them. This is what leadership is about. Leadership is a person's ability to influence others to accomplish his or her objectives.

Military strategists have known for some time the importance of leadership. Look at what some of them have said:

"It was not the Prussian army, which for seven years defended Prussia against the three most powerful nations in Europe, it was Frederick the Great."—Napoleon Bonaparte[1]

"Which army will win is answered by which of the two commanders has the most ability."—Sun Tzu[2]

"An army of deer led by a lion is more feared than an army of lions led by a deer."—attributed to Philip of Macedonia

Willingness to change the status quo

Great Marketing Leaders

Here are a dozen marketing leaders who exemplify the lion in Philip of Macedon's famous quote. In no way is this a complete list. We realize we have left out some great leaders, and to them we apologize. These are examples of the larger group of men and women who have made a difference.

1) **Mary Kay Ash (Mary Kay Cosmetics).** She recognized that money is only one of the things that make people light up. Her vision and willingness to change the status quo in terms of "reward-by-recognition" has allowed her to build a sales force of 300,000 and current sales in excess of $600 million.[3]

2) **James Burke (Johnson & Johnson).** He demonstrated via the Tylenol tragedy the value of leadership and the role of morality in the modern corporation.

3) **Michael Eisner (Disney).** He took over an ailing theme park and movie company from Roy Disney and turned it into an industry giant. He did it by keeping focused on a corporate objective of family fun. He brought the concept of family fun to retail, magazines, even a housing development, while keeping the theme parks and movies successful.

4) **Bill Gates (Microsoft).** His success as a leader is evidenced by his ranking as the richest American. However, his unusual combination of passion and pragmatism allowed him to reverse course and make the jump from PCs to the Internet. His actions demonstrated that he puts little stock in fighting the last war, repeating the same behaviors and solving the same problems.

5) **Erivan Haub (Tengelmann).** He personally led his company to become the largest food retailer in the world. Starting with a small German retail chain, Mr. Haub grew the business to include supermarket chains in

Holland, Austria, Italy, Canada and the United States. Also, he was a leader in entering Eastern Germany, Hungary and Czechoslovakia after the demise of the Berlin Wall.

6) **Phil Knight (Nike)**. He determined that Nike would not sell shoes, but the athletic ideals of determination, individuality, self-sacrifice and winning. Under his leadership, in the last decade, this also-ran sneaker company has emerged as one of world's Top 10 brands.

7) **Ray Kroc (McDonald's)**. He took a concept no one wanted to invest in, changed America's eating habits forever and popularized new foods, like breakfast sandwiches.

8) **Tom Monaghan (Domino's)**. He made home delivery a national—not just local—program, beat the giant Pizza Hut in home delivery and never lost sight of his objective.

9) **Anita Roddick (Body Shop)**. Like Mary Kay, she revolutionized the manufacturing and retailing sectors by challenging traditional paradigms, allowing her to compete in an industry marked by giants in both manufacturing and retailing.

10) **P. Roy Vagelos (Merck)**. He made the giant pharmaceutical company the undisputed leader in all areas of the industry. Moreover, while achieving financial success, Merck under his leadership was recognized as the "most admired company" in the USA for seven consecutive years in the late 1980s and early 1990s. What a record!

11) **Sam Walton (Wal-Mart)**. He made customer focus the key to success, showed that good service is possible with low prices, moved Sears from No. 1 to No. 3, and became a major competitor to unaware food retailers.

12) **Jack Welch (General Electric)**. He made

The leader as preacher of vision

strategy a keystone of operations for this electronics giant. One of the leaders he attempted to emulate was Sam Walton.

Leadership: A State of Mind, Not a Position

While we have focused on the more visible industry leaders, leadership is not limited to the people at the top. Leadership can be manifested by anyone who gets his or her group to move more effectively in a prescribed direction. A leader is the person everyone first looks to when a problem occurs or a new issue arises. A leader is the person others want on their team or committee.

As we detail the components of leadership, find examples at every level within your organization of people who manifest these traits. Stay close to them.

If your company's strategy is to be successful—either in its development or execution—you must have a leader. Although we call some people natural-born leaders, usually these traits can be developed with sufficient time, effort and direction. You can be the leader. Remember, *Success Leaves Clues*, and successful leaders also leave clues.

What Makes a Leader?

We have a very simple definition of a leader: a preacher of vision and a lover of change.

It is not the objective of this book to examine all of the components or hallmarks of leadership. But there are a few very important aspects of leadership any strategist should be aware of.

Robert Coleman, described as an obscure scientist in the *Wall Street Journal*, demonstrated the role a leader plays in a company. When he took over MediSense Inc., the company made portable diabetes monitors that didn't work, and it couldn't pay its bills. Worst of all, it had to compete with giants like Johnson and Johnson, which had $1.5 billion in blood monitoring equipment.

Coleman created a vision for the company and took

the difficult steps to make the vision reality. It meant recalling most of its products from the market, laying off one-third of the work force and telling securities analysts to watch and benchmark the company's progress against his vision. After three years of losing money but sticking with the vision, Coleman brought the company back. Sales are up 250 percent over sales in his first year, and the company was sold to Abbott Laboratories for $876 million.

Unfortunately, leadership often is not taught in traditional undergraduate, graduate or executive business programs. Although many management courses address leadership sometime during the course of the semester, it usually is not a major part of the curriculum. As St. Joseph's University, we offer no specific leadership course in the business school, but the Reserve Officer Training Corps (ROTC) does. History has taught them the importance of leadership. Good management is not necessarily good leadership. Managers administer, leaders motivate.

Speaking of the military, a former West Point cadet still carries in his wallet a brief ethic for leaders:

> Risk more than others think is safe. Care more than others think is wise. Dream more than others think is practical, and expect more than others think is possible.[4]

Some would argue that leadership is instinctive and cannot be taught. Maybe so, but there are some important characteristics that potential leaders should strive for and develop. You will notice that many of these traits are conflicting. The real leader knows when to use the right trait at the right time.

Leadership Traits

1) Vision

First and foremost, the leader must have a vision of what he or she wants to accomplish. A vision is more than a goal; it is the future—what and where

Managers administer, leaders motivate

People will march for a sentence

the company will be. A leader is obsessed with the vision. He shares it and his excitement about it with everyone in the organization—who must believe in it almost as much as the leader does. Keep in mind that vision is like passion: It can't be experienced alone; it must be shared.

A vision statement must be concise and direct. People will march for a sentence, but they won't budge for a paragraph. Recall President Kennedy's statement in the early 1960s that the United States would "put a man on the moon by the end of the decade," or Martin Luther King's assertion that "we shall overcome."

Research has confirmed the importance of vision. A study of the relationship between vision and performance demonstrated that companies with vision outperformed those companies lacking vision.[5] Incidentally, this study reviewed a hundred years of data. Obviously, vision is not a new success phenomenon. Historically, such vision has been made up of strong cultural and philosophical foundations, plus ambitious goals.

Be advised, though, that when it comes to strategic vision, you cannot be successful by being a "romantic." A romantic is a visionary without common sense.

2) Robustness

Leaders must be able to stand the shock of war, and marketing leaders must be able to stand the shock of bad news. When the battle is going badly, the leader must never let the troops lose sight of the vision or lose faith in the company's ability to achieve that vision. Some call this *robustness*; others refer to this trait as *poise*. Poise is what makes you a master of situations.

Look at some of the successful businesses today. In many cases, the company "took a shelling" before it turned the corner on success. For instance, Frank Perdue believed that he could market fresh chicken at a premium price. Many traditional thinkers held that chicken was a commodity that could never be branded. But Perdue never let the naysayers slow him down.

3) Willingness to Take Risks

A leader is prepared to take risks to realize the vision. He or she recognizes that to succeed, risks may be necessary. The key is not to be reckless, but to be informed on all aspects of the decision. That decision will move everyone closer to the vision.

Risk taking isn't just taking a corporate risk. It usually involves taking a personal risk, as well. You do what is best for the company—even though you might lose your job, your reputation or both.

An example of personal risk taking is the inventor of the contraceptive sponge. He knew that his vision would be successful. After being turned down by the traditional thinkers who knew better, he used his own capital. He soon had to sell his house and move his family into his parents' home. He reduced his food budget and spent every waking hour working on his idea. Today, his product is in every drug store in America.

Likewise, consider the risks undertaken by the president and CEO of Honda, Nobuhiko Kawamoto. After a fairy-tale come-from-behind auto success story in the '80s, Honda suddenly started falling apart in the early '90s. Honda car sales fell in 1993 and again in 1994. Two years later, Honda was zooming ahead of its competitors to enjoy the greatest success of its 48-year history.

How did Mr. Kawamoto achieve this phenomenal turnaround? He visited the company's revered founder, Soichiro Honda, a few months before he died in 1991 to say what no other CEO would dare to tell him: The company would have to be revamped. "Mr. Honda was too oriented toward engineering," recalls Kawamoto. "People after him did things his way and the thinking became vague." That's another example of real personal risk taking.[6]

However, some of the leaders we cite here are no longer with their companies. Many of the preview readers of this book suggested that we should not include any great leader or strategist who was later

Taking a personal risk

71

What will the boss think?

fired. However, we know that leaders take risks and are bold, and sometimes they get in trouble. Unfortunately, the boards of directors or their immediate superiors are not so bold or such risk takers.

Retired IBM CEO Thomas Watson Jr. provides an insightful example regarding the encouragement of risk taking. As the story goes, IBM lost $10 million due to the mistake of a subordinate, who handed in his resignation in shame. Watson rejected it categorically. "Not on your life!" he said. "You think I'll let you go now, after spending $10 million on your education?"[7]

You have all had personal experiences where colleagues would not entertain new ideas, not because of the corporate risk, but the personal risk. What will the boss say if it fails? Examine military history. Napoleon was a great leader, and we know what happened to him. General Patton was a great leader, but the automobile accident that led to his death is still unresolved. Maybe it was the military version of being fired.

Recently, an advertising executive for a large food retailer considered changing his weekly handout from the usual ridiculous list of brand names and prices to include some reasons to shop at the supermarket. We call this a differential advantage, but the trade calls it image advertising. After listening to the employees' suggestions, he decided it was too big a risk. He worried what the top management would think. Whether it was a good idea or bad idea was of little consequence. It's ironic that a very successful competitor with dynamic leadership produces a high-quality magazine monthly. The 125 glossy, color pages include branded products' advertising, as well as recipes for the advertised products, articles on entertaining, games, coupons and absolutely *no* prices. Do you think there is any correlation between the latter's success and its leadership? We do.

4) **Competitiveness**

A leader recognizes that war means competing,

and competitiveness is essential to strong leadership. The leader must be willing not only to take a punch, but also to throw a punch. The leader must be prepared for battle, not shy away from it.

Just look at Mitchell Leibovitz, CEO of Pep Boys—Manny, Moe and Jack—who wants to annihilate other auto parts retailers. When Pep Boys forces chains such as Auto Zone, Western Auto or Genuine Parts to abandon a location, he adds a snapshot of the closed store to his collection. He burns or buries baseball caps bearing the competition's logos, and he videotapes the ritual to show to his 14,500 employees. "I don't believe in friendly competition," he said. "I want to put them out of business."[8]

5) Boldness and Decisiveness

Boldness and decisiveness involve believing in your products and standing by them, regardless of the odds. Churchill said, "Safety first is the road to ruin in war." The leader must be bold. A *USA Today* headline advised the new General Motors CEO, "Be Bold or Fail."[9]

Steve Wynn has been called everything from flamboyant to an all-around inspirational leader. We call him bold. Wynn took an industry that was characterized by smoke-filled casinos congested with sullen gamblers and created a bold new image. His new casino, Mirage, built in 1989 in Las Vegas, is a family vacation center, with as much excitement throughout the property as on the casino floor. The Mirage experience is about creating fun, not simply placing bets.

The volcano spewing lava in the front of the building is the hallmark of his creation. It was a new concept that brought everyone into the casino world. He took on the traditional and created a new paradigm for gambling. But his really bold move was to leave Atlantic City when everyone was clamoring to build a new casino there. He sold his very successful Golden Nugget—for a huge profit—and "retreated" to Las Vegas to change the face of U.S. casinos. His boldness paid off. Mirage's stock increased from $6 to more than $50.[10]

One leader's rule: "Be Bold or Fail"

Boldness is for the bad occasions

Perhaps there is no better contemporary example of someone who demonstrates these traits than Bill Gates. As new Web software standards threatened to make Windows 95 irrelevant, Gates agreed that the Internet was going to drive demand for PCs and software. Gates did a 180 (something obsessed leaders can rarely do). He ordered that Microsoft become Web-centric, dumping that which didn't fit and reshaping everything else. Gates was the one person who made the difference.

It is always difficult to discover the characteristic of boldness, since, in most cases, it reveals itself only in the difficult times. Boldness is for the bad occasions. A headline in *USA Today* stated, "Crises Require Bold Action." One of the few positive aspects of crises is that one bold leader can make a big difference. Ben Rosen, chairman of Compaq Computer, was quoted in the same article: "You need one person who makes a difference, whether it's the president of the U.S. or head of a company or group leader or mail room clerk. One bold person can make a difference."[11]

It took the boldness of George Fisher to bring Kodak back from the near dead. In 1993, a securities analyst wrote that the future of Kodak was so grim, he doubted that even George Fisher could save it. Fisher took bold and decisive steps to turn the company around. He sold off unprofitable businesses and invested heavily in the future. Fisher transformed yesterday's moribund bureaucracy into tomorrow's innovator. The results of Fisher's bold new direction for Kodak are an increase in stock prices from about $45 per share when he took over to $74 in mid-1996.[12]

Leadership experts give the following recommendations for leadership in crisis.

1) Make a bold move right away. Don't wait. Make changes quickly. Don't be afraid to make a symbolic move, either. The leader must show action to the employees, the customers, the competition and the financial analysts. Whatever you do, *move*.

2) If you have bad news, get it over with. Don't let bad news dribble out. But be sure to convey all the emotion that is attached to bad news.

3) Set specific, measurable goals. Don't leave any question about what you want to accomplish.

4) Get a core team behind you. Get rid of the old team, those associated with the problems. Look at Sears. The giant retailer had been losing the retail wars in a big way. However, before Arthur Martinez became CEO in 1995, Sear executives clung to the belief that this moribund retailer was still America's store. It's hard to fall on your sword and give up your old ways of doing things.

6) **Opportunism**

Remember our earlier example of the small baking company that owned the franchise on snack cakes in a regional market. Everyone loved its products and, for years, the product did very well. The various presidents just "kept the watch" while the product sold. In the 1970s, sales started to decline as consumer preferences changed, and the president at the time still "kept the watch." Soon, he left, and a new man stepped forward and made sweeping changes. It was time for a home run, and he hit it.

A leader must step forward when he or she is needed. When things are going smoothly, the leader may be a caretaker or morale maintainer. When things are bad, he or she must take charge. Everyone looks to the leader.

A more recent example of a leader for the bad times is arrogant Al Dunlap. Whether you like Al Dunlap or not does not detract from the fact that he has shown that he can bring back the value to a company. His last tenure before taking on the CEO's position at Sunbeam Corp. was as CEO of Scott Paper. Scott was in trouble and, according to *Forbes*, losing money.

He brings in new management

Dunlap injects new life into tired businesses by following some basic principles. He claims to first decide what business the company is in. Second, he brings in new management. Third, he makes onetime major cuts. And fourth, he develops and invests in the right strategy. It looks as if he may have read the first edition of *Success Leaves Clues*.

Did he turn the company around? In a way, he did. He sold the company to Kimberly-Clark for a huge shareholder profit and was the darling of the shareholders. Unfortunately, he did it by firing thousands of loyal, longtime Scott employees, while at the same time making more than $100 million for himself. While the ethics of his actions is a topic of conversation on such TV shows as *Nightline* and *60 Minutes*, he did what his board of directors asked of him.[13]

(Of course, Dunlap's subsequent experience at Sunbeam Industries was much worse. But that failure only suggests the exception which proves the rule. Much has been made of his arrogance at Sunbeam. Equally fatal was the fact that he had grown complacent and stuck too closely to the same handful of tactics.)

Lee Iacocca is another example of a leader for the bad times. When Chrysler was almost out of business, he turned it around. A cautionary note: No matter how opportunistic a leader may be, he or she cannot "make a silk purse from a sow's ear."

However, keep in mind that the newly appointed CEO of Chrysler, Robert J. Eaton, watched Chrysler "at least once a decade ... spring from its deathbed to a miraculous recovery." While it's great to have a leader "bring you back" from death, as Mr. Eaton pointed out, the challenging solution is to "stop getting sick."[14]

One of the most dramatic comebacks from a near-death experience is Boeing. Granted, the aircraft industry is a cyclical one, but Boeing had experienced three years of declining revenues and six years of falling employment. Philip M. Condit is turning the ship around.

In 1991, revenues started a slide to a low of less

than a reported $20 billion, and the drop in income was more precipitous. Things were bad when Condit took the CEO job in April 1995. He faced the scariest situation for any CEO: change. Condit has motivated thousands of employees and brought change to Boeing during troubled times. The results speak for themselves: a dramatic increase in profit, and stock prices reaching new highs. When times get tough, the tough step forward. Condit was at the front of that line.[15]

7) Grace Under Pressure

A leader stands tall when things go poorly. Everyone in the company looks to the leader as a model at a time of crisis. The leader sets the tone for how the company will react.

There are examples of grace under pressure in the food and drug industries. Look at the reaction of James Burke of Johnson and Johnson during the Tylenol poisoning scare. He looked at his mission statement, which said something like: "J&J will serve safe, efficacious products to its customers." He felt that the product was not safe and everyone should be reimbursed, *no questions asked*.

Many people thought that admitting publicly that there was a problem or implying fault by giving money back would mean the end of the brand. However, we all know Tylenol is still here, bigger than ever.

Contrast Burke's grace under pressure with the Perrier fiasco. So far, Perrier has not returned to its former position of leadership, and it probably never will.

In Tom Peters' book *Thriving on Chaos*,[16] he describes the Coleman Co.'s reaction to a product failure. Basically, Mr. Coleman terminated a meeting of company lawyers, engineers and marketers who were attempting to minimize the impact of a defective product. His charge to the group, before anyone could even present him with the liabilities and risks, was to order a recall and replacement or refund.

"Pressure is what makes diamonds"

Said Old Man Coleman, "You mean we've got goods out there that aren't working? Get 'em back. Replace 'em, and find out why." End of meeting! That's grace under pressure. It's also class.

Compare Coleman's response to that of Edwin Artzt, chairman of Procter and Gamble (P&G) during the early '90s. The new chairman was facing rough times: more competition and less consumer interest in P&G's brands. *The Wall Street Journal* reported that the leader turned meetings into humiliating public hazings, resulting in a dozen senior executives jumping from the damaged and listing ship. Suffice it to say that Mr. Artzt is no longer captain of P&G.[17]

Unfortunately, the list of bad leaders' reactions to a crisis is much longer than the list of good ones'. This should come as no surprise, since there are not that many real leaders.

One last point on pressure: Good leaders expect pressure. They know it's coming and prepare for it. Some even redirect it into something positive. Dave Pitassi, president of Drypers, a small player in the disposable diaper business, described pressure as "exhilarating" and said, "Pressure is what makes diamonds."[18]

8) Innovativeness

This may be one of the most important characteristics of a leader, because most corporate structures do not reward innovativeness. If the leader is not an innovator, the company may not be innovative. It is possible for the leader to encourage innovativeness through the reward structure or by proclamation, but, in general, he or she must be the corporate innovator.

Joel Barker's excellent video *Paradigms* describes in detail why it is so difficult for companies to innovate—and how to encourage change in the corporate structure.

While most innovation comes from necessity, some leaders make it part of everyday life. Paul Mulcahy, past president of the advertising/promotion arm of Campbell Soup, set resources aside to evaluate

new techniques and approaches to advertising. No idea was rejected out of hand. In fact, Campbell's was often the partner of ventures testing new communication ideas.

The company that has best institutionalized innovation is 3M. The company's system of professional bootlegging of company time and resources for personal innovation has led not only to sales and profit success, but also to being rated one of America's most admired companies. 3M encourages its professional staff members to spend up to 20 percent of their time researching and developing new products and concepts. Promising ideas are funded and eventually taken to market, with the champions sharing in the rewards.

Few companies would even think about a system such as this, better yet institute it. But, then again, there aren't many real leaders, either.

But how about Rubbermaid? From humble origins as a manufacturer of toy balloons in the 1920s, Rubbermaid has evolved into the leading marketer of plastic and rubber items for the home, car, deck, playground, etc. (What business is Rubbermaid in? See the next chapter.)

During the past 20 years, sales have rocketed from $100 million to almost $2 billion. One of the products that recently resulted from the company's relentless focus on innovation is a "litterless lunch"—it lets you pack a lunch without using any disposables.[19]

In the words of one of the leading innovators, Nike, "What happens when innovation is king? Doors open and never close. The din of life is praised, not hushed. Father is builder, mother poet and the child is both."[20]

Innovation is certainly something that the retail food industry has failed to accomplish. Try to think of some of the major innovations in this industry. Why did the food retailers let convenience store chains come in and take their customers?

While convenience stores were making it quick and easy to come in and buy milk, the supermar-

Promising ideas are funded

Companies that failed to innovate

kets put the dairy section in the back of stores and made customers wait in long lines to pay. While fast food and other non-traditional food stores developed, supermarkets waited until about half the food that goes into our mouths came from these and other new sources—then supermarkets reacted.

Check out newspaper advertising from the 1950s. You might be surprised to see that supermarket advertising is virtually the same as 40 years ago—long lists of manufacturers' brands with the current prices. You can't tell one store's advertising from another.

The list of companies that failed to innovate is many times longer than the list of innovators. In fact, for every successful venture by a new startup company, there are several companies that failed due to the lack of innovation.

Leadership Status in Your Organization

A leader need not posses all of these traits, but must have at least some of them. To be successful as an organization, all of the traits of leadership must be resident somewhere in the management team. Complete Worksheet 1 to gauge your organization's leadership.

Counterpoint

Many of the traits listed above may become flaws when taken to excess. A great leader also can decide when enough is enough. It is said that a good general not only sees the way to victory, but he also knows when victory is impossible.

After a few successes, leaders often feel invincible. They take unnecessary risks or are too bold. This often leads to their downfall. Hitler is an example of a man who led his country out of a bad situation into a worse situation. But he did lead. Saddam Hussein also led his country to new levels. Before the United States decided that he had led enough when he invaded Kuwait, it had pro-

vided him with all sorts of resources, including military aid.

Consider the case of Levi Classics. A failure resulted when Levi introduced a line of wool-blend suits. All the research has indicated that consumers associated Levi with casual wear, not suits. Prior to its foray into the suit business, Levi had not known failure. Remember, success tends to breed complacency.

Likewise Bristol-Myers Squibb with Nuprin, AT&T with computers and the three soft drink musketeers: Coca-Cola with New Coke, PepsiCo with Crystal Pepsi and 7UP with 7UP Gold.

On the other hand, Kellogg realized that the spending war with General Mills was creating two losers. Something had to be done. No matter how much Kellogg spent on advertising and promotion, General Mills would match it to keep its share.

Finally, on October 5, 1992, it was announced that Kellogg's CEO had called a truce. Keeping the spending wars going strong would have led to the companies' eventual defeat. Prudence led financial analyst Joanna Scharf Rossien to say, "The biggest negative on Kellogg has been the huge increases in spending, and if they plan to moderate that, it's a strong fundamental positive."[21]

All the above traits also must be moderated by prudence. Leaders know when to be bold and when to be prudent, and followers never know.

How Does Wall Street Value Leadership?

Wall Street investors know the value of leadership. Just look at Wal-Mart's stock price after the untimely death of Sam Walton. Investors have knocked down Wal-Mart's market value by $7.7 billion.[22] Or look at the price of Sunbeam's stock after it was announced that Al Dunlap was the new CEO.

Wall Street understands that it is possible to make profits from previously unprofitable companies—

Leaders
know when
to be
prudent

or for small companies to beat giants in the game of business. But to do it, you need leadership.

Chapter 6 Clues

- Make sure everyone on your team understands the vision.

- Don't be afraid to take risks and even fail, but learn from these experiences.

- Be opportunistic, but don't lose sight of your vision.

- Remember to keep your head when all around you are losing theirs.

Chapter 7:

RULE 2—KNOW WHAT IS UNDER YOUR UMBRELLA

While there may be little debate about the pre-eminence of leadership in the rules of strategy, there are differing opinions about what comes next.

Some would argue that any strategy which is market- or customer-driven should place Get and Stay Close to the Customer (Rule 3) ahead of Know What Is Under Your Umbrella.

While we believe that the customer is queen or king, we don't subscribe to non-systematic or unconstrained pursuit of customer satisfaction.

Recall our definition of marketing: the process of understanding and satisfying customer needs at a profit. The qualifying phrase, "at a profit," demands that the marketing strategist pursue those markets that the business is best equipped to satisfy while generating a fair return to its owners.

Therefore, before you can concentrate on getting and staying close to the customer, you need to know what is under your umbrella.

What Business Are You In?

The directive to know what is under your umbrella is simply a metaphoric way to express the notion of understanding what business you are in. At the outset of our executive seminars on marketing strategy, we ask attendees to identify them-

"We sell hope"

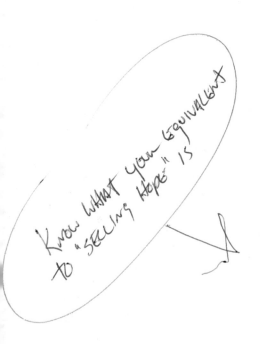

Know WHAT your Equivalent
to "SELLING Hope" IS

selves and tell us what business they are in. Almost without fail, these successful managers tell us what they do or what their companies make.

Beware! Our businesses are not defined by what we make. Rather, they are defined by what we sell. Better yet, they are defined not by what we make or what we sell, but by what people buy. Even better, though, is a characterization of our businesses—not in terms of what we make, not in terms of what we sell, not even in terms of what people buy—but in terms of "What problems do we solve for the customer?"

For the purposes of this book, the term "problem" is not limited to its pejorative interpretation (i.e., something bad). Rather, the intended use here is to describe any discrepancy that exists between an individual's actual and desired state. A lottery winner provides a lot of marketers with opportunities to solve the problem of how best to enjoy his or her winnings.

Perhaps Charles Revson, the founder of Revlon, expressed it best when he said, "At the factories, we make cosmetics. At the counter, we sell hope." You see, no one wants goods and services, per se. Nor does anyone have an intrinsic desire for the features or attributes associated with the various brand alternatives.

What a consumer seeks is a solution to a problem. The solution is found in the benefits derived from the attributes of a particular product offering. Said another way, people select brands based on the features or attributes that provide benefits which are capable of solving the customer's problem.

Most businesses can quickly list what they produce or make. However, as noted above, often the issue of what problems we solve is not so self-evident. Before you address the issue of what is under your umbrella, we will give you a few more examples for illustrative purposes.

If we asked, "What business is Disney in?" most would reply theme parks, movies, records, etc.

However, we would be falling into the "what we make" trap. All of these worthy products and services have attributes associated with them that produce customer benefit satisfaction—to solve the real problem of finding family fun. If you asked Disney executives, "What business is Disney in?" the reply would be "family fun."

Now, when Disney casts about to find new opportunities and related strategies, it looks to add those products or services that fit under the family fun umbrella. Where did Disney see an opportunity to provide family fun? They looked no further than 21st century America's town square—namely, the shopping mall.

Research indicates that 57 percent of Americans "hate to shop." Worse yet, the number of people who hate shopping increases to nearly 7 in 10 (actually, 68 percent) during the Christmas holidays. Disney said, "Let's bring family fun to the malls"—and opened the Disney Store, which has set new retailing standards for both sales and profits per square foot.

If you continue to have doubts as to whether Disney knows what business it is in, consider the name and focus of its recently launched magazine. If you guessed *Family Fun*, you are not only right on target with Disney, you understand the importance of knowing what is under your umbrella.

But Disney isn't done yet! What else do you think would make sense, given the Disney umbrella? If you said "cruise line," you'd be correct. Disney thinks a cruise line is consistent with family fun and has gotten into the business. Obviously, Disney doesn't have operational cruise line experience, but it didn't have retailing experience, either. However, it does have "family fun" experience. Think the cruise line will be a success? We do.

Ask Phil Knight, founder of Nike, if he sell shoes. Nike doesn't even show a product in its advertisements. Knight reckoned that people don't root for a product, but for a favorite team or a courageous athlete. Nike would not sell shoes, but the athletic ideals of determination, individuality, self-sacri-

Disney sells "family fun"

Providing parental peace of mind

fice and winning. Obviously, Knight's effort is the equivalent of Charles Revson selling "hope."

How about Fisher-Price? That's an easy one. Toys, you say. You might even add educational or durable—or even the attribute *safe*—before toys. Again, this is what Fisher-Price makes.

But what problem did Fisher-Price solve for parents? It rids parents of their worry about toys. Keep in mind: The attribute of safety in toys would have no bearing on the parental decision-making process, unless toys were something that parents perceived as a potential harm to their children.

Fisher-Price described its umbrella in terms of providing parental peace of mind. Using this as its umbrella, it focused on identifying those situations causing parental concern. Such an orientation first led Fisher-Price to market children's high chairs. Can you imagine the consternation caused by those managers who were still production-oriented (let's sell what we make), when someone suggested that the leading toy manufacturer market a piece of furniture?

Was the company's name at the time Fisher-Price Toys or Fisher-Price Toys and Furniture?

Credit, however, the leadership at Fisher-Price for having a vision and understanding what problems it had the license from parents to solve. By the way, it is not an accident that companies such as Fisher-Price and Disney are perceived as visionary. Knowing what problems you solve for the market can provide lots of new and exciting—i.e., visionary—opportunities for organizations that put this rule into practice.

After its foray into children's high chairs, Fisher-Price began to offer a lot of non-toy products under its parental peace of mind umbrella. Such products as infant car seats and room monitors were extremely successful for Fisher-Price.

In fact, the one notable exception to its string of successful non-toy new product launches was in the area of children's clothing. Is it that parents are not concerned about safety in clothing? In a

way, the answer is both *no* and *yes. No,* because parents do care about safe clothing. Consider the demand for fire-retardant sleepwear.

Yes, because—with the exception of the tragedies associated with children's sleepwear—the manufacturers of children's clothing other than sleepwear promised safe clothing as a minimum, not as a point of differentiation.

As a result, safety in children's pants, shirts, sweaters, etc., was not a parental peace of mind issue, and parents did not give any additional weight or value to children's clothing manufactured by Fisher-Price. Therefore, children's clothing did not fit under the Fisher-Price umbrella. The message from the children's clothing example is that the probability of success is enhanced when the offerings under your umbrella are truly unique, rather than simply "me too" options.

Recall from the previous chapter our discussion of the innovations introduced by Rubbermaid. We all know that it makes rubber and plastic items for the home, office, car, etc. That is what Rubbermaid makes, but what problems does it solve for the customer?

If you said "organized protection or storage of your stuff" we would nod our heads in agreement. It is because of this umbrella that the most recent innovation, a litterless lunch box, appears to solve a real customer problem and should prove to be very successful.

But one of the best examples of firms that understand the difference between what they make and what they sell are the upscale pen manufacturers. While sales of other writing instruments are declining in the electronic age, sales of luxury pens are increasing. Luxury pens are being sold not as much to write with, but as a statement of style. Montblanc and a host of smaller European makers do a brisk business in very expensive "limited-edition" pens.[1]

But low-end pen manufacturers beware. You may not be able to extend your umbrella to the high

The offerings under your umbrella

What people want is office efficiency

end. Pilot Corp. of Japan intends to try, even though its president has said, "Nobody in our industry has ever been successful selling both high-priced and low-priced pens." We wish Pilot luck, but could it be there is a reason why "nobody has ever been successful," and might it have something to do with those companies' umbrellas?

What does John Hancock make? Life insurance. But what is it selling? Trust. David D'Assandro of John Hancock said that Hancock's advertising during the Olympics made sense, since the "Olympics represent the highest level of achievement, trust and credibility, and that's what we sell."[2]

How about Barnes and Noble? That's easy, you say. It's a book store. True, books are for sale there, but that's not what is being bought. According to founder and CEO Leonard Riggio, Barnes and Noble is selling entertainment. The stores are designed to permit customers to enjoy an entertaining shopping experience. The design includes comfortable chairs, coffee bars and lots of open browsing space.

Does giving up some selling space for entertainment make money? You bet! Return on investment is a plump 28 percent, and Barnes and Noble is opening 90 superstores per year in its effort to dominate its industry.[3]

Want some other examples? Consider Xerox. For a long time, Xerox focused on what it made: copiers. Xerox was obsessed with making the state-of-the-art copier, which it defined in terms of speed and cost per copy. Copiers got bigger, and corporations had dedicated copier rooms, where everyone from top management (or their secretaries) to the most junior clerk stood in line to have their originals copied while they waited.

But people don't want copies for their intrinsic value. What people want is office efficiency. Xerox nearly went out of business in the late 1970s, when it stopped solving its customers' problems and the low-cost Japanese competitors caught it napping. In the 1980s, the company took a de-

tour into financial services. How does this fit under its "office efficiency" umbrella?

Today, Xerox is targeting the home office. This appears to fit under—or be a logical extension to—solving clients' office efficiency problems. However, despite now clearly knowing what business Xerox is in, CEO Paul A. Allaire admits that the company has a long way to go before it can reclaim its past glory. Allaire was quoted as saying, "We will need to change Xerox more in the next five years than we have in the past 10."[4]

Another giant that appeared to lose sight of what business it was in and what problems the market gave it license to solve was Levi's, the world's largest manufacturer of jeans. It made jeans that were a great solution to the market's need for casual comfort. In the early 1980s, in an effort to sustain its double-digit growth in volume and earnings, Levi's decided to manufacture a classic wool suit under the Levi's brand name.

Focus groups, salespeople and retailers all said that Levi's did not have permission to solve a problem in which the product or solution would be a classic wool suit. Levi's response was that once the market saw that Levi's was capable of making a classic wool suit, they would asterisk Levi's "casual comfort" perception. However, Levi's classic wool suit failure has been well-documented.[5]

Now, Levi's is making another attempt to enter the dress clothes business. This time, it is going only slightly dressier, with a dress slack called Slates by Levi's. It is made of a new microweave fabric that never wrinkles.

If casual is the umbrella of Levi's, why didn't they just call them Slates and not add "by Levi's"? We bet this line will not achieve the success of Dockers—but, then, not too many new products would.

Do failures leave clues, as well? Fisher-Price's venture into children's clothing, Xerox's foray into financial services and Levi's pursuit of the classic wool suit market certainly seemed to be outside their respective umbrellas. Was anybody watch-

Levi's classic wool suit failure

"They don't think of Microsoft as fun"

ing the Public Broadcasting Service documentary on Levi's or learning from these other rather visible violations of this rule of strategy?

Apparently, Microsoft was not. Microsoft has recently re-entered the home market for educational and entertainment software. Microsoft claims it has learned from its unsuccessful earlier forays into the consumer market. However, by her own admission, Patty Stonesifer, head of Microsoft's consumer division, notes that "consumer fun" is not a problem for which Microsoft is perceived as a solution: "People think of Microsoft as technological innovation ... but they don't think of Microsoft as fun."[6]

Apparently, Microsoft defines its umbrella in much broader and different terms than does the marketplace. However, there is no indication that the consumer's perception of Microsoft has changed. Peter Rogers, an analyst with Robertson Stephens & Co., says, "You can't count Microsoft out, but it isn't driving anybody under in its consumer business the way it is in its more established businesses."

Rogers' sentiments are echoed by a competitor to Microsoft, who states, "It would be dangerous to discount Microsoft's potential in consumer software, but we aren't shaking in our boots."[7]

Speaking of high-tech, what business would you say Sega is in? While it makes computer games for TV, according to Sega, it is in the "escapism" business. Think about it for a minute. Isn't that what kids of all ages (7 to 70) are doing when they are sitting in front of the game?

If escapism is Sega's umbrella, what other high-tech escapes can you think of? How about competing with Disney by creating virtual reality theme parks—parks without real estate, expensive travel and long lines. Just turn on your TV, put on your virtual reality helmet and enter a new world. Will it take business from traditional theme parks? Wait and see.

Complete Worksheet 2 to better understand what

business you are in.

The Growth Paradox

One of the questions that is always asked after we give an example of a firm that went outside the umbrella and failed is, "Why did the company do it?"

The answer, most likely, is the quest for growth. When a company is successful, it often finds it hard to attract new customers. The more successful it is, the fewer potential new customers are out there. Having achieved success through continued growth, the company faces a dilemma: How can it continue the growth in a category where it already has most of the customers?

Its answer often is to look for new customers outside the initial franchise area. Find a new market for the product. In the words of *Star Trek*, "Boldly go where no man has gone before." But the results often prove fatal, when you lose sight of the reasons that your product was successful in the first place.

Look at what happened at McDonald's. McDonald's not only owned, it created the concept of fast food. It had a stranglehold on the business—especially the kids market. As in any business, competition increased, and same-store profits leveled out. McDonald's sought to grow. The company added more menu items every time a competitor added a new item. McDonald's, the hamburger and french fry king, added chicken, ribs, fish, apple pie, salad, breakfast, etc.

Recently, it added the Arch Deluxe to capture the adult market. The problem with great success in one market—i.e., kids—is that it makes it more difficult to capture another market: adults. The logic of McDonald's appears to be that adults will put up with the noisy kids playing in the playgrounds and running around the store with hats and balloons in order to get an Arch Deluxe. Not likely.

Or maybe they thought they were doing the par-

Parents weren't just sitting there

y

Most people would say "iced tea"

ents of the kids a favor by providing an "adult sandwich." But parents weren't just sitting there while their kids ate Happy Meals; they were eating the standard fare. And they sure weren't going to take the kids to a different fast food restaurant for better adult food. Kids love McDonald's.[8]

Another example is Delta Airlines. It has successfully run an airline recognized for quality and service. Now, to expand business into the "shuttle" market, it has created a Delta shuttle. Pressured by such successes as Southwest Airlines, Delta felt the need to grow—but it either stretched the umbrella or went too far. We think Delta Express is likely to go the way of rival Continental Lite: It will lose money until all the key executives have found new jobs, then the company will close down the business.

Why? Delta seems to be considering the shuttle for all the wrong reasons. Pilots have agreed to accept less pay, planes will fly more hours a day, and they will put 30 percent more passengers on the planes. But where do the customers fall into this analysis? What is their perception of the "new airline"?

We agree completely with Michael Boyd, president of Aviation Systems Research Inc., who said, "A separate entity with a separate brand name confuses the public (customers) and takes management attention away from the main product."

Finally, there is Snapple. Just a few years ago, if you did word association with consumers and said "Snapple," most people would say "iced tea." But Snapple faced some stiff competition from all sides on its iced tea franchise. The big boys—like Coke and Pepsi—got into the fray, and so did startups like Arizona. To keep its leadership position and grow, Snapple started making all sorts of drinks, such as exotic fruit drinks and flavored iced teas. The product line grew and grew, and Snapple's image became blurred. Today, if you ask consumers what comes to mind when you say "iced tea," many say "Arizona."[9]

Snapple also provides a great example of the tremendous risk and cost associated with not following Rule 2: Know What Is Under Your Umbrella. Quaker Oats, which paid more than $1.6 billion for the brand in 1995, will probably sell it for $300 million in 1997. That's a $1.3 billion lesson. It would have been cheaper to buy and read this book!

Many of the failures we will discuss in Chapter 14 are examples of the growth paradox. The successful product has made the company accustomed to growth, made it expect continued growth and forced the product into markets outside the umbrella in search of future growth.

No matter how much you want growth, most likely you won't find it in markets outside your umbrella—regardless of how much you advertise, or distribute, or cut price, or promote. Don't leave the protection of your umbrella.

How Do You Determine What Is Under Your Umbrella?

There are four criteria you must consider before you can determine if a new product or service will fit under your existing umbrella:

1) Can I do it?

2) Will the target market give me permission to do it?

3) Will the competition allow me to do it?

4) Can I satisfy the organization's strategic and financial goals?

Can I Do It?

In essence, this requires a rigorous business self-assessment. As you will see, Rules 4 and 5 require that you know the playing field and who you are playing against. Part of Rule 2 is knowing yourself.

To be effective, this exercise must be objective,

Be ruthless and relentless

rigorous and extremely self-critical. When we have conducted these analyses with our clients, invariably, someone protests that we are being too exhaustive or too critical in our efforts.

Make no mistake about this exercise—it is not the time to provide motivational speeches about the organization and its people. Save those words for the quarterly sales and marketing meetings. You can be certain that your primary competitors know your shortcomings. Don't be blinded by your own perceptions—as reflected by press releases and laudatory customer letters. This analysis is designed to determine "what is," not what you wish the situation to be. Be ruthless and relentless.

When Campbell Soup realized it was in the "midday appetite satisfaction business"—as opposed to the soup business—it attempted to enter the fresh salad business with a product called Fresh Chef. While everyone knows that the useful shelf life of a can of condensed soup is just short of eternity, the time from field to store for salads is measured in hours, not life spans. While the market probably would have given it permission to market a lunchtime salad, Campbell's was unable to acquire the expertise to do so.

Will the Target Market Give Me Permission to Do It?

Chapter 2 provided a very simple definition of marketing: the process of understanding and satisfying customer needs at a profit. In that chapter and Chapter 8, we emphasize the importance of listening to the customer and caution against playing Whisper Down the Alley.

Most marketing professionals understand the role and importance of market research in developing a winning marketing strategy. These same managers endorse the need for information processing systems and information management.

Why is it, then, that most new products fail? Of

course, tactical or executional shortcomings lead to product failures in the marketplace. However, we believe that not enough marketers take the perspective of potential customers within the target market.

While it is true that we want people to buy our brands, we tend to focus too much on what we make, rather than what problems we will solve for the target market. In addition, we tend to be too enamored with the physical product that we make available to the target market. Remember, people don't want any of the products that we manufacture and distribute. They don't even desire the attributes that these products offer them. What they want are the benefits associated with the purchase and consumption of products we market. Even more simply, they want solutions to problems.

As previously noted, problems here are not necessarily bad or negative states; they are merely discrepancies that occur between the customer's actual and desired state. If your offering closes the gap between the actual and desired state better than any other offering, you will be the winner.

The secret is to find out what problems you can solve, solve them and get it right the first time.

Unlike our military and sporting analogies, in which you can win by defeating the enemy, you can develop a winning marketing strategy only by satisfying the customer better than anyone else.

Remember, our goal is to understand completely the target market, not only our own customers.

IBM continued to focus on the market for products that it made—mainframe computers. All of its research was geared toward satisfying this group of customers. Even as the number of customers for which mainframes were the best solution continued to shrink, IBM became more focused on them. As the market shifted and the mainframe segment contracted, IBM should have been looking to find new solutions for its target

They want solutions to problems

AT&T used a classic retreat strategy

market. This is the difference between a market-focused company and a customer-focused company.

The noted failures of Levi's, Fisher-Price and Xerox—and the soon-to-be failure of Microsoft—more than anything else, can be attributed to the fact that each of these additions to the companies' respective umbrellas was not given the most important license necessary for success.

It's not a mercantile or "doing business as" license. Rather, it is a customer license to solve well-defined problems from the customer's—not the marketer's—perspective.

Will the Competition Allow Me to Do It?

This criteria is so important that we have created Rule 5 (Know Who You Are Playing Against). However, consider for a moment AT&T's multi-billion-dollar losses, as it attempted to enter the computer market in the years since deregulation (January 1, 1984).

True, the market did not see computers as fitting under the AT&T communications umbrella. But did AT&T, with the research resources of its Bell Laboratories (now Lucent), have the capability to produce a highly functional computer? Certainly.

Do you think the aggressive defensive efforts of IBM had anything to do with AT&T's withdrawal from the UNIX operating system market? In effect, AT&T used a classic retreat strategy when it partnered its communication strengths with NCR's point-of-purchase facilitating capabilities.

Can I Meet the Firm's Strategic and Financial Goals?

Basically, this last criterion requires that, to fit under your umbrella, the potential offerings must contribute to your firm's related strategic and financial goals.

Even if the answer to the first three criteria is posi-

tive, you still must ask yourself if this particular opportunity is "on strategy"—and if it meets the company's agreed-upon financial goals (total profit, profitable market share, return on investment, etc.).

Complete Worksheet 3 to test the appropriateness of new product or service ideas.

Hold Up Umbrellas, Not Tents

Put the offerings you want to support profitably under tight, well-constructed umbrellas. Too many marketers erect massive tents in an effort to hold any and all offerings even remotely related to what the market has given them license to do.

There are several problems related to this, and each goes back to the criteria.

First, the more you have under your tent, the less the market perceives you as being the best (not just a good) solution to its problems.

Second, the bigger the tent, the more expertise you must have or acquire to support this large structure.

Third, the bigger the tent, the more susceptible it is to the winds of competition.

How does an umbrella differ? An umbrella is small and simple enough to be retracted in the face of adverse environmental conditions (including competition). It's not so easy to fold your tent in the face of a quickly brewing storm. Finally, tents require more infrastructure than umbrellas, and this can lessen the contribution to the bottom line.

If you want to solve more problems, hold aloft different size and color umbrellas. Don't build a huge customer-unfriendly, company-incompatible, competition-vulnerable, costly-to-maintain, cavernous tent.

A great example of a company that has multiple tents is Procter and Gamble. Most consumers have no idea how many different products the company makes—from pharmaceuticals to cake mixes, and

from potato chips to cosmetics. Imagine if P&G used the same brand name for every product: Don't you think consumers would find it difficult to purchase Tide detergent and Tide cake mix?

Chapter 7 Clues

- Know what your equivalent to "selling hope" is.

- Look at your organization critically. Look again from the perspective of a major competitor. Be merciless.

- Find out what problems customers give you permission to solve. Solve them better than anyone else.

- Make sure new ventures fit both philosophy and financially. (Push the numbers.)

- Consider lots of multi-sized and multi-colored umbrellas before you decide to erect a tent.

Chapter 8:

RULE 3—GET AND STAY CLOSE TO THE CUSTOMER

Ten years ago, a bookstore typically was a musty, cluttered place, where every square inch of space was filled with books for sale.

Today, such companies as Barnes and Noble have converted these book dungeons into hospitable, comfortable environments to browse, read and, of course, buy. The old bookstores or dungeons will go the way of other once-famous, now-extinct creatures—namely, dragons.

"Know the enemy" and "know yourself"—two military rules best articulated by Sun Tzu—will be discussed in depth in the next chapters. But marketers have an added rule: Get and Stay Close to the Customer. This should be the most obvious of the rules of strategy to the student of marketing.

After all, how can you satisfy your customer if you don't know what he or she wants? What should be obvious is, in fact, one of the most overlooked rules.

The evolution of business in the United States was such that the demand for goods and services seemed unlimited and growth seemed eternal. The leaders of industry were operations people who searched for more productive ways to manufacture our ever-growing list of new products.

Cost reduction was the method of increasing profitability.

What customers were willing to buy

Unfortunately, demand was not unlimited, as originally dreamed, and competition added to the pressure. Furthermore, consumers became choosier as their initial needs were being satisfied.

In order to "beat the pressure," American business spent more and more time and money persuading consumers to buy their products. This started the mass advertising approach to marketing. Attention was focused on getting people to buy what the companies were making so efficiently.

This worked for a while, but soon the cost of convincing consumers to buy products that companies wanted to make was becoming higher than the cost of making products the consumers wanted to buy. Eventually, various business leaders realized they had to change. Rather than just convince customers to buy after the fact, they had to find out what customers were willing to buy and produce it. To do this, they had to get and stay close to their customers in order to find out what they actually wanted.

It has not been an easy change. There are still many, many firms that are totally inwardly or competitively focused. As an executive from Tenneco's natural gas division said, "Corporate arrogance was our culture. We said, 'Here are our services we think customers need,' but we never asked them."[1]

Even the big-name manufacturer sometimes loses sight of the customer by worrying too much about competition. Look at what happened in the cigarette industry, where the tobacco companies were pitting their brand-name products against one another in an all-out advertising/promotion war. The wars were being financed by charging loyal customers more without increasing value. The big names, such as Philip Morris, lost sight of the need to satisfy the customer, and private-label cigarette sales increased by almost 70 percent by mid-1993.[2]

This temporary loss of vision is not the sole domain of the tobacco companies. Private-label refrigerated pasta is up almost 80 percent, private-

label photographic film is up 55 percent, and private-label frozen poultry is up more than 104 percent.[3] Fortunately for the branded manufacturers, many of the private-label products required astute marketing by retailers, so there is still a chance of a branded comeback.

If the customer was king in the 1960s and 1970s, then in the 1990s, the customer is a dictator. In order to compete in the 21st century, the brand manager and middle managers must get and stay close to their customer.

Don't Ask Customers to Compromise

Compromises occur when a firm or industry imposes its own operating practices or constraints on customers. Compromises are not tradeoffs. Tradeoffs are the legitimate choices customers make among different product or service offerings. By contrast, a compromise is a concession demanded of consumers by all or most service or product providers. In selecting a hotel, for example, a customer can trade off luxury for economy by choosing between a Ritz-Carlton and a Days Inn. But the hotel industry forces customers to compromise by not permitting check-in before 4 p.m.

By following Rule 3, there are several ways in which companies can find and exploit compromise-breaking opportunities in any industry. First, shop the way the customer shops. Sounds simple, but do you actually shop for the products you sell? If you don't, how can you develop any shopping insight?

Second, pay careful attention to how the customer really uses the product or service. Consumers often exhibit compensatory behavior. They devise their own ways of using the product or service to compensate for the fact that if they did only what the company intended them to do, they wouldn't really get what they wanted.

Third, explore customers' latent dissatisfactions. Go beneath the obvious and easily articulated customer dissatisfactions with a particular product or service to get customers to articulate their un-

No one recognizes you as being important

happiness with the product or service *category*. Chrysler's development of the minivan tapped into the latent dissatisfaction with both station wagons and full-size vans. Station wagons couldn't carry enough and were hard to load and unload. Full-size vans were more useful, but they were not fun to drive. Minivans broke the compromise by "cubing out" the box design of the station wagon.[4]

No Glamour in Meeting Customers

Len Schlesinger, a professor at Harvard University, tells a story about lecturing one time when his father was in the audience. His father was a tradesman and knew little about business. Len spoke about the need to know the customer. After the speech, he asked his father what he thought. His father gave some kindly remarks, but asked what kind of business person wouldn't know his customer.

This question begs an answer. Why do so few marketing executives know their consumers and customers? Plain and simple: There is no glamour in spending time with customers. The excitement is being wined and dined by ad agency executives, or being taken by limo to meetings across the country, or using the latest technology to communicate with colleagues across the world. It is not exciting to call Mrs. Jones to see how she likes your products, or to walk around a retail store and talk to the shoppers. No one recognizes you as being important or having budgets to spend. Besides, they have a research department for that task. Scientific focus groups handle consumers.

We have sat through thousands of hours of marketing presentations. We have seen hundreds of pie charts, graphs and pictures in these meetings, but almost never hear a single marketer refer to a consumer as if they actually know one. They seem to think consumers are mystical entities that appear like leprechauns. No one actually sees them, but they know they are there.

There is glamour in profits, and there are profits in spending time with consumers and customers.

We think there *is* glamour in meeting customers!

Not Just Your Direct Customer

Sometimes manufacturers actually ignore the ultimate consumers. They offer the excuse: "Our customer is the retailer or distributor, so we only must make them happy," or even, "We can't be responsible for what others in the channels do with our products."

This attitude is pure nonsense. Everyone's job in the entire distribution channel is to satisfy the ultimate consumer or customer. No excuses!

There are some great clues left by successful companies that have followed this rule. Look at Kohler plumbing fixtures. At one time, it focused virtually all its marketing efforts exclusively on building contractors and distributors. Then it added a very effective program designed to speak directly to consumers with products they wanted. Today, it is one of the most successful plumbing supply companies in America.

Want another example? Owens-Corning insulation. It did the same thing with the use of the Pink Panther for its direct-to-consumer insulation products.

Even the health industry is part of the change. Pharmaceutical companies are no longer worshipping exclusively at the altar of the "god in a white coat," and the health care insurers are changing, as well. Lawrence English, president of CIGNA, has given his staff two years to get acquainted with their customers or "heads will roll."[5] By the way, Mr. English must believe that success leaves clues. He has used L.L. Bean, one of the most customer-focused companies in America, as the model for his company. It also appears that he understands the role of leadership.

Even middle managers are starting to get the message. Duane Hartly of Hewlett-Packard said of the middle managers, "Things have changed. Those who don't make the cut [i.e., don't get promoted or are let go] don't listen. They don't listen to cus-

A totally inwardly focused company

tomers, the market, the field or their own employees. They just flat out get out of touch."[6]

Even the Big Guys Learn, Just Slower

Failure to follow the rule to get and stay close to the customer has made many giants of the 1960s dwarfs in the 1990s. Sears is a good example. While Wal-Mart's top executives were spending four to five days in the field talking to customers, employees, distributors and anyone else who happened to talk to them, Sears executives stayed put.

Sears stopped thinking of itself as a marketing brand and, in many ways, adopted the philosophy of an industrial company. One Sears executive said, "Nobody is minding the store. By the time [Sears] top management began to notice things weren't going well at the stores, the competition had carved out a hefty chunk of Sears."[7]

Sears is coming back with a new consumer focus. Sears' market share has been increasing, and its stock price has finally rebounded. Time will determine if where America used to shop again becomes America's place to shop.

Another giant that paid the price of losing sight of the customer is IBM. Once Big Blue was a totally inwardly focused company with its own language that customers were expected to learn. It took a major loss of market share and profits to wake up the sleeping giant, but a turnaround is in sight. The new CEO is reportedly not answering questions in IBMese—and wants a new name for products that are customer-friendly. In fact, IBM's Aptiva and other new PCs are designed to reduce desktop clutter. They feature sleek designs and new eye-catching colors. IBM's PCs finally emphasize fashion, as well as function. IBM has refocused. Don't sell your stock yet.

Remember Mr. Kawamoto, who successfully turned around Honda? This is what he said about Rule 3: "The traditions that guided this company

for 40 years weren't functioning properly. Our focus on the customer was vague. It must be clear."[8]

It Ain't Just Price Anymore

Many so-called marketers have brushed aside the whole consumer focus issue and claim it's just a numbers game—cut cost and lower price. That may have worked a few decades ago, but not today.

"Americans have become very purposeful shoppers. They are reengineering, just like corporate America. We call it Precision Shopping," explains an executive from Grey Advertising.[9]

Low price without added value won't do it in the 1990s. By focusing on service and added value, price becomes less critical. A customer focus lets you find what consumers value and make that part of the offering. A recent study indicates that consumers are less price sensitive today than before. "Only 37 percent of its respondents compare price anymore, versus 54 percent in 1991."[10] Price is still important, but consumers are less inclined to shop around when a product completely satisfies them. People will pay for added value—but *they* have to value it, not *you*.

People want more for their dollar, and that doesn't mean just lower price. Value connects companies with customers in a way that price cannot. Price is an isolationist's dream; value is the source of communication with the customer.

Take a clue from Rubbermaid, with its Constant Value Improvement program. "We wanted to be sure our associates understood that you can bring value to the customer in all kinds of ways."[11] Not just price.

From a purely strategic perspective, getting additional sales by lowering price will work only if you are in a position to be the lowest price in the market—and are able to sustain that price with lower cost structures. Two companies that use price strategically are Wal-Mart and food retailer Aldi Stores. Both these companies have developed lower cost structures that enable them to sustain a low-price

People will pay for added value

strategy and, most importantly, give them the ability to outlast any (foolish) competitor who starts a price war.

No marketer should be proud of temporary sales gains by lowering price. Anyone can give product away; it takes a professional to charge a premium for it. In general, most price cutting is not strategic, but rather just panic decision-making when sales seem to be below expectations. These price cuts usually do nothing but reduce the margins and profit, while temporarily producing sales. Professional marketers find the attributes valued by consumers and provides them at a fair price.

We don't want to give the impression that we think there are never cases where lowering prices makes sense. There are many cases in which it is the best course of action. But most examples we've seen are pure tactical maneuvering—not strategic.

Don't Forget the Distribution Channel

We know most of our examples have focused on the ultimate consumer, but make no mistake about it: You must understand the needs and wants of all the members of the distribution channel, as well as the consumer.

Here's a great clue from Dave Pitassi, president of Drypers. The company spent time talking with retailers and discovered that the P&G and Kimberly-Clark diapers were used as loss leaders. They made no money on the diapers, but attracted the new mothers to the store and sold baby food and other baby products for a profit.

Based on this information, Drypers strategically positioned itself at a price $1 less than the leading brands, which provided a profit on the product to the retailer.[12] It was more than just a price cut. It was *strategic pricing*, because it was difficult for the giants to meet that price, given their much larger market share. When they tried, the results were disastrous.

For one 13-week period in 1993, in the midst of a price war started by P&G, Drypers experienced a 17 percent increase in dollar sales. During that

same period, P&G realized a 16 percent decrease in dollar sales. Kimberly-Clark had a .5 percent decrease in dollar sales.

What about unit sales? You would expect that since P&G was the price cutter, its unit sales would rise significantly, while Drypers' would fall. In fact, the opposite happened: Drypers' unit sales increased 25 percent, while P&G's decreased 9 percent.[13]

It should be noted that Drypers suffered through some difficult times during the diaper price wars. However, as of 1996, Drypers held 6.8 percent of the grocery store market—more than ever.[14]

Further, Drypers was able to get shelf space without paying high slotting allowances by custom designing promotional programs to the needs of specific stores. Again, this was difficult for the giants to do, since they were wedded to national promotional programs.

Another example of getting and staying close to distributors can be found in the recent launch of a new product line called Quantum by Black and Decker. During the development process, the Black and Decker Quantum project team—including engineers, designers and marketers—visited retailers, such as Home Depot, Lowe's, Hechinger's and Wal-Mart. The team showed them prototypes of the new line, and got feedback on retail fit and pricing. The result: One month prior to shipment (in August 1993), Quantum walked away with a prestigious Retailers' Choice Award at the National Hardware Show, a sort of Academy Awards for the hardware industry.[15]

How Can You Become More Customer-Oriented?

Before you can practice marketing strategy, you must practice marketing—i.e., become totally market-focused and market-driven. You must believe that your license to do business comes from the consumer—not the Federal Trade Commission, Food & Drug Administration, board of directors or

Learn what's cool

your direct supervisor. The consumer will provide all the answers for you to be successful.

We stress the word *believe* because we have met a number of marketers who really don't respect—nor do they listen to—the consumer. They see dealing with customers as a necessary evil. "If consumers weren't so fickle and demanding, we could get on with our work," one manager complained to us.

Here are clues left by some successful marketers to kids. Levi's uses teen advisors in 12 cities to learn what's cool, and tailors its ads accordingly. Converse goes to the inner city basketball courts to learn what is cool with the teens. Mountain Dew goes to bike races and quizzes the contestants about what they like and dislike—and not just about beverages. About all aspects of their life. Mountain Dew attributes the decision to record its theme song with the knowledge gained from the teens.

The one belief held by most experts is that the "coolness doesn't go from the product to the kid, it goes from the kid to the product." Or, as they would say, "Be there or be square." Get close or get out.

The one big advantage companies that target teens have is that senior management knows it doesn't understand this group and it must make a concerted effort to get that knowledge. On the other hand, companies that target adults often think they know all about adults, since they are adults. In one case, a brand manager was presenting a plan for next year's activities. Included in the plan was a substantial budget for consumer research. As he said in his presentation, "We will base our marketing program on what the consumer wants and will pay for." He was interrupted by the president, who said, "Cut research to zero. If you want to know about the consumer, just ask me." This president had not been in the market for 10 years, and hadn't talked to a single consumer since then.[16]

Steps You Can Take

Here are a few suggestions that you might want to implement in your organization to heighten respect for the customer. Some may be effective in helping gain an understanding of customers' needs and wants. Others are important symbolic means of demonstrating your respect for the individuals who ultimately determine your success.

1) **Talk with (not to) and listen to at least one business customer per week.** Do not try to sell anything, just find out what some of the problems he or she has doing business are. You may be of help. One manufacturer found out that its sales force was more technically skilled than the client's buyers. In many cases, the buyer did not understand or even use the information the sellers were using in their sales pitch. It was "over their heads." The company sponsored seminars for the retail buyers to help them use more of the information that the seller was providing in the sales pitch. The result was that the client's buyers did a better job. The problem was solved and sales increased.

2) **Talk with (not to) and listen to at least one consumer per week.** It is incredible how many marketing managers rarely talk with consumers. How do these people find out what the ultimate users of their products want? Usually, marketing delegates this responsibility, saying, "That's why we have our research department." Hogwash! The research department was never intended to be the only way companies hear from customers. Another response is that focus groups cost so much they can't afford to do them so often. Incredible again. Since when do you need a focus group to talk with consumers? Most marketing managers have been sold a "bill of goods" that you must have focus groups to talk with consumers. Just go into a market and ask someone why he or she bought your product. Ask someone why the competitors' offering was selected. Ask someone why he or she walked past both products. It's not scientific, right? We hope you haven't also been led to believe that focus groups *are* scientific. Remember, when fo-

Seminars
for the
retail
buyers

Volunteering to call customers

cus group researchers charge $2,000 per group, they have to convince you it's more than just a short conversation with consumers.

Another very important point to remember is that it's not the customer's or consumer's job to tell you what products to make. Ask them what problems they have, then figure out how your products or services can solve those problems. If you have already asked what you can do to get them to buy your offering, we bet they said, "Just lower the price."

Restek, a small manufacturer of lab equipment, keeps its personnel in touch with the customer by making everyone in the 70-person firm handle the tech-support line, including engineers and the CEO. But this customer-focused company doesn't just wait for customers to call in. There is one program where employees can boost their performance evaluations by volunteering to call customers under the company's "call-back program." Each month, the company phones 200 to 300 customers and checks on how the product is performing. The call-back program gives Restek direct word on why customers don't come back and immediate feedback on new products. But does it work? Restek has grown more than 50 percent since 1991, and sales are projected to grow even more in the future.[17]

Even more surprising is that retailers don't talk with consumers. Here they are, walking all around the store, and most store managers we have talked with virtually never just chat with consumers. Likewise, the top retail managers at corporate headquarters are just like their manufacturing counterparts—too busy to leave the office.

3) **Make every marketing manager answer the 800-number consumer hotline.** Let him or her hear some of the problems or success stories firsthand.

4) **Create notebooks with pictures and descriptions of some of your consumers and customers.** Make the managers understand these are not

just share points or pie charts they are dealing with. They are real people with homes and families. Remember that your products are for these people, not for a market, store or city, but for real people. Even if you have thousands or millions of consumers, know at least 10 of them. Remember that most products are sold one transaction at a time. When showing charts and diagrams, put one of the pictures of the customers on the screen. Remind everyone that these are the people you work for. You will enjoy a bigger share of the market if you make more of these real people happy.

5) **Get out and share a meal with your customers.** It doesn't have to be a major production involving public relations and photographers to show everyone how close you are to the market.

6) **If you market consumer package products, do the family shopping.** Go to a supermarket or mass merchandiser. Navigate your cart up and down the aisles. Look at all the shelves and observe other shoppers. Is it easy to spot your products? Shop the competition. Shop other categories. Remember, success leaves clues.

7) **Work in a retail store.** This applies to manufacturers and retailers alike. Most retail middle managers and top managers haven't worked in a store for years, and some are proud of it. Similarly, marketing managers haven't been in a store for years, except for the annual parade of high-level executives through the operation. We're sure you know what we're talking about. When the store manager is warned one month in advance that the big boss is coming, he or she has time to stock every shelf, clean, arrange product, prepare breakfast for the big boss and bring in extra help for the day. No lines are evident when the boss is there!

Another list of ways to listen to your retail store customers is available from consultant Harold Lloyd, who has given the presentation, *Listen Up! Someone Is Trying to Tell You Something.*[18] (If you want a copy, call Harold at 757/721-0017.)

Do the family shopping

Leadership by example is always the best way

Respect Your Customers and Consumers

Everyone in marketing—and the entire organization, for that matter—must show respect for the consumer. Whenever someone who works for you shows disrespect, you must correct him or her immediately. This respect must come from the top of the organization.

At Southwest Airlines, it comes straight from CEO Herbert Kelleher, who said, "We dignify the customer." Southwest's strategy is to give the customers what they want and respect them. How does the company accomplish this? Some of its tactics are purely symbolic; for example, the word *customer* is capitalized in every ad, brochure and annual report. There are other practices, such as sending birthday cards to frequent flyers, having employees stay with customers and keep them amused during delays, and having customers sit in with personnel managers to interview potential employees. Southwest's customer-driven strategy has paid off to the tune of a 256 percent increase in profits in 1995.[19]

Marketing managers can't tell others that they should talk with and listen to consumers when they don't do this themselves. They must lead by example. We witnessed leadership by example during a telephone conversation with a very senior manager at Kraft/General Foods. The manager excused herself to take another call and, upon her return, apologized, explaining that it was an important call. We said, "Must have been the president." She responded, "I wouldn't have interrupted our conversation for the president. It was a consumer on our 800 number, and she wanted to speak with someone in charge." That is a real belief in the importance of the consumer. This attitude must have rubbed off on everyone, because many companies' customer service staff would never put the call through.

Contrast this response with the one given to us by a senior marketing manager in a regional telephone company. When asked how often she comes in contact with the consumers, she responded with a combination of surprise and disdain. She said

that she didn't get as high as she did in the company to have to talk with consumers. Undoubtedly, her attitude will rub off on everyone in her organization, also.

Complete Worksheet 4 to assess how close you and your associates are to the customer.

Get and stay close to the customer. Listen carefully and observe closely. Dignify your current, as well as your potential, customers. Set an example for your organization. Be the success that leaves the clues.

Chapter 8 Clues

- Solve the customer's problems and that will solve your problems.

- Get out of the office and meet with your customers.

- Get out of the office and meet with your customers' customers.

- Don't let market research be the sole source of customer contact (regardless of what market research says).

Chapter 9:

RULES 4, 5 AND 6 — KNOW YOUR PLAYING FIELD; KNOW YOUR REAL RIVALS; USE THE ELEMENT OF SURPRISE

We've grouped Rules 4, 5 and 6 together because they all involve market intelligence. While Rule 4 (Know Your Playing Field) and its corollary, Rule 5 (Know Your Real Rivals), are simply stated, for some reason, they are often difficult for organizations to follow. The essence of these two rules is that you cannot develop strategy outside the context of your environment and your competition. You must know more than what's going on in your own company.

Can you imagine the late, great football coach "Bear" Bryant developing a game plan without knowing the conditions under which the game would be played or without a detailed scouting report of the opposition's strengths, weaknesses and tendencies? Of course not! But, every day, marketing strategies are designed and executed with insufficient regard to the environment (your playing field) and to the relevant competitors (your real rivals). As a result of unorganized or disorganized intelligence, organizations that have failed

Surprise is critical

to adhere to these rules find themselves following a strategy that is doomed before the first tactic is executed.

Most marketers view organizing intelligence only in terms of competitive analysis (who you are playing against). While competitive analysis is certainly a key component of any intelligence-gathering exercise, it is only part of what must be done to be in the know.

In Chapter 7 (Know What Is Under Your Umbrella), the intelligence focus was on your organization. In Chapter 8 (Get and Stay Close to Your Customer), the primary consideration was developing an intimate understanding of the problems of your target market that you can solve better than any other marketer. In this chapter, besides competitive analysis, we will highlight the environmental variables that influence our outcomes.

Similarly, the element of surprise (Rule 6) is critical to strategic success in marketing. If organizing intelligence is designed to achieve understanding of the environment and the participants (competitors, yourself and customers), then surprise is the designed negation of organized intelligence. The objective is to minimize any advance warning of your real strategic intentions. Surprise is a technique used to reduce the value of your competitor's intelligence-gathering.

Presented together, these different yet related rules underscore the importance of competitive and market knowledge in strategic decision-making. You cannot and will not enjoy success in the marketplace unless you can reduce uncertainty in strategic decision-making. Likewise, if you can design, introduce and modify your own strategies without "spilling the beans" to those who could benefit most from early detection, then you can deny them the same learning that you seek.

A simple guideline for determining what should be kept a secret is, "Would this same information about a key competitor give you a strategic advantage?" If the answer is *yes*, then you run the

risk of losing the critical element of surprise by letting your intentions be known beforehand.

Organize Intelligence

Recall our definition of a leader: a preacher of vision and a lover of change. One's vision is predicated on some assessment of the present and the underlying future trends. All too often, we confuse having a vision with some form of mysticism. We're not talking about crystal balls or tea leaves here. What we are suggesting is that your vision is enhanced if you can see today clearly and identify the relevant environmental and market trends that will govern tomorrow and beyond. This can be done only by systematically organizing the relevant information.

In the same vein, before you can change anything, you need to know what is happening. Again, the effective and efficient use of intelligence can reduce risks and increase the probability of strategic success.

Sun Tzu stated, "Nothing should be as favorably regarded as intelligence; nothing should be as generously rewarded as intelligence."[1] With advance information, costly mistakes can be avoided, destruction averted and the path to a winning strategy made clear.

Change Is the Only Constant

When we were kids, there used to be a show on television on Sunday nights called *The Wonderful World of Disney*. One episode used time-lapse photography to show a beautiful yellow rose opening right before our eyes.

Well, as you can imagine, being inquisitive youngsters, we couldn't wait until the next morning to run into our families' gardens to watch the rose unfold. After 20 minutes of watching "nothing" happening, we went back to playing ball.

Were the roses in our families' gardens changing? Most definitely! However, like most change

Key environmental variables

in life, the rate of change was almost imperceptible. In fact, change is happening all the time. It is the only constant.

Two quotes that capture the changing environment confronting business today:

"Little is as it was. Nothing is as it will be."

"We cannot change the wind, but we can adjust our sails."

Environmental Scanning

While the scientific community conducts experiments in laboratories or controlled environments, the marketer's laboratory is the marketplace, replete with uncontrollable variables that will influence the outcome of even the most creative marketing strategy. Therefore, it is imperative that you develop a systematic approach to studying your market, so that you can better understand the key variables that, in many cases, will spell the difference between success and failure.

The key environmental variables you should regularly and systematically scan include the following:

- Political variables;

- Legal variables;

- Economic variables;

- Technological variables;

- Cultural variables;

- Social variables; and

- Competitive variables.

The terms *environmental variables* and *uncontrollable variables* do not give you license to ignore the situational context within which you must develop a marketing strategy. By *environmental*, we mean "outside but surrounding the operations of your organization." By *uncontrollable*, we mean "beyond the direct sphere of command of the strategist or the tactician."

However, this does not mean that you cannot influence some of these variables. For example, political action committees (PACs) have proved effective in shaping the legal and political environment. Even if you cannot influence every environmental factor, you must fully understand the nature of these variables and adjust your marketing strategy to reflect and take advantage of these contextual factors.

For example, Allied military strategists could not change the extremely hot desert sand (the physical environment) that confronted them in Saudi Arabia and Iraq during Desert Storm. However, they modified their strategy, training and outfitting to take the field-of-battle conditions into consideration.

Similarly, the coach of a visiting football team needs to develop a strategy that incorporates the effects of a large, hostile crowd supporting the home team. The weather, playing field and even the hotel and locker room accommodations will affect the visitors, and must be taken into account when developing the game plan or strategy.

This might not be one of our rules if the environment remained constant once you understood it. But it doesn't! The environment is changing constantly, so you must regularly review it. Since the environment is forever in flux, you can harness these changes and use them as potential sources for strategic opportunity.

We have developed a fairly simple four-step checklist to help you understand these changes and make them work for you—not vice versa. Please note that the environmental scanning system outlined below is based on scanning the environment affecting the target market or markets you serve.

To be successful, you must be specific to your market or to the kinds of problems that your products or services solve. In other words, for marketing strategy purposes, the appropriate environment for study is not the entire company with its many offerings. Rather, you must monitor according to relevant homogeneous markets.

Field-of-battle conditions

The "so what?" question

Step 1: Identify major changes in the environment, regardless of the strategic opportunity (or threat) potential. For example, changes in the technological environment have had a significant impact on the advertising media choices available to marketers.

Step 2: Characterize the change (trend). For example, in the past, network television has been by far the dominant medium used by consumer goods marketers. Now, technology has allowed the broadcast medium to move away from network television into narrow casting via cable television. In addition, similar technological innovations permit the multimedia influence—once limited to television in the home—to move into the store to the point of sale.

Step 3: Identify the impact of this observed trend for a specific product or service. Basically, this is the "so what?" question. For example, if your firm markets goods that qualify as unplanned or impulse purchases, such as salty snacks (chips, pretzels, peanuts, etc.), the availability of in-store advertising would be extremely relevant to the formulation of your marketing strategy.

Step 4: Identify the specific marketing opportunities that this trend and its impact provide to your organization. In other words, what can you do to take advantage of a change that will have the impact you have hypothesized? Here we will let you do some thinking. If you were a major marketer of salty snacks—such as Frito Lay, Anderson Pretzels or Herr's—what specific strategic opportunities should you consider as a result of changes in technology, with the resulting trends and impact on the sale of this category of products?

Use Worksheet 5 to work through the four steps of environmental scanning.

This is one place where we differ from many of the disciples of competitive intelligence. Most of the large corporations in America have "competitive intelligence" departments that serve all products, all markets and all managers. We feel this is prop-

erly the work of the strategist or his or her direct staff. While there are some important functions conducted by corporatewide departments, in general, we believe these departments are under-utilized.

But this should be no surprise—you've already read what we think of corporatewide market research.

We could fill the book with examples of companies that failed to see the world changing before them. Look at how the American automobile industry failed to see the movement toward small cars; how the pharmaceutical industry failed to see the power shift from doctors to large buying groups, such as HMOs; how supermarkets missed the time-famine of today's shopper; and how the computer mainframe manufacturers missed the "PC boat."

The media is no exception. Network television's market share has consistently decreased from near-monopolistic proportions to just another commodity media alternative. How about magazines? Over the past decade, *Town & Country* has seen a 66 percent plunge in advertising.[2] The magazine, long famous for its gushing descriptions of dowagers and its "debutante of the month" covers, failed to respond to the changing reader audience.

However, there are recent examples of marketers who understand that the world is not only changing before our eyes, but also that such uncontrollable changes present lots of opportunity to develop a strategic difference. Some universities have finally stopped defining themselves as "campus operators" and now, more appropriately, see themselves as "enhancers of personal/professional development" (Rule 2). As a result, technology in the form of videoconferencing and the Internet allows universities to offer long-distance learning.

Virtual classrooms and on-line degrees address the needs of today's time-starved professional seeking lifelong learning. Duke University in Durham, North Carolina, has launched a global

Perceived as "more American"

executive MBA program, and Queen's University in Toronto, Ontario, Canada, has set up a nation-wide executive MBA program, mainly conducted through videoconferencing.

By carefully monitoring the changes in technology and economic infrastructure, community banks recognized the opportunity to address the growing social/cultural trend of people wanting to be treated as individuals—something the identityless huge banks have failed to do. Consumers are tired of getting a new bank name on their checks each month.

Likewise, Fuji Photo Film has recognized the need to be perceived as "more American." Having signed a 10-year contract with Wal-Mart, Fuji developed a campaign called "Fuji. Part of the American landscape."

The Fuji campaign recognizes that the only way the company can compete with Kodak's long-established relationship with the U.S. market is to offer the consumer a product perceived as having Japanese quality, but being made in America.[3]

The checklist approach that we just described should be undertaken for each of the relevant environmental variables. The format for environmental scanning is simple. However, the task of identifying the appropriate environmental variables, collecting the relevant data, analyzing the findings and subsequently building this information into your marketing strategy requires a substantial commitment of human and dollar resources.

Of course, we cannot assure you of a marketing success if you environmentally scan properly, but we can almost guarantee failure if you ignore these variables.

Counterpoint

When conducting your analysis of the external environment, you are, in effect, trying to bring the future into the present. A word of caution is in order: Make sure that the future has some connection to where consumers are today. Keep in

mind the slogan of Panasonic: "just slightly ahead of our time." Video phones, interactive TV and in-home food shopping are just a sample of promising future trends that have yet to live up to their advance billings.

Consider the case of electronic banking. According to Citicorp Chairman John S. Reed, it could take 50 to 70 years before full-scale electronic banking takes hold with the majority of the population. Privacy and security are at the top of the list of consumer issues that must be resolved first. In this case, is technology ahead of the consumer, or can Citicorp learn from Microsoft's ability to understand the consumer and deliver the desired content? Stay tuned.[4]

Know Your Real Rivals

You also need to consider competitive variables. But who defines the competition?

Consider the story of a group of tourists on an African safari. After riding in a Range Rover for hours, they stopped at a watering hole to get a drink and stretch their legs. Before the guide could warn them, two members of the safari wandered off into the bush and came face to face with a lioness ready to attack. One of the two started to slowly take off his heavy boots. His colleague asked what he was doing. He replied, "I'm going to make a run for it." His partner scoffed, "You're silly. You can't outrun a lion." To which the now bootless gentleman replied, "I don't have to outrun the lion. I only have to outrun you!"

Remember, you and your apparent competitors do not define the competitive array. Only the customer defines whom she believes provides an acceptable solution to her problem.

Recently, while giving a speech to supermarket executives, we asked if they considered Boston Market a competitor. They were almost unanimous in their response: *No!* Why? Because Boston Market is not a supermarket. When Boston Market executives were asked the same question, their response was *yes*. Which group do you think bet-

"You can't outrun a lion"

Consumers are in the driver's seat

ter understands what business they are in (Rule 2)?

You see, the supermarket executives were defining competition by the obvious—businesses that look and function as they do. The Boston Market executives were merely telling us that the consumer had to decide between cooking a meal or buying a meal already prepared. This made them competitors.

Automotive dealers represent a group that is slowly waking up to changes in the competitive array. Like the supermarket executives, owners of new car dealerships only considered other auto dealerships their competitors.

Driving the change in focus is the recent entry into the market of used-car superstores led by retailers from outside the auto industry—and the explosion of services and information on the Internet. Car sales are moving from individually owned, local dealerships to megastores offering high-volume discount pricing, childcare centers, coffee bars, touch-screen computers and extended shopping hours.

The good news for consumers is that these non-traditional auto sources have forced traditional auto sources (new car dealerships) to address many of the abuses that have made car salespeople some of the most reviled small-business people in America. Finally, consumers are in the driver's seat, and pushy dealers look like dinosaurs.[5]

Competitive Analysis

Competition is another environmental or uncontrollable variable. However, because of the importance of knowing intimately and exhaustively those organizations that vie with you for the same customers, we will treat this external variable separately.

In *The Art of War*, Sun Tzu advised:

Know the enemy and know yourself; in a hun-

dred battles you will never be in peril. When you are ignorant of the enemy but know yourself, your chances of winning or losing are equal. If ignorant of both your enemy and yourself, you are certain in every battle to be in peril.[6]

You must know your competitors intimately. Notice we said competitors, not competition. Don't treat your competitors as a homogeneous entity. No NFL head coach would have a book on the competition, as a whole. No coach would develop a "seasonal strategy." If we view competition as a homogeneous entity, we tend to analyze in the aggregate, rather than at the individual level. In addition, we tend to have an undifferentiated strategy, putting us at a competitive disadvantage.

We insist that our clients maintain separate files, binders and exhibits for each of the competitors in their respective markets. We encourage them to develop sections of their strategy that respond to specific competitors, and to avoid the words *the competition.*

Basically, we recommend a SWOT (strengths, weaknesses, opportunities and threats) analysis of each of your competitors, as well as your company. What does each competitor do well or have available to combat you and other competitors (a strategic threat)? What weaknesses does each appear to have that may be exploited (a strategic opportunity)?

Worksheet 6 helps you begin to know more about your competitors. After you complete it, you can conduct a SWOT analysis.

Valuable sources of competitive information include suppliers, customers, media, government, advertising agencies and the competition itself. In each case, we are not suggesting that you do anything unethical or misleading to gather competitive intelligence. Information is readily available; all you have to do is look, listen and ask.

In a recent study of the return on investment (ROI) of 14 competitive intelligence activities, every respondent estimated at least a 100 percent return

Avoid the words "the competition"

Competitive intelligence gathering

on investment on all but one of the activities. The lone exception was patent searching, which the respondents believed "was a cost of doing business" and offered a zero ROI.

The average payback for all research projects from all respondents was 310 percent, indicating that the average business competitive intelligence project is seen as having an excellent ROI.[7] The results for each of the 14 categories were:

Patent searching	0 percent
Purchasing off-the-shelf studies	150 percent
Using sales staff to collect data	150 percent
News clipping service	175 percent
On-line database searching	183 percent
Collecting competitive ads	194 percent
Benchmarking	200 percent
Formal competitive intelligence	200 percent
Focus groups	367 percent
Customer market research	380 percent
Competitive literature	514 percent
Research at trade shows	575 percent
Attending conferences	580 percent
Distribution channel research	700 percent

Cybersleuthing

How would you like to get a kind of newspaper report every single day on your main competitors? What if it included highly coveted secrets, such as the names of their suppliers or a list of their biggest customers? Or what if it had a section that tracked their new patent applications, whether they paid their bills on time or, even better, when they are planning to release a bombshell new product or service.

Well, with a computer, a modem and Internet access, you can mine a mother lode of comprehensive and timely information—most of it free. More specifically, with just a little Worldwide Web know-

how, you can surf for what's new and newsworthy about your industry, rivals and clients. By tapping into Web sites, chat groups and bulletin boards on the Net, you can venture into the enlightening world of competitive intelligence gathering. For more insight into cybersleuthing, we recommend you consult an article written by Denis Eskow, titled "Cybersleuthing," in the October/November 1996 edition of *Your Company*.

Super Sleuths

Before we leave the issue of developing the competitive edge, consider the words attributed to Gen. George S. Patton on the subject:

> I have studied the enemy all of my life. I have read the memoirs of his generals and leaders. I have even read his philosophers and listened to his music. I have studied in detail the account of every damned one of his battles. I know exactly how he will react under any given set of circumstances. And he hasn't the slightest idea of what I am going to do. So when the time comes, I'm going to whip the hell out of him.

If you are looking for advice from a modern day business general, consider the advice attributed to Ray Smith, CEO of Bell Atlantic. He recommends that as strategists, we should analyze the game through the other players' eyes. Place yourself in the shoes of your opponents to understand how they will counter your strategic and tactical moves. Such an approach is especially important in preventing the tunnel vision that results in a too-narrow focus on a single competitor. While you are concentrating on the headlights of the truck coming down the highway, sometimes you don't see the guy on the motorcycle trying to cut you off from the right lane.

Another example of using competitive knowledge to gain the upper hand is Purina's attack on Alpo's entry into the puppy food market. By any measure of market dominance, Purina is a leader, but when it came to halting the expansion of Alpo's

"I know exactly how he will react"

127

"Where are all the customers?"

new puppy food, the company took the path of least resistance (and money). Purina knew that since Alpo was much smaller, it didn't have much depth of talent in the middle management levels.

Rather than fight in the market with promotions, advertising and deals, the company sued Alpo for making various claims in its advertising. Although Alpo was certain to win the case, it required that top management be dedicated to the lawsuit. Little new work was done and the rollout was put on hold. The longer Purina could delay expansion, the better it could prepare for a battle with overwhelming odds. Did it work? Alpo does have puppy food, but it took only a fraction of the Purina business.

Even the frequently maligned banks can provide examples of using competitive knowledge to their advantage. For instance, Mellon Bank, having recently gone through a merger with PSFS, knew that when a bank completes a merger, the executives' focus is on consolidation, system conversions and manpower layoffs.

So, when its major competitor completed a merger, Mellon went full tilt into the predatory game of luring customers from the company. It used every tactic in the bankers book to get new customers. Mellon knew the competition had more on its mind than keeping customers. When the systems in the newly merged banks finally worked, executives could then ask, "Where are all the customers?"[8]

Excellent examples of organizations that take competitive analysis seriously are Marriott, Coors, Xerox and the Japanese. Before Marriott launched its economy motel offering, Fairfield Inn, it visited scores of competitive budget motels—noting such factors as room layout, quality of furnishings, quietness of rooms, customer amenities, customer service, etc.

Similarly, Coors wanted to get into the wine cooler business dominated by Gallo. However, after breaking down the components in the Gallo offering and

talking to the ingredient suppliers and engineers familiar with the production process, Coors concluded that it could not provide the marketplace with a viable competitive alternative. Therefore, it decided not to pursue this market. Sometimes, it is better to know what you shouldn't do.

Xerox routinized its competitive intelligence process by training 200 line managers to look for changes in pricing, new technologies and even new competitors.[9]

In 1993, AT&T moved roughly half of its $200 million consumer long-distance advertising account to Foote, Cone & Belding Communications (FCB). According to Dick Martin, AT&T's executive vice president of public relations and advertising, each of the five agencies that bid for the business gave AT&T some invaluable insights into the long-distance business. However, FCB provided AT&T with ideas concerning what the competitive response to FCB's ad campaign would be and what AT&T's counter-response could be.[10]

In Japan, competitive intelligence is everyone's business. Unfortunately, in the United States, too many companies delegate this task to a staff corporate intelligence department, to the marketing research department or, worse, to the corporate librarian.

While corporate intelligence departments are useful for the development of corporate strategy, normally, their focus is financially oriented and deficient in terms of the competitor's marketing strengths and weaknesses. To be of value to the marketer, intelligence gathering and dissemination must be close to the battle and immediately actionable.

Some firms have addressed the need for timely and reliable competitive intelligence by establishing 800 numbers for all of their employees. Any strategic or tactical information is called into the 800 number. These companies ensure that the information is not only collected, but also followed up on—to see that it is delivered to those organi-

Close to the battle and immediately actionable

Find the leaks and fix them

zational units best prepared to respond to the data.

You see, most organizations do have competitive intelligence gathering networks. The question is: What happens to the data once they are collected? Do you know what happens in your organization?

Keep in mind the reason we go to such lengths to know the competition. According to Kenichi Ohmae, "Competitive realities are what we test possible strategies about."[11]

We can't develop and test possible strategies unless we know the various competitors as well as General Patton knew his enemies. Would you be confident making the kind of statement Patton made about your key combatants for a particular market?

Counterintelligence

Finally, don't forget to engage in counterintelligence. What do the other players in your markets know about you? We are not referring merely to self-assessment. Rather, what information do you deliberately or accidentally make available to anyone with competitive intelligence antennae turned on?

In addition, what steps do you take to safeguard information that would strategically or tactically weaken your marketing efforts if a competitor acquired it? Look at your organization from the perspective of a key competitor. Find the leaks and fix them.

Use the Element of Surprise

Oh, how this rule is violated on a daily basis! We become so enamored with our brilliant strategies that we tell all who will listen and show those who won't listen. Remember the words of Frederick the Great. In 1747, he gave these instructions to his generals, "Everything which the enemy least expects will succeed the best."[12]

More recently, General H. Norman Schwarzkopf, when interviewed on national television following

Operation Desert Storm, indicated that the advantage is to the attacker who can determine the time and place of the battle.

Surprise does not necessarily mean that the competition has no knowledge of your strategy. Rather, surprise can include those situations in which the reaction time by the competition renders its response either too little or too late.

Don't confuse surprise with secrecy. True, you may lose the critical element of surprise if you allow the components of your strategy to be leaked to the media or detected by the competitive intelligence network of organizations pursuing the same markets. More importantly, you may lose the battle and even the marketing war.

But surprise is more than secrecy. Surprise means doing the unexpected. We close this chapter with this advice regarding the relationship of surprise to strategy: Do the inconceivable. The highest-risk strategy is often the best strategy, because no one expects it.

Would you be surprised by a shoe store that didn't have any shoes? That's exactly the approach taken by Custom Foot, which opened recently in Westport, Connecticut. Custom Foot can draw from more than 10 million different shoes, one for every desire. The shoes just don't happen to have been made yet. Instead of trying on shoes at the store, your foot is scanned, capturing even the smallest difference in size and width. The information is electronically transferred to Italy, and the shoes are made to order. You have virtually an unlimited number of designs to choose from. We would agree with the naysayers that this type of store isn't for everybody, but that is its strength. This is an example of doing the unexpected. Only time will tell if Custom Foot unexpectedly goes out of business.[13]

Look at how Hershey Foods surprised the competition by breaking its tradition of not selling refrigerated products.[14] Until the early '90s, Hershey could be counted on to keep close to its core com-

Do the inconceivable

Honeywell kept Litton jumping

petencies—i.e., candy. Admittedly, Hershey took a risk by entering the refrigerated pudding category—and surprised competitors who have come to expect the traditional from Hershey. Hershey recognized that it's always a risk to violate past practices that have been successful, but sometimes leaders take calculated risks to capture new markets. Or, in the words of the ill-fated Burger King commercial, "Sometimes you gotta break the rules."

Apparently, Hershey's foray into the refrigerated case of the supermarket is not the first time the company broke out of the candy wrapper and surprised the competition. Consider Hershey's introduction of Reese's peanut butter, which grabbed a 5 percent market share in its first year of national distribution. This prompted established competitors to drop their prices quickly.

Think the competition was surprised? Probably. But do you think customers were surprised by non-candy Hershey products? Well, maybe they were, but it didn't stop them from buying oodles of product. Apparently, consumers were more aware of Hershey's legitimacy (umbrella) in these areas than its competitors were.

Honeywell used knowledge of the competition—and the element of surprise—to keep Litton Industries at bay. In the battle of the aerospace guidance systems, Honeywell kept Litton jumping by continually surprising the company with new approaches and new tactics. In the late 1970s and early 1980s, Honeywell used a superior technology to knock Litton out of the market for inertial reference systems (IRS), used in airplanes for navigation. In 1984, when Litton entered the market with the same technology, Honeywell used its higher volume from its early success to slash production costs and freeze Litton out again, this time on price.

Litton went to the purchasers of the airplanes, not the manufacturers, and got a toehold with KLM Royal Dutch Airlines and Lufthansa. Boeing, which

had only used Honeywell IRS, now had to offer Litton as an option.

But guess who made the plug that went from the IRS to the navigation system? Honeywell began charging $30,000 more for a plug from the Litton IRS than for the one from the Honeywell IRS. KLM and Lufthansa did buy Litton's system, but only after Litton reimbursed them for the Honeywell plugs. Litton made no other sales in that battle of the sales war.

Honeywell didn't rest on its laurels, though. In 1986, it bought the aerospace unit of Unisys, which made an array of cockpit instruments. In a later battle, it discounted these cockpit instruments to win IRS orders.

In 1988, Litton invested tens of millions of dollars in a new product whose simpler design made it lighter, smaller and long lasting. To finance the product, the company raised the prices on existing navigation products. Buyers for airplane manufacturers would get a sales pitch for the new product at the same time they were getting a 25 percent increase on other Litton products. Honeywell smelled blood and attacked when it was least expected. But did it work? From the early 1980s to 1993, Honeywell sold roughly 12,000 navigation systems vs. 1,100 for Litton. What do you think?[15]

Another example of doing the unexpected comes from Steve Wynn's Mirage Resorts in Las Vegas. While mainstream casino operators were targeting gambling adults, Steve Wynn introduced a casino for the whole family. Mirage offers such family services as baby-sitting and caters to family needs. The occupancy rate for the Mirage is reported to be well above national standards, and it is expected that it will take years for the competition to respond.

Southwest Airlines surprised the airline industry "big shots" by freeing itself from the shackles of traditional airline paradigms. Southwest eliminated the advance ticket purchase requirement

A lot of media attention

and waived the mandatory "Saturday night stay-over" condition for low fare eligibility. True, Southwest flies less than 5 percent of all domestic passengers, yet it forced the ultraconservative airline industry into doing business Southwest's way.

You may think it's difficult to do the unexpected in the medical field, but Oxford Health Plans of Norwalk, Connecticut, got a jump on its competitors by adding a service not usually associated with traditional health care organizations. Oxford added a number of "alternative" medical treatments, including acupuncture, massage therapy and holistic medicine. Other providers are up in arms over the bold approach, but most likely they are just angry that they were beat to the punch. When it comes to signing up new members, Oxford will have something special to offer prospective clients.

Make no mistake, doing the unexpected causes controversy. And the competition will raise all sorts of objections—in this case, challenging the "professionalism" of Oxford. You might remember when Merck first bought Medco. The purchase raised the hackles of the other pharmaceutical companies. "A respected pharmaceutical company, such as Merck, should not be associated with a managed care provider," they grumbled. Today, most pharmaceutical companies are looking to make similar purchases, and we think you will see other HMOs include non-traditional treatments.[16]

Finally, surprise sometimes can simply create a lot of media attention that would not otherwise come your way. Yves Saint Laurent named his newest perfume Champagne. The company was immediately sued in France and other European countries to change the name from the sacred *Champagne* to a name more becoming a perfume. While all the commotion swirled about Saint Laurent, the company sold more than 3 million bottles of Champagne, making it a profitable scent in its first year—an almost unheard of accomplishment among new perfumes.[17]

You might think it would be hard for giants—also under the lights of Wall Street—to surprise anyone, but that's just what Microsoft did when it gave away new technology to competitors. Microsoft spent $100 million and seven years to develop key file-linking software, then gave it to the competition. Surprised? A lot of people were. Some thought it was crazy. But Microsoft is crazy like a fox.

Of course, Microsoft may have learned from Sony, which, years earlier, invented the Betamax video-tape recorder/player. It was superior to the VHS system, but Sony kept it all to itself. The VHS technology was shared with numerous manufacturers and became the industry standard. Do you own a Betamax?

Microsoft wants its technology to become the industry standard, and what better way to do this than by giving it to the industry? Of course, it is not by chance Microsoft will be the prevailing expert as the software rolls out.[18]

Worksheet 7 helps you identify ways to surprise your competitors.

Chapter 9 Clues

* Make the process of collecting intelligence everyone's responsibility.

* Understand which environmental variables have the greatest impact on your marketing strategy.

* Have a routine and regular process for environmental scanning.

* Find an opportunity in each trend.

* Develop a mechanism to get competitive information from the market to the strategist.

An opportunity in each trend

Chapter 10:

RULE 7—FOCUS, FOCUS, FOCUS

This is the one rule that differs slightly from the others. While most rules help determine *how* to win the marketing wars, this rule focuses on *what* you win.

It is also the one rule most often violated. If you learn nothing else from this book, we hope that each time you consider an action, you will ask yourself, "Does this action help me attain my objective?" If the answer is *yes*, consider doing it. But if the answer is *no*, then either change the objective or don't do it. Simple, isn't it?

Why is the objective so important? It is important because it clearly affects all the remaining rules. How can you decide how to get somewhere if you don't know where you're going? We should have learned this from *Alice in Wonderland*. Remember when Alice was lost in the garden? She stood, confused, facing many paths through the garden, but she had no idea which one to take. She asked the Cheshire Cat, who was sitting in a nearby tree, "Which path should I take?"

He replied, "Where do you want to go?"

She answered, "I don't know; I'm lost."

"In that case, take any path," he directed, "since that will get you there."

But Focus, Focus, Focus means more than having goals. It means sticking to those goals. It means

You will get blown off course

using the goals as a guidepost through the daily barrage of problems and opportunities that tend to lead businesses astray. Think about the advice that Boy Scouts give to hikers lost in the woods. Pick an object as far in the distance as you can see, such as a mountaintop or a tall tree on the horizon. The object, not immediately attainable, becomes the goal of your hike to safety. Your business objective serves the same purpose. It sets the course of your hike to profitability. It is a constant reference point in a changing environment.

But what if you get off course? One marketer with a mariner background likened his goals to the points on a compass. As he got tossed around in the storms of daily decision-making, his business compass kept him on course. Without it, he would be lost at sea.

One important aspect of the compass analogy is that no matter how hard you try, when you're in a storm, you will get blown off course. The compass helps you get back on course. The same is true in business. If you think you won't be tossed between opportunities and major problems and occasionally lose your course, you are very naive (and we recommend you read this book at least twice). You will lose your course, and this rule will bring you back.

By the way, don't be discouraged by the storms of business. As with nature, business storms are a way of life. But keep in mind the English proverb that states, "A smooth sea never made a skillful mariner."

Almost as bad as having no goals is having ho-hum goals. In the words of Mitchell Leibovitz, CEO of Pep Boys, "If you want to have ho-hum results, have ho-hum goals."[1]

Did you ever wonder why very successful companies with well-positioned products seem to experience a downturn in sales? Many times, it is the pressure for growth that leads marketers to stray from their successful objectives and strategies. The changing of strategy wouldn't be such a problem

if it generally led to increased sales and profits. But that usually isn't the case. The old adage "You got to dance with the one that brung ya" makes as much sense here as it did in the dance halls of old.

Maintaining your objective doesn't mean stagnation. You can and should be looking for new opportunities for existing products within the current objectives. Of course, you should constantly reevaluate your objectives, also. But expanding or broadening outside the existing objective structure purely for growth often leads to failure. As Tom Pirko, president of Bevmark, a Los Angeles beverage consulting firm, stated, "You never want to turn a brand away from its core franchise (by attempting to cast a wider net in a search for new opportunities)."[2]

Consider the advice of Warren Buffet, the second richest American, when he purchased controlling interest in Geico, an insurer that focuses solely on automobile insurance. Buffet said, "I believe in focus in business. I would love it if Geico stays focused on what it does and does it even better."[3]

Knowing the Objective

You would think that of all the rules of marketing, maintaining the objective would "go without saying." Naturally, all managers pursue their objectives. Unfortunately, this is often one of the most neglected aspects of business. Most companies don't have a clear understanding of what their objective really is.

You don't believe us? What is your objective? Ask your colleagues or employees to describe the company's, division's or group's objective. Have them write it down. You'll be surprised by the responses.

A friend of ours visited a small bank in the Northeast to solicit a consulting contract to do strategic planning. The top management was skeptical. It was a small company run by only three key people: the president, vice president and treasurer. They

"I believe in focus in business"

Proclaim the objectives

were friends, talked often during the day, regularly lunched together and even socialized frequently. They wondered why they needed to formalize the process. They were asked individually to write down where they wanted their company to be in five years. In other words, where were they headed? As you can guess, all three gave different answers, and our friend landed the consulting contract.

If it is difficult to articulate objectives in a small, closely held company, it is even more difficult in a larger company. Don't think that because you are working with a small group in your product team or in your stores or in your buyers' group that everyone knows the objectives. Don't let size, friendliness, amount of integration, etc., obscure the fact that you must proclaim the objectives if you are ever to have a strategy.

Remember that strategy is defined as how you get from where you are to where you want to be. You must know exactly where you want to be. You might think that the objective is clearer in the military—capture Paris, Pork Chop Hill or whatever—and that objectives are more obtuse in business. We might not agree that they are clearer in the military—just ask the strategist about his objectives in Vietnam or Grenada. But we do agree that objectives often are more obtuse in business.

Quantify Your Objective

Try to explain to someone how tall you are without using numbers. You are taller than this, shorter than that, etc. After a few hundred words, you may have communicated how tall you are, but don't have that person buy you clothes for Christmas.

The same is true in business. The more you quantify your objectives, the easier it is to communicate them and understand them. Just look at the objectives of David Johnson when he took over as CEO of Campbell Soup. He stated "20-20-20." For every year for the next three years, the company objectives were a 20 percent increase in net earn-

ings per share, a 20 percent increase on the return on equity and a 20 percent increase on the average cash return on assets. Easy to communicate? You bet. He had all sorts of promotions around the company that said "20-20-20." Easy to understand? The financial group said that even marketing could understand that.

All objectives are not financial, however. Objectives may be stated in terms of how you want the consumers or customers to change. Advertising objectives may be the percentage of people who remember an ad. Promotional objectives may be the number of people who redeem coupons and rebates or purchase the promoted product instead of the traditional one. Sales objectives may be the percentage of sales to new clients, the percentage of visits to non-buyers or the number of repeat sales made. In one unusual case, we were involved with an advertising campaign where the objective was specified by the x/y coordinates on a perceptual map for a new product.

Regardless of the objective, it must be quantified. Quantifying it can help in the communication of the objective. Attaching a simple message also can help, such as Johnson's "20-20-20," or Monahan's "Pizza fast, pizza hot," or Smith's "When it absolutely, positively has to get there overnight."

How about LifeUSA, a fast-growing insurance company that is writing billions of dollars of insurance but is infamous for bureaucratic inertia, painful cost cutting and massive layoffs? LifeUSA is focusing on speed. It wants to be a fast company—literally. It guarantees to make commission payments to agents within 24 hours, issue policies to customers within 48 hours and respond to questions from agents within 48 minutes. The last commitment is the core responsibility of the FASTeam (Fast Answer Support Team), the company's lifeline to its independent agents. That's focus![4]

Delta does an even better job of communicating the objective to its employees with "You don't just join a company, you join an objective."

Life USA is focusing on speed

The Sirens on the rocks are calling

These may seem like advertising slogans for the masses, but you can bet that Domino's employees know exactly what has to be done with "Pizza fast, pizza hot."

Stay With Your Objective

Specifying your objective is a difficult first step. Next, you have to keep to the objective. Don't be distracted by the false hopes of new profits, which were part of the original strategy. The Sirens on the rocks are calling for you to divert your attention to the new hope. Tie yourself to the mast and put wax in your staff's ears the way Ulysses did.

Look at what happened at Subaru. In the 1980s, its reliable, inexpensive all-wheel-drive subcompacts made it the industry darling. In 1986, Subaru sales reached 183,242 vehicles. In 1989, Subaru launched a new line of larger, more expensive cars under the Legacy name and tried to reposition itself as an alternative for well-heeled buyers who were snapping up Honda Accords and Toyota Camrys. The up-market pricing strategy muddied the Subaru utilitarian image.

Perhaps the "new" objective had bigger payoffs. How can you fault managers for going after bigger markets?

The problem is: They went after bigger markets, and the result was similar to that experienced by companies that don't stay with successful objectives and take market leaders head on. In 1989, sales began a free fall that the company has not been able to halt. In 1992, sales fell to 104,800 cars, down 43 percent from the 1986 peak. Chastened, Subaru executives claimed that they wanted to return to the old objectives. The introduction of the Impreza in 1993 was viewed as a return to the original objective.[5]

Similarly, another auto company is moving away from a long-held position in the market. Volvo is almost synonymous with the word *safety*. There must be a thousand companies that would love to be so closely associated—and widely recognized—

with that position. But what is Volvo doing? Changing! It is moving into "a sedan that is fun to drive."

Why? Besides the fact that advertising executives don't get promoted for running the previous executive's ads, Volvo has indicated that the image of safety gave the impression of "plodding and sluggish," and sales were below desired levels.[6] After more than 25 years of convincing people that it was the safest car on the road, it will now be fun to drive. Only time will tell, but we bet it won't work, and Volvo will return to the safety of a position based on safety.

A great example of a company that temporarily lost focus and was brought back to the core business is Knight-Ridder. This communication company was involved in all sorts of businesses, such as the Knight-Ridder Financial (real-time financial news) and Information Design Labs, which were eventually sold. It returned its focus to the biggest asset of the company: local newspapers. Knight-Ridder owns 31 dailies across the country and has the ability to deliver local news. The papers went back to covering local issues and staying focused on local events. The networks, *The Wall Street Journal* and *The New York Times* can cover the national news; Knight-Ridder would own the local issues.

This type of action is not without internal conflicts. The professional reporter cares more about Pulitzer Prizes than profits, and those prizes don't usually go to neighborhood stories. Others thought Knight-Ridder should be in the middle of the new electronic era. However, a strong leader focused on the company strength can bring the corporation to success.

How successful has the refocused approach been? Between 1985 and 1995, the stock price hardly budged. But, in 1996, it climbed by about 38 percent.[7] Focus pays.

Even the big guys lose sight of their original objectives. Just look at what happened to Pepsi. In an attempt to change its strategy from marketing to

A short-term negative impact

the young generation to one that included both young and old, Pepsi changed its advertising to a "Gotta have it" theme. We all know that the effects of ad campaigns on sales are difficult to measure. However, it appears that Pepsi's less-focused approach didn't win it much—if any—advantage in the supermarket. For the first nine months of 1992, Pepsi's grocery store market share dropped 0.2 percent to 14.8 percent.[8] Recognizing the value of maintaining the objective, Pepsi returned to "Be Young. Have Fun. Drink Pepsi."

Imagine how many offers Domino's would receive to move from just delivering pizza to providing table service. The furniture people would try to convince them, the store managers who watch some people come in and ask where to sit would try to convince them, and real estate salespeople who try to sell more expensive sites for walk-in traffic would try to convince them. But any idea is worth considering at Domino's only if it makes pizza faster or hotter. Otherwise, forget it.

Michael J. Smith, CEO of Lands' End, recognized that the company had lost focus. The growth paradox was no doubt affecting previous management, and they pursued businesses beyond their core. They created specialty catalogs, such as Textures, a more fashionable catalog, and MontBell, an outdoors catalog, and even attempted an international catalog. Smith put it all on hold to get back to what had made the company successful: great products, fair prices and unsurpassed customer service. To accomplish this, he further broke tradition by not cutting personnel, but adding personnel. He made major decisions that had a short-term negative impact on the bottom line, but a positive long-term effect. When a particular product fell below Lands' End standards, he "booted" it from the catalog. He chose to stick the company with hundreds of thousands of units in inventory, rather than sell sub-par products to loyal customers.

The critics have said that Lands' End will fall behind competitors, such as Eddie Bauer, but we

believe you can't be too far from the mark when you stay focused on your customers.[9]

Borden Inc., the ailing food giant, failed to follow this rule. During the 1980s, Borden assumed $1.9 billion in debt to acquire 91 regional food and industrial companies.[10] The problem was Borden had no singleness of purpose; it was simply a clutch of unintegrated businesses. The results from failing to follow this rule are devastating. Two of its four businesses—dairy and snacks—now operate at a loss. When you include the other two businesses—grocery products and chemicals—total operating income decreased by almost 50 percent in 1993. In the meantime, its share price plummeted more than 40 percent in a soaring stock market.[11] Does this answer any questions you might have had about the importance of focus?

In *Winning the Marketing War*, Gerald Michaelson provides two other examples.[12] The first is Neutrogena, which stayed with its objective to be good at one thing: luxury skin care products. The focus on that purpose has produced brand recognition among more than two-thirds of the consumers in the target audience, and a 90 percent brand loyalty rate. The other company was RCA, which changed objectives—with four different strategies in 10 years.

Just because you've lost focus doesn't mean you can't get back in line. Look at Radio Shack. It made a fortune selling inexpensive electronic gadgets unavailable elsewhere. Everyone knew Radio Shack had those unusual electronic gifts and accessories. Unfortunately, the people at Tandy Corp. thought they had a distribution channel through which they could push almost anything, including big-ticket items, such as computers and televisions. They lost focus on what customers gave them permission to sell.

Radio Shack's CEO, Leonard H. Roberts, refocused the company. His turnaround strategy included getting back to the original gizmo emphasis, the

A clutch of unintegrated businesses

"Going back to our roots"

product area Radio Shack continues to dominate. By the way, Roberts was CEO of a major fast food chain before joining Radio Shack. We think he believes success leaves clues, since he is using proven fast food strategies to turn around Radio Shack.

It's back to the future for Fox, the upstart fourth network. Stung by declining primetime ratings less than a month into the 1996 fall season, Fox executives conceded that their plan to broaden the network's appeal from young adults to the 18- to 49-year-olds craved by advertisers had largely failed. So, the network returned to cutting-edge programs targeted at 18- to 34-year-olds. In fact, when the network announced its refocus, the president said, "We are going back to our roots."[13]

Perhaps the best example of refocusing comes from America's once pre-eminent department store, Sears. When Arthur Martinez took over as CEO of the Sears merchandise group in 1992, downtrodden Sears was in the process of losing $3.9 billion. Martinez unloaded its financial-services businesses (Allstate Insurance, Coldwell Banker real estate, Dean Witter brokerage and the Discover credit card). He sold its famous headquarters, the 110-story Sears Tower, and terminated the Sears catalog. In 1992, Sears was tagged a "Dinosaur" by *Fortune* (along with IBM and General Motors). In 1996, Sears earned $1.3 billion. How did Martinez accomplish this? He did so by refocusing Sears on the "middle-American mom."[14]

It's not just the big corporations that make this mistake. Sam and Libby's was a small but successful shoe company that specialized in inexpensive ballet-style shoes. In its effort to grow bigger, it lost focus. The owners, Sam and Libby Edelman, wanted to become a full-line clothing company, like Esprit. They went public with an initial stock price of $14.50. It reached a high of $24, before plunging to one dollar and change. Eventually, the lack of focus caught up with them.[15]

Sam Edelman recognized he had veered off course

and repositioned the company as an excellent—and again profitable—moderately priced shoe business by returning to an emphasis on ballet-style shoes.

It's Not Always Easy

There is no doubt that this is one of the most difficult rules to follow. It is not because having singleness of purpose is difficult, but rather because the lack of continuity of leadership is so common.

Consider the case of Burger King. In 1993, James Adamson became Burger King's ninth CEO since 1980. During this same time period, there had been 10 different advertising campaigns, such as the forgettable "Herb the nerd" and "Sometimes you've gotta break the rules." In fact, the company had four different campaigns in the previous five years.[16] The results: Burger King continued to lose market share to the leader, McDonald's.

As an aside, Adamson stated that Burger King had to "get the message out that we do it [sell hamburgers, fries and Cokes] better than anyone else."[17] Only recently, under CEO No. 12, has Burger King begun to refocus at the expense of McDonald's. The rules do work!

But this isn't just a CEO problem. Look at your own organization. We bet that many of the key middle management people and brand managers have been at the same position less than two years. Now think about why this leads to a violation of this rule. People become famous by "making a name for themselves" with new programs. Who has been promoted to the position of vice president and had the whispers in the hall be, "He was really great, he did everything his predecessor did"? We receive accolades by changing something, not by doing the same thing. So, the natural organizational tendency is to violate this rule and change, change, change.

Worksheet 8 will help you assess your organization's focus.

Lack of continuity of leadership

"Quick pizza appetite satisfaction"

Counterpoint

As with most of our rules, you must know when you are being resistant to legitimate change and when you are just being stupid. Consider Pizza Hut. Long before Domino's was a force in the market, Pizza Hut owned it. Certainly, there were mom-and-pop operations in some areas, but there was no significant national competition.

Why didn't Pizza Hut take the home-delivery market before Domino's got a foothold? The company had as its objective to be a pizza restaurant with a building, tables, chairs, etc. The only question was how to get more business from the restaurants.

When we were in Wichita on a consulting visit, we suggested such ideas as giving ovens to high schools and supplying the pre-made pizza. These ideas were ruled out because Pizza Hut foolishly maintained that it was in the restaurant business. In effect, Pizza Hut was trapped for a long time in a production-oriented mode—it "ran pizza restaurants." What it apparently failed to recognize is that consumers wanted "quick pizza appetite satisfaction." That's a market-driven focus. That's what Domino's gave the market. Success!

Of course, Domino's isn't infallible. Remember the adage, "Success breeds complacency"? More recently, Domino's began to offer cheesesteak sandwiches under the Domino's umbrella. How does this contribute to the maintenance of its objectives? How does this reinforce its unique claim of "pizza fast, pizza hot"? Do you think it fits under the Domino's umbrella, or is Domino's losing focus?

It is said that the first organization Ray Kroc approached with his new restaurant idea was Howard Johnson's, but since Kroc's restaurant didn't have seats, menus or waitresses, his plan did not fit the HoJo model. McDonald's, on the other hand, knew when it was time to change and add new ideas and new objectives. McDonald's introduced the breakfast sandwich for time-starved consumers and appealed to the health-conscious market with chicken choices.

148

Maintaining your objective too long can be as much of a problem as changing it too often. How long is too long? If we could answer that question, we would be on the beaches of Rio, not writing this book.

Chapter 10 Clues

- If an action doesn't take you closer to your objective, think twice.

- Don't have too many goals.

- Don't have ho-hum goals.

- Remember, goals are like fish and house guests. They tend to stink when they are around too long.

They tend to stink

Chapter 11:

RULE 8—CONCENTRATE YOUR RESOURCES

If big fish eat little fish, how do little fish ever grow big? You only have to look at nature to learn the marketing solution: Keep away from the big fish, or swim in schools.

Think about other animals, like wolves or hyenas. How have they survived? A Cape buffalo could easily kill or defend itself against the hyena, or an elk could easily avoid a single wolf. Yet the wolves and hyenas usually get the buffalo and the elk. How do they accomplish this seemingly impossible feat? They concentrate.

The rule of concentration means having more resources at the point of attack than the competition does. Total size of the company means little—what matters is how much is amassed at the single point of attack. This important rule is valued highly by the military, but often ignored entirely by marketers.

Now, some students of marketing confuse this rule with the previous rule (Focus, Focus, Focus). The terminology itself may be confusing, since you can "concentrate" your attention or "focus" your attention. But the difference between the two is meaningful. Simply stated, *focus* is concerned with effectiveness—namely, what you want to achieve. *Concentration* is concerned with efficiency—namely, how you intend to use your resources. Focus means that you have objectives, and you never lose sight of those objectives. Concentration

A numerically superior army

means you put your resources at the point of attack, pitting your strengths against your competitor's weaknesses.

Don't let terminology get in the way of understanding these two critical rules.

What Military Leaders Say About Concentration

"The art of war is to have a numerically superior army to the enemy at the point of attack."—Napoleon[1]

"A military force that is just strong enough to take on an objective will suffer heavy casualties and win. A force vastly superior to the enemy will win without serious loss."—Mark Watson[2]

"The principles of war could, for brevity, be condensed into a single word—concentration."—B.H. Liddell Hart[3]

Of all the rules overlooked or violated by business strategists, this would have to be near the top of the list. Why? Part of the explanation emanates from the organization of firms. In general, the brand management system permits a brand or product manager to do whatever is necessary for his or her product. But the process of competing for scarce resources within a company often leads to either an equal distribution of resources among brands—or to some other equity-based rule, such as based on the proportion of sales. However, this actually leads to the dispersion of resources, rather than their concentration. Keep in mind that brands compete not only for financial resources, but also for research time, package designers' time, creative advertising time, etc.

The problem of concentration extends beyond the product management system. The driving force of American business is growth. Big business wants to grow bigger, and constant growth is the call to action. But how can a big business grow bigger? Usually, a business will grow by outperforming the competition within a market, thereby continu-

ing to increase market share, sales and profit. At a particular point, however, the company can no longer profitably increase the number of customers within that specific market. Do managers say, "We got all we can from that market. I guess we have to be satisfied with it"? The big companies seek growth through diversification and, more recently, through alliances. In other words, they no longer concentrate on the business that made them big.

This would not present a problem if growth strategies were always—or even generally—successful. Consider the world's largest industrial company, General Motors. Its revenues of $123 billion are more than the combined gross national product of Saudi Arabia, Egypt and Kuwait, yet during the mid-1990s, GM experienced record losses.[4]

Look at IBM. Big Blue has owned the mainframe market, which is still profitable. But IBM has gotten into just about every other high-tech market, too. Has the strategy paid off? It cost John Akers, the CEO, his job and resulted in the worst financial performance in the history of the company.

How about PepsiCo? Long considered a formidable challenger to Coca-Cola, PepsiCo finds itself at a severe disadvantage to Coke in the beverage business. Coca-Cola has focused its energies almost exclusively on a single business and has been described as "faster, better financed and more ferocious" than Pepsi. While Coke has concentrated its resources in the beverages market, PepsiCo has been supporting three core businesses: beverages, restaurants and snacks. At a press conference in the fall of 1996, a manager of a fund with more than 3 million shares said this about the restaurant business, "No one can understand why you don't just spin this thing off. It diverts management's attention, it doesn't fit with the company's other business, and you're not running it well."[5]

Pepsi finally got the message. It announced that Tricon (three icons—KFC, Pizza Hut and Taco Bell) will be the new name of PepsiCo's restaurant em-

"I guess we have to be satisfied"

Pepsi finally got the message

pire—to be spun off as a stand-alone company in fall 1997.[6]

In case you're not convinced, Federal Express provides still another example. Federal Express concentrated all its resources on one specific product: overnight letters and small packages. Federal Express succeeded, in part, because it concentrated.

Do you think anyone could have been a success in that business, when the competition was the U.S. Postal Service? Not so! In fact, Emery Air Freight was in the same business, except it shipped anything and everything, not only small packages and letters. Is Emery as successful as the concentrated overnight service? Not even close! In fact, Federal Express got so far ahead that Mr. Emery got fired.[7]

By concentrating on overnight delivery of small packages, Federal Express owned the minds of consumers as the company that does the job best. As Al Ries and Jack Trout say in *Positioning: The Battle for the Mind*, "The objective is to have a clear, distinctive position in the minds of the customer and Federal Express had both."[8]

How has Federal Express reacted to success? It imitated Emery! Federal Express bought the Flying Tiger Co. and began a worldwide cargo service. Is this approach to concentrating paying off? No! Federal has lost over a billion dollars in its international operations in the early '90s.[9]

Much of Frito Lay's success can be attributed to concentration. There are local and regional salty snack manufacturers that make at least as good a potato chip—maybe even a better chip, according to blind taste tests. Yet Frito Lay controls the market with a more than 40 percent share nationally.[10] How? It has more people (an 11,000-person army) and more trucks, makes more calls and buys more advertising. And the Frito Lay foot soldiers are amazingly well-trained in tactics. Frito Lay expects its field force to do more than just deliver. They are supposed to sell the product, not just

drop it off. It has more of almost everything than the competition, including focus on the salty snack business. That is how victory is measured in the snack food war.

Frito Lay has maintained a narrow focus, even when it added new products, such as Doritos and flavored chips. Having learned that the essence of marketing today is to concentrate resources, Frito Lay has become stronger by staying focused and concentrated.

Even a successful company must stay vigilant about focus. Back in the 1980s, Frito Lay let its eyes wander from the product that made it famous: potato chips. The share was slipping, and interest focused on new products and new concepts. But, like most good companies, management brought back the focus—and concentrated the resources— to be successful again. Executives discovered that they were complacent about the chips. Focus groups told them the chips were too greasy, too bland and too boring. Frito Lay focused its re- sources on redesigning and repositioning the po- tato chip. It spent a reported $90 million to use genetics to create a perfect potato, retooled facto- ries and examined new recipes for the frying pro- cess. The company did not leave the consumer out of the process, either. It studied why people buy snacks and what is most appealing to them about snacks.

Concentration of the resources so that they could make a difference on a key brand again brought Frito Lay to its leadership position. Concentrating its resources and making a significant difference with a brand is one reason Frito stays on top. To- day, Frito Lay sells half of all the potato chips sold in America.[11]

King's Supermarket is a food retailer in northern New Jersey that has stayed focused, as well. King's has maintained an upscale image that focuses on the highest-quality fresh food and prepared foods for its time-starved customers. When it expands, King's continues to look to high-income markets.

How victory can be measured

Growth should be from a position of strength

It stocks the products its customers want (and will pay premium prices for) and offers other services that its customers have come to expect. King's has been very successful in markets where others have fared poorly.

Similarly, consider Pepsi's concentration on activities in Mexico. Under the code name Tormenta del Desierto (or Operation Desert Storm), Pepsi tripled its market share to 24 percent under the leadership of Manuel Rubiralta. "Operating from a heavily guarded command bunker, Rubiralta smuggled in and stashed 250 new trucks around the city, along with 500,000 cases of new glass bottles and 8,000 storage coolers. He put 1,150 new employees through an intense 16-day training regimen," reported *Forbes*. The results: After four months of motivated shock troops hitting the streets, Pepsi went from being sold in 6,900 locations to 18,600 locations.[12]

Don't be confused: Concentration does not mean that growth is impossible. It does mean that growth should be from a position of strength. Although Pepsi has been under attack for the failure to concentrate in the beverage business by pursuing the restaurant business, it has demonstrated its concentration abilities within food service. Pepsi expanded its fast food market by moving into new concentrated markets. Rather than just adding a new business, it concentrated in the fried chicken business, the pizza business and the Mexican food business. Taco Bell offers almost exclusively Mexican food. Nobody needs to apologize for not having hamburgers. When a customer chooses Taco Bell, he or she knows what to expect. Note that Pepsi concentrated in areas where there was not much competition. All of us could name more than a few firms that sell hamburgers, but who else sells tacos?

General Mills provides another example of concentration in the food service business. At one time, its restaurant chains included Red Lobster (what does it sell?) and Olive Garden (Italian only). And, for a while, it even owned China Coast. Appar-

ently, General Mills underestimated the extent to which individually owned and operated Chinese restaurants would go to defend their positions in the market. Not fully understanding the competition (Rule 5) resulted in a forced surrender to the local entrepreneurs.

Not everyone is going to the same school, however. Just look at McDonald's. Successful, sure, but where has all the growth come from? Not from concentration in the United States. Year after year, the company has added items to the menu. Once a "burger, fries and Coke" company, McDonald's now offers more than 43 items—as far from hamburgers as salads, chicken, ribs and even pasta. Growth has resulted from expansion in international markets; domestic sales have been flat for the past few years.

Of course, most of us have heard more than enough about McDonald's failed Arch Deluxe and 55-cent burgers. Customers were confused and claimed to be misled. McDonald's profits, market share and stock price suffered. Executives and ad agencies were fired. Lack of concentration is indeed costly—in the short and long run.[13]

Concentration Is Not Easy

The major impediment to concentration is the corporate desire for growth, even when the growth is unprofitable growth. When a company sets its corporate eyes on a sales growth objective, it minimizes the role of regular, consistent profits from a concentrated business.

One of the classic examples of a failure to concentrate was the Chevrolet "Heartbeat of America" strategy. If you can remember the advertisement associated with the strategy, it showed virtually every segment of America (for a nanosecond each). Blacks, singles, young people, families, elderly, handicapped—you name it—were all part of the target. On whom were they concentrating?

Two critical factors must be in place if a company is to concentrate its resources. First, it must be

Jack Welch successfully sacrificed products

able to allocate resources based on the principles of concentration, and second, it must be able to allocate and reallocate quickly.

As previously mentioned, some companies' allocations are based on the prior year's allocation or on some political basis, rather than on strategy and a need to concentrate. Some executives have told us that they concentrate their resources in every one of their markets. However, when you attempt to concentrate everywhere, you wind up concentrating nowhere.

The allocation decision is very difficult for many vice presidents, because it often means some products will be sacrificed. The vice president must understand that the troops of the sacrificed products are not going to take the sacrifice lightly. They will (and should) argue for their cause. But the vice president must use his or her perspective to decide what is best for the company—not try to please everyone in the company. In essence, to allocate based on concentration, the vice president needs to shoot the losers. However, pulling the trigger (or the plug) is never an easy task.

Jack Welch successfully sacrificed products at GE. He reviewed the company's businesses and decided to concentrate on the nine categories of business in which GE currently held the No. 1 or No. 2 position or was close enough to achieve that rank quickly. If GE couldn't be No. 1 or No. 2, it would get out of that business. That is concentration, and that is great leadership.

The second critical factor—allocation and quick reallocation—presents a difficulty. Once the battle is started, it may be necessary to deploy resources quickly. The problem is that, often, all the resources have already been allocated. If reserves happen to be found, they usually are treated as untouchable, set aside for dividends and not for battle.

In some cases, companies could change their allocation of resources, but internal bureaucracy makes it almost impossible to change the plan.

Virtually no army in the world commits all its troops to one battle unless it really is a "do or die" battle determining the outcome of the war. The Israeli army committed all its troops to battle in the famous Seven Day War. If it had been a seven-week war, Israel might not have won.

A company may change its plans and concentrate its resources in a single point. One of the most dramatic examples occurred when AT&T was tired of losing market share in its own backyard, New York City. Therefore, it amassed a sales force composed of NYC office and salespeople, salespeople from other sales districts and regional managers—almost anyone who could sell long-distance service. The program was a success. Business was recaptured. The big fish won that round, as usual.

One very interesting example in the food industry is the concentration of resources that surrounds a new supermarket store opening: Extra store personnel, bands playing outside, games for the kids and promotional giveaways, such as presents for the women shoppers, attract customers. The result? Usually, this is the biggest day the store will ever have. Why does management stop everything on day two? From this point on, the new supermarket acts the same as the competition. We're told they can't afford to keep up the concentration. Maybe that's true, but what logic dictates that we revert to no concentration?

Concentrate on Weaknesses

Unfortunately, concentrating the resources of the firm on one product isn't enough to win consistently. You must focus on a specific point or issue. A classic example is AT&T long-distance service. It may hold the record for the greatest loss of share for a major consumer company in history. It had significantly more resources directed to the long-distance market than any of its competitors. However, its major competitors, MCI and Sprint, focused all their resources on one point each; both points were AT&T weaknesses.

We revert to no concentration

AT&T was again on the defense

MCI attacked AT&T on the cost of long-distance service. Every advertisement, every direct mail piece involved price comparisons. MCI also developed the very successful "Friends and Family" campaign, which gave even bigger savings to people consumers called frequently. You should also note that this campaign turned thousands of current customers into salespeople for MCI, since friends and family had to be MCI subscribers for the customer to get the bigger discount. AT&T was on the defense—"We don't cost that much more!"

Sprint attacked AT&T on the sound quality of the calls. With Sprint, you could hear a pin drop. AT&T was again on the defense—"We have good call quality, too." At first, the engineers at AT&T dismissed the Sprint claims, because they knew that AT&T's sound quality was as good as or even better than Sprint's. In fact, many of the Sprint calls were routed over AT&T lines. But, by concentrating its message to the customer via the "pin drop" commercial, Sprint convinced potential customers that it had better quality—and it didn't matter what the engineers with oscilloscopes said.

Did concentration work? AT&T's share of the market dropped from 100 percent before deregulation to 60 percent and still falling. That translates into billions of dollars lost annually.

As we previously noted, Campbell's was late in exploiting the health angle on soup. It was afraid that making a "healthy soup" would lead consumers to believe that the original soup was not healthy. This would hurt sales. By the time Campbell's listened to its customers instead of the financial people, it was late in introducing Special Request, a delicious "healthy" soup, and Healthy Choice soups were already on their way to the market.

Marks and Spencer (M&S) is a example of a prominent European retailer that concentrated on the private-label business. Virtually all its products are Saint Michael's brand—M&S's private label. No matter how well branded products sell in Great

Britain, M&S sells carloads of private label. Not surprisingly, Saint Michael's is the leading brand in England.

Once you break down only a small portion of the competition's defenses, you usually can enter with a smaller, more effective force through the breach. This is the key to concentrating on weaknesses. Remember Napoleon's words: "Fire must be concentrated at one point and as soon as the breach is made, the equilibrium is broken."[14]

Look at how Marriott found one small, but significant area in the hotel experience to concentrate on: check-in. Marriott discovered that check-in speed is one of five factors that drive customer satisfaction. So, Marriott concentrated on improving the speed of check-in. It changed the duties of the check-in clerks, reorganized the titles and classifications of all employees who were involved in check-in in any way (from the bell hops to the concierge), and instituted a crosstraining program for employees so that everyone was capable of speeding up the process. The result was a reduction in the average check-in time from almost 3 minutes to slightly more than a minute and a half.[15]

Find the Gap in the Market and Make Sure There Is a Market in the Gap

Concentration isn't always as easy as it appears. Once you find a gap in the market where there is no competition, you have to make sure there's a market in the gap.

For example, look at the case of Breyer's Marble Classics ice cream. Breyer's looked at the existing market and saw an opportunity between the everyday store brand and the premium brands, such as Ben and Jerry's and Haagen-Dazs. There were no competitors in that position and it was perceived as a great opportunity. There was a gap in the market.

Unfortunately, there was no market in the gap. It seemed that those who would step up from the

Enter through the breach

ConAgra made health a strength

basic ice creams wanted to go "all the way." The premium ice cream buyers, on the other hand, were unwilling to give up the great taste of their high-fat ice cream for the moderately priced Marble Classics. The result: Marble Classics melted away.

Concentration Everywhere Means Concentration Nowhere

Healthy Choice is a great example of concentration in the food business that has gone awry. There is no question what you are getting—a healthy choice. Low everything except taste, it says. By concentrating on the single health theme, ConAgra has been able to extend its product line into many other categories. In the beginning, its choice of category was based on markets where the competition was weak. While many companies were trying to hide their "unhealthy" images, ConAgra made health a strength.

More recently, ConAgra stopped concentrating on categories that fit its original expansion criteria (appropriateness of a health claim and weak competition) and appears to be attempting to concentrate everywhere. The results? Disappointing.

Another example is Lee Jeans. At one time, it owned the specialty store market for jeans and charged a premium for its products. Along came the mass merchandisers (Wal-Mart and K-Mart), who moved significantly more jeans through their stores than did the specialty stores. The Siren call was too much for Lee to resist. It succumbed to the mass market and lost its shirt—or, should we say, its jeans? As one Lee executive remarked after a post-mortem, "You can make it with class, or make it for the mass, but you can't do both."

RJR Nabisco's once-hot SnackWell line is under pressure to reverse its fortunes. Its recent downward trend has investors worried that the heavy line extensions are leading to brand dilution in terms of consumer perceptions and company resourcing. According to Al Ries of Ries and Trout positioning fame, "They put a SnackWell's stamp

on anything that stays still long enough." Yet the name alone is no guarantee: While SnackWell's new breakfast bars did $300 million in sales their first full year, pretzels and chips never got off the ground.

Apparently, Nabisco has not learned about the ramifications of violating this rule. In an effort to scramble for non-SnackWell successes, Nabisco introduced 77 new products in one year, including low-fat Planters nuts and non-fat Newtons Cobblers. Now, CEO Greeniaus admits Nabisco may have spread itself too thin. "We probably overdid our new product activity by 20 percent," said Greeniaus. "Anything that looked half decent, we ran with it." That's certainly not consistent with concentration.[16]

Where to Concentrate

No doubt one of the best places to concentrate is in specific market segments—i.e., use precision target marketing. The idea is to serve one segment of the market better than any competitor does. Keep in mind that today, as we've said, there are no longer markets for products that everybody likes a little, only markets for products that somebody likes a lot.

Look at the sales and profits from the businesses that have concentrated on the kids' market. It has been estimated that the kids' toothpaste market alone has gone from zero to more than $250 million. And look at kids' frozen dinners.

Quaker Oats concentrated on the market for athletes with the sports drink Gatorade when the other beverage companies were still worrying about colas. It was reported that, at one point, before the competitors woke up, Gatorade contributed about 25 percent of Quaker Oats' total profit. Even P&G, one of America's best marketers, indicated to us a few years ago that it would never get into a beverage market as small as Gatorade. Some small market: Today, Gatorade is estimated to be worth more than $1 billion.

Riches in niches

A number of food retailers have found riches in niches, as well. Look at Stew Leonard, who bills his operation as the "world's largest dairy store."

Or what about *Money* magazine's 1993 store of the year: Fresh Fields, a supermarket that focuses on "good for you" foods that are fresh, as well as organically grown?

Since we referred to hotels earlier, let's check back in with them. A couple of the major chains catering to business travelers have concentrated on giving that audience everything they need for a great night's stay. What do you think the business traveler needs that grandparents visiting their children don't need? How about multiple phone lines, voice mail, data lines for computers and fax machines?

Some hotels are even concentrating on the female business traveler. They have provided in-room irons/ironing boards, special parking and room security, flowers and special in-room amenities (blow dryers and fragrances).

Concentrating on Distribution

While many companies have concentrated on the ultimate consumer, Labatt's USA concentrated on the distribution channel. In 1987, it bought tiny Latrobe Brewing Co., maker of Rolling Rock beer, during a period when many regional brewers were either closing or being swallowed up by the giants. While industry total sales in 1992 fell 2 percent, Labatt's enjoyed a 15 percent increase, capping a four-year national expansion.[17]

How did Labatt's do it? It concentrated on the restaurants and tavern channels of distribution. By using in-bar promotions, such as its famous "bucket of rocks"—six Rolling Rocks served in an ice-filled metal pail, Labatt's was able to generate the kind of visibility most marketers covet.

Although it couldn't outspend or out-promote Bud everywhere, it could make an impact in one segment.

Concentrating on Advertising

Advertising can be very effective as a method of concentration. The concept is to own a share of the customer's mind by making sure he or she knows about your product.

Both Advil and Nuprin introduced an ibuprofen tablet at about the same time. Even though the products were identical except for color, Advil outsold Nuprin 3 to 1. Advil spent almost 15 percent of its sales dollars on advertising. That seems expensive, until you consider the results.

When it comes to advertising, concentration is not just spending more, however. Concentration can be achieved by employing a consistent theme or message. Look at the success of Mickey Mouse as the spokesmouse for Disney, or the Maytag washing machine repairman, or Lorne Green for Alpo.

The concept of concentration on the message or theme is particularly difficult when outside advertising agencies are involved. Their executives don't get famous by doing the same thing each year. Likewise, new brand managers may be difficult to control, because they realize that they won't be promoted for showing a predecessor's advertisements.

Concentration also can mean putting all your resources into one specific advertising media. This is best exemplified by the Vermont Teddy Bear Co. (VTB). The company realized that by mass marketing its products, it couldn't compete against the Fisher-Prices of the world or get into the Toys 'R' Us channels.

So, VTB concentrated on direct response advertising with an 800 number and spent 100 percent of its advertising budget on talk-radio. The company attributes its sensational growth from $300,000 in 1988 to almost $11 million in 1992 to this concentration.[18]

Take care when deciding to concentrate on advertising. You cannot compensate for poor strategy by spending more dollars.

Advil outsold Nuprin 3 to 1

Targeting small towns

Concentrating on Regions

It should be clear that it is possible to be a small player in a big market or a big player in a small market. Most of the growth-oriented companies must go to the big markets to make the "big bucks," but others have successfully competed in regions that made them No. 1. Hills coffee is a good example. Although it has only about 10 percent of the coffee business nationally, it has as much as 40 percent of the market in some of the targeted regions.

Another good example is Wal-Mart. For a long time, Sam Walton eschewed the urban markets. His concentration strategy was to target small towns—a variation of the regional approach.

The success that smaller companies have had with regional marketing has made the giants take a closer look. In an attempt to be regionally oriented, Campbell Soup totally reorganized by expanding from nine sales regions to 22 marketing regions. Anheuser-Busch entered the regional marketing arena, as well. In California, it has garnered a 60 percent to 70 percent share of the Hispanic market.[19]

Worksheet 9 is designed to help you identify concentration opportunities in your organization.

Counterpoint

Concentration is one of the most important rules of strategy. Marketing is about concentration. But there is a difference between concentration and constipation. The latter implies that you can't move. Many marketers concentrate so much that they ignore changes taking place in the world and don't think of the future. Failure to change and adapt lead to failure, just the same. Unfortunately, it is usually a slower death, as your market gradually disappears.

Don't make the mistake of Tastykake. While the market for cupcakes changed into a market for lowfat or fat-free products, Tastykake was still concentrated (or constipated) on cupcakes.

It was the outstanding leadership of a new president who recognized the need to continue to concentrate, but not on a single product. Today, the focus is on making great-tasting convenient consumable treats. Tastykake stopped trying to sell what it could make (cupcakes) and began to make a number of treats that the market indicated it would buy. That's concentration. It is also a success story.

Concentration is a resource phenomenon. It means deploying resources, such that your identified strengths are matched against the specific weaknesses of your competitors. Remember, it is applied resources and total resources that will determine the outcome of the strategic battle.

Chapter 11 Clues

- Concentrate your strengths against your competitor's weaknesses.

- Concentrate on something, not everything.

- Don't get trapped in the "fairness" paradox (treating every situation equally).

- Know the difference between concentration and constipation.

168

Chapter 12:

RULES 9 AND 10

—BE MOBILE; ADVANCE AND SECURE

Our last two rules are so interrelated that they are best discussed together. To be an effective strategist, you must change; you must adapt your strategy to fit the new customers, new competition and new environment. Moreover, your strategies must enable you to be mobile. When you think you have found the "patented" formula for success, you have probably begun your demise.

Being mobile (Rule 9) and striving to win mean that sometimes you must move forward (Rule 10). You can't just defend, defend, defend. Obviously, this implies some risk. To minimize the risk, the strategist must follow the rule of security (also Rule 10). If you move forward, be sure you have a place to fall back to if you are not immediately successful.

The successful firm designs a strategy that permits it to move forward, stop and secure. Then, when all is ready, it will move forward again. Should one of the attack strategies run into strong opposition, the firm can move back to its secure position, regroup and start again.

Let's look at each rule separately in order to explain them, but keep in mind that it is their combination that's most important.

It's Hard to Hit a Moving Target

Mobility means that you not only must realize the need to change. You must be able to change.

Focus is a prerequisite for any shot

You must have the organizational capability to be mobile in the marketplace and, of course, within your company. You must be able to change products, channels of distribution, promotions and locations if the environment demands.

Some readers believe that mobility contradicts the rule of focus. Not so. Both offer a specific type of advice. Consider as an analogy the shooting gallery at the arcade. There are two types of targets you can shoot. One is the stationary target, while the other moves around the background. Which is the hardest to hit? The moving target. Well, the same is true in business. You make it more difficult for the competition to get you in their sights if you keep moving. But, regardless of which target you choose—stationary or moving—you must focus your attention on that one target. Focus is a prerequisite for any shot.

I am reminded of the first time I went quail hunting. The quail gather in coveys of 15 to 20 birds. They jump suddenly out of the bush and take flight. The first time this happened, I was certain that by simply pointing the shotgun in the vicinity of the sky blackened with birds, I would shoot at least three to four birds. In fact, I didn't know what all the excitement was about quail hunting. Regardless, I shot and, to my utter surprise, I shot *no* birds. It was then that I was told that no matter how many targets there are, you still must aim at them one at a time. I never forget that lesson in my business dealings, either.

Being mobile means more than just not getting hit—it also means moving into a position from which you can take the offense (Rule 10) or take advantage of changes in the market. Look once again at supermarkets. They have absolutely ignored this rule. They have created stores "for all people," and try to convince everyone to shop in the same store. They allowed convenience stores to get a foothold in the business. There was no reason for this. They could have created this type of store to service the convenience needs of their customers, but they stayed pat. The fast food res-

taurants came in and took away more meal occasions. Many of the manufacturers stayed mobile and got into this segment of the food business. Until recently, PepsiCo owned Taco Bell, KFC and Pizza Hut, and General Foods owned Red Lobster and Olive Garden. Then the comfort food restaurants, such as Boston Market, came in—selling better-quality meals, with ease in both purchase and cleanup. The supermarkets remain stationary. We believe their first major act will be to put the plywood on the doors and windows.

Being mobile implies that you get both the defensive and offensive advantage from your strategy. You can move to the most advantageous position, and you can keep the competition from drawing a bead on you.

The marketing manager also must realize that people within his or her organization will fight change, rather than accept the need to be mobile. Let's face it—doing the same thing generally makes their jobs easier and more risk-free in the short run. This chapter is not about change, per se; it's about mobility.

How important is mobility? Just look around. How many companies are out of business or suffered significant economic harm because of the failure to mobilize, or the failure to adapt to the new battlefield, or the failure to change until it was too late? The list is endless and includes some big players. IBM wouldn't get into the PC market with a major commitment until it cost thousands of jobs, including the president's. Sears had its success formula that was not changed until it was too late.

What will the fate of the branded companies be in the face of new competition from private labels? So far, many have fought to convince consumers not to change, rather than make private label, in some form, part of the business. Is the reason for the strong defense that they believe the change is a fad, rather than a trend, or have they built their marketing strategy on an immobile foundation?

Many marketing executives believe the marketing

Move to the most advantageous position

Merck is making itself more mobile

wars can be won exclusively with firepower—more advertising, more products, more distribution outlets, etc. This is a good start.

George S. Patton said, "Battles are won by fire and movement. The purpose of the movement is to get the fire in a more advantageous place to play the enemy. This is from the rear or the flank."[1]

But, for all those who remain opposed to change, there are those who have mobilized. Look at Merck. The pharmaceuticals industry prides itself on not changing, but Merck went ahead and bought a major mail-order drug business—which, in effect, competes with its traditional business. Many say Merck paid too much for the business, but could it be that the executives recognized the enhanced mobility it has added to the Merck marketing arsenal? Merck now will be able to position itself in more markets and shift its resources to markets of the future, rather than use them to defend decaying markets.

Is it by chance that Merck is one of the leading companies in the world? In 10 years, when drug companies are clamoring to get into non-traditional businesses, will the critics still say Merck paid too much? We think Merck is making itself more mobile, and that's good marketing.

Campbell Soup is another company that has made a number of changes in order to stay mobile. Not all of the changes have been overwhelming successes, but no one can fault Campbell for not staying mobile. Just look at the company. It totally changed its marketing program to bring marketing closer to the market with the regional marketing organization. Even more recently, to facilitate decision-making, Campbell reorganized the market research department to be closer to the brand groups.

By the way, you may remember one of Schwarzkopf's interviews after Desert Storm. He was asked when he knew the U.S.-led Allied troops were going to win the war. The general responded that he knew on the fourth day of the war. That was when

the Iraqis buried their tanks and lost their mobility.

A loss of mobility can be the death knell for a business, as well.

Keep in mind that mobility is not just changing. It's how you change. We know that there are thousands of new products (changes) in the market every year, but most fail. The brand managers of those products might ask, "Look, we were mobile, and where did that get us?"

Mobility is a way of thinking that puts your competition in a less desirable position. In order to do that, *you* have to move frequently. Be mobile! What you move or change tactically is a result of where you want to be. But, strategically, you have to place yourself in the advantageous position.

So many times, we can learn from our kids. Watch them sometime when they play "King of the Mountain." After watching the "king" push people down the steep slope, they move to a side that makes it easier to take on the leader. Yet marketers so often build their own Maginot line: This is our product, and here is where we stand.

On one occasion, we were at a planning meeting with a large canned food processor. Sales were not as good as desired, and a new plan had to be developed. After hours of discussion, one executive stood up and said, "We have the ability to make thousands of cans every hour, and we make cans cheaper than anyone else. We are a canned food company. We should make canned food." This is not mobility.

Mobility in the Market

Whether it is a tank maneuvering on the battlefield or a quarterback scrambling in the backfield, mobility is important. In the marketplace, this might be a constantly changing product. Changing the product is a good example of mobility, but, as we shall see, it is not the only example.

There is no doubt that the marketplace is the first

The speed at which you change

place to look for examples of where a company should be or could be mobile. Companies are quick to change the characteristics of their products. Coke and Pepsi introduced "clear" products. Mennen introduced "clear" deodorant. Tide has "concentrated" products. Campbell has Ramen noodles, and on and on.

But mobility is not simply changing something; it also entails the speed at which you change. For example, in an attempt to capitalize on rapid shifts in consumer tastes, Coke announced it will greatly shorten both the time it takes to launch new products and the life cycle of those products. This is a significant departure from Coke's tradition of carefully creating new products, researching and nurturing them over long periods of time. This type of change is requisite if Coke is to be mobile in the 1990s and beyond.

You must have the appropriate policies and procedures that both encourage and permit mobility.

But mobility means more. It means being willing to serve different customers. Some of the companies just mentioned changed their products but continued to target the same consumers. There is nothing wrong with that, per se, but sometimes more mobility is needed. For example, when the food companies watched the family size change from a family of four to single-person households, they responded with exactly the same food they had always prepared, but they put it in smaller cans. Anyone who has ever lived alone knows that he or she eats differently from the way the "typical family" (whatever that means) eats. But the companies simply put the same food into smaller packages. Why?

One reason might be that they were not close enough to the customer. While we don't know for sure, we would bet that the very executives who made the decisions to put their food in small cans were not from single-person households and never actually talked about food with people who were. Oh sure, they read the research reports. Perhaps they even had a long "bottom line" talk with the focus group leader. But they did not meet with a

single customer. We've talked about this problem in previous chapters.

Heinz understood the rule of mobility when it bought Weight Watchers, which sold its products primarily through the retail clubs that have been established across the country for overweight people to meet, learn from and reinforce one another's successes. But this retail club could never become the huge market a company like Heinz would covet. Therefore, Heinz took advantage of its marketing capabilities and introduced the low-calorie food to the retail food freezer cases.

Heinz moved forward to new markets, but it also had a safe fort: the classroom weight-loss programs. As hard as Weight Watchers executives worked at attracting new consumers, they were careful not to ignore the die-hard dieters in the programs. With good reason, according to *Food Business*: Weight Watchers International members number more than 3.5 million and shop 14 percent more often than non-members.[2]

In 1992, while winning the new product company of the year award, Heinz also launched a database marketing program aimed at boosting sales (and loyalty) of Weight Watchers' core business. Not only did the company secure the fort of the core customer, but by giving it attention, the company actually increased participation by 40 percent. This is at a time when Nutri/System, one of the largest weight-loss companies, nearly went out of business.

Weight Watchers was mobile, went forward and protected its rear.

Mobility in Marketing Tactics

Being mobile doesn't only mean creating new products. It means being prepared to change how the company markets products, such as by altering channels of distribution, advertising methods or pricing structures. It means that R&D must be oriented toward finding new ways to fight the war, as well as finding how to fight the same war better.

All that the competition will give

Bernard Foods, a processor of chilled foods, used mobility in its distribution strategy to achieve success. Steve Foster, vice president of sales, said, "We have a company that has been successful in growing because we strategically picked off market by market and did not try to become a national company (in one action)."[3]

In another case, one advertising executive told us that he gets involved in as many innovative communication approaches as possible. He says he knows most will fail, but some will succeed, and he wants to be with the winners. Unfortunately, this type of thinking is less common, as more short-term profit-oriented executives cut budgets that don't bring immediate success.

But make no mistake: The issue of being mobile—being able to reposition your firm to take advantage of all that the competition and the market will give—is an attitudinal issue. As we said in the first paragraph, some people can't face change and others won't.

Even the behemoths can follow the rule of mobility. Wal-Mart traditionally has focused on the rural non-metropolitan markets for its store openings. As good sites get scarcer, Wal-Mart recognized the need to move. It has now targeted slightly more upscale markets for new store openings. After years of wooing rural and middle-income shoppers, many would argue that the company had nowhere else to go but up. It may be true, but the company still has chosen to make the move. It also has recognized the need to change some stores to be more in tune with the high-tech shopper, especially around schools and universities. And it has added a kiosk, called the Smartz concept—it brings products not usually found in Wal-Marts to the stores that need them.

The open question is whether this is following the rule of mobility, or just another example of the growth paradox. Wal-Mart sales have not grown as they did in the past, and the company may be desperate for increases. We were not in the board

room of Wal-Mart to listen in on the conversations that led to the changes in this very successful company, but we believe Wal-Mart has been deliberate in its strategies in the past and we bet on them. Not everyone agrees with us, however. When Wal-Mart announced it was focusing on J.C. Penney and its consumers, a Penney's spokeswoman said, "[We're] not worried." Let's ask her again in three years.[4]

To take advantage of future opportunities, you must get the staff thinking change. Suppliers such as Synectics can teach exercises that help people think outside the traditional envelope. Companies such as 3M have procedures that encourage future thinking and mobility. (For a more detailed discussion, see *In Search of Excellence*.[5]) As mentioned previously, 3M gives its employees time—company time—to work on their own projects. Called bootstrapping, it has been the source of much success at 3M. What you do may vary, but be aware that, as a company, you can give signals of how you value mobility and change. Give the right signals—give the signals of success.

Complete Worksheet 10 to assess your organization's mobility.

Advance

Being mobile isn't valuable unless you know where you're going. And, at some point, that should be forward. One executive remarked to us that, basically, you are either going forward or going backward; there is no in between. Going forward should not be misconstrued to mean going head-to-head with the competition. It means that, at some point, you must take the initiative.

Initiative is important. When you are on the offensive, you decide where the battle will be fought. You decide what attributes will be highlighted in your advertising and where your products will be found in the store. You are off the ball first, and you decide which way the play will be run.

Encourage future thinking and mobility

Forced into a "me too" defense

We have written many times about Domino's Pizza. Just look at the value of taking the initiative and attacking Pizza Hut with home delivery. Domino's decided the acceptable time for delivery; Domino's decided the toppings; Domino's decided the price. Pizza Hut was forced into a "me too" defense.

As you will see in later chapters, we do not advocate a frontal attack under all circumstances. In fact, successful frontal attacks are few and far between. But going forward means you don't wait for everyone to catch up to you. It means you take the offensive, not only in the market but in research, in services, in packaging and in any related business.

You will see in later chapters that there are basically three strategic approaches: offensive, defensive and avoidance. The advantages of each approach are discussed in depth in the chapters, but one very important point must be made here. If you don't take the offense at some point (using offensive or avoidance strategies), you can't take the lead. Defense may keep you from losing, but offense can make you a winner.

Of all the rules we have discussed so far, this may be the one where the reader says, "Of course!" However, so many times, a company finds its place in the market and defends it, but never really tries to move forward. This may be a successful tactic in the short run, but eventually everyone will catch up to you or surround you. Your competitors will have plenty of time to build their forts next to yours. So, mobility becomes essential, and moving forward is the only way to go at some point.

How about the decision by the successful cable shopping network QVC to form strategic alliances with museums—most notably the Smithsonian. Such alliances allow QVC to upgrade its image to one of class. Long perceived as the ultimate infomercial, this alliance provides QVC with the mobility to legitimately pursue new markets. That's strategic mobility.

As is often the case, there is a counterpoint to this

rule. Quite often, firms move forward for the wrong reason. The quest for growth often forces strategists to look for new sources of sales and profits in areas that might not be productive. They often violate the previous rules—such as Know What Is Under Your Umbrella (Rule 2) and Concentrate Your Resources (Rule 8)—in order to find new riches.

The goal is to move forward within a well-developed and executed strategy—not just move in the hope of finding a new growth opportunity. So many products fail because the forward movement is in violation of the rules.

Secure

Many times, a company has been so caught up in success and the desire to move forward that it has failed to consider the possibility that it might not be successful. Then what? Is it lost, or can the company find that safe haven of established markets that permits it to recover and begin anew at a later time?

Security counterbalances forward movement. This part of the rule says, "Don't think you are invincible. Have a place to regroup."

This is one of the rules that usually is observed. Unfortunately, we believe its observance is not so much an understanding of the rules of strategy, but rather a failure to take risks and take the offense. Regardless, it is important to have a secure position or base that will allow the company to withdraw to lick its wounds or regroup.

Without the security of a safe haven, the risks of the offense are greater than they should be. Instead of just a forward thrust to test the waters of a new market, they become a "do or die" action. Without security, you can understand why so many managers are reluctant to take aggressive steps.

Look at what happens when this rule is violated. Midway Airline was doing a good job and making

Midway wanted to grow

money with limited service between Chicago and a few other major markets. Like everyone else in business, Midway wanted to grow. So, it expanded by flying more routes and establishing hubs in other cities. However, Midway was affected by a number of unfortunate events, such as an increase in the cost of fuel and a decrease in business travel, and it was forced to withdraw and recoup. But—and this is a big but—the airline had bet everything on the expansion. It had to make the expansion a success or go out of business. Guess what? Midway went out of business.

A good example of a company that advanced and secured is General Mills. As previously mentioned, it entered the restaurant business with a seafood chain called Red Lobster. It was a success, and the company rolled it out systematically across the United States. If any location failed, the firm was in a financial position to pull back without damaging the remainder of the business.

General Mills then created the Olive Garden, with the same rules of introduction.

When it created its third restaurant concept, China Coast, it was not so lucky. The idea did not prove to be as successful, and it was withdrawn from the market. However, by following this rule, the company did not jeopardize its already successful businesses.

The exact reverse happened to a small entrepreneur in the East. Actually, he wasn't small; his business was small. He had just a couple of retail food stores when he reached the same conclusion General Mills and Pepsi had reached: More food will be sold prepared rather then in basic ingredients in the future. He was way ahead of the competition and was excited to create a concept of a supermarket-type store that sold primarily prepared food: ready-to-heat or ready-to-eat. He immediately built four stores and financed this expansion totally from his own resources. Two of the stores were booming successes, one did OK, but one was a failure. Unfortunately for the entrepreneur, the project required all four to be success-

ful. The stores failed, and he retreated to just one of his original stores. Today, there are stores like the ones he tried to launch all across the country, but none are his.

Rite Aid was a successful drug store chain. But, like many growing businesses, it felt the need to grow through the acquisition and development of other specialty retail (non-drug) operations. This would make sense, if Rite Aid had followed the rule of securing its base business before moving into new territories.

Unfortunately, Rite Aid didn't follow this rule. This once dominant drug store chain was forced into a major restructuring to get back into the black. Rite Aid sold its automotive parts business, dry cleaning chain, medical services company and Encore books.

On the surface, it would appear that Rite Aid did secure its base business, since it still has the drug stores to fall back on. However, Rite Aid was forced to close 200 drug stores as part of the corporate restructuring plan.[6]

Liz Claiborne (LC) is another example of the same phenomenon. The company grew to be the largest women's apparel business in the United States by focusing on clothes for the working woman. But the growth urge struck and LC expanded into numerous other lines of business, including accessories, fragrances, men's clothes and clothes for large women. By now, you can guess the rest of the story. In 1993, profits were off by 40 percent and the company was in trouble. Once an exciting company, the chairman, Jerome Chazen, believed it would be a challenge to put innovativeness and excitement back into the core business.

In this case, the advance was at the cost of the loss of focus on the base business. Liz Claiborne failed to see the disappearance of its primary distribution channel (department stores). In addition, it failed to recognize that brand images in the base business were blurring.

The failure to secure was costly. By refocusing,

Forced into a major restructuring

Loss of focus on the base business

Chazen hoped to get back the lost base business, shore up distribution channels and ensure that each of the brands had a distinctive image. Once it recaptures the market, Liz Claiborne must secure before going after the riches of new markets.[7]

By nearly every measure—consumer acceptance, competitor reaction and Wall Street "buy" signals, Boston Market (Boston Chicken Inc.) has been perceived as a strategic marketing success. In fact, Boston Market could legitimately be used as a good example of following most of the rules. The one exception is "advance and secure."

In 1996, it was disclosed that franchisees' operating losses had jumped from $9.8 million in 1993 to more than $149 million in 1995. Average annual losses for each store jumped from $54,750 to $180,400. Despite all of the acclaim heaped upon Boston Market, the stores don't make money. Why? It's simple—the costs are too high and the sales are too low. Despite being apparently insecure from an operational perspective, Steve Beck, chairman and CEO, announced that Boston Market intended to triple the number of stores to 3,600 by the year 2002.[8]

It appears that Boston Market is finally beginning to realize the need to secure. Losses in 1996 grew an additional 5.4 percent to $156 million in red ink. In mid-1997, the company announced that it plans to open just 150 to 200 locations per year and close several others. These attempts to secure, while ego-deflating, may permit Boston Market to survive.[9]

Another favorite example of the value of security may be found at Enterprise Car Rental, which decided that it would be too difficult to go head-to-head with the rental car giants at the airports. That's where most of the business was, but it was where most of the competition was, too. So Enterprise went first to a different market—people who rent cars when their cars are in the shop for repairs. Cars were delivered to the repair shop or home, and the cars were priced at about the price point insurance companies allowed for car rental.

Enterprise marketed not only to consumers, but to repair shops, as well, making their job easier. With a solid base established, Enterprise is slowly moving to the airports. Even if it stumbles, the non-airport business will be there to fall back on. That's security!

The major consideration for developing a secure position is that you must make plans for the safe haven before you begin your forward movement. You must make security a part of your offensive plan. While it requires you to admit you might not be successful, it is a necessary prerequisite for long-term success.

Where can you find security? It sounds good to say that you must have a secure position to fall back on, but how do you create one? There are any number of ways to attain security. A few methods will be shown below.

Brand Loyalty

Brand loyalty is an overworked concept, but there is no doubt that it can be your security. Brand loyalty is the built-up equity that exists in a name, the trust consumers have in your brand. It means you can make equity withdrawals for new ventures and, if you fail, you can go back to the original product or product line.

Creating a brand extension is a way to execute this. Look at Uncle Ben's, which is solid in the rice business. The product is valued by consumers. So Uncle Ben's went into the "sauces" business, knowing that if it was successful, consumers would be buying rice and buying the sauce to put on it. If it failed, people would continue to buy Uncle Ben's rice, just as before.

The Swiss learned a bitter lesson when they lost almost all their watch business to the Japanese company Seiko. But the Swiss came back strong many years later with a new strategy based on style, not timekeeping accuracy. They created the Swiss Watch Co. (Swatch), a line of fashionable (and collectible) watches. Now, Swatch has ex-

A little more time on the shelf

tended its market into other fashion accessories, such as head bands and scarves. Consumers have a strong loyalty to the Swatch watch—which, for Swatch, represents its security.

Distribution Channels

Good relationships with the distribution channel can mean more than just smooth operations. When your business starts to slow down, your secure position might be with the distributor. You might get a little more time on the shelf. You might get better shelf placement for your base product, giving you the little extra you need to withstand losses from a new venture. The distributor might give you better position in its advertising or even a better payment schedule.

Keep in mind that the distributor isn't doing this because he or she feels sorry for you. It's because, when things were going well, you treated the distributor with respect. When you were on top, you shared your success with everyone you dealt with.

We must add a personal comment here on distributor relations. So many young brand managers who are given a successful brand for the first time act like the King of the Universe. They prance around as if they will decide every aspect of how "their" product is sold. People will dance to their tune or else. We must tell you, we've seen an awful lot of them eat crow four or five years later. And everyone is out for their scalps. When you're on top, share—because when you fall from grace, your colleagues will be your security.

Security must be built into your strategy from the very beginning. You can't just run forward—no matter how prepared or well-planned your strategy may seem—without some thought as to what happens if you fail. No one can be successful every time, and the manager who follows the rule of security will be back to fight another day.

Consider three recent advances that your organization attempted. Complete Worksheet 11 to assess your adherence to the 10th and final rule.

Chapter 12 Clues

- Avoid bogging down either mentally or in the marketplace.

- Keep moving—it's easier to hit a stationary target.

- To win, you must take the offense.

- Before you go out on a limb, make sure the limb is sound and the tree is in good health.

Back to fight another day

Chapter 13:

OFFENSIVE STRATEGIES, PART ONE

In order to win the war, at some point in time you must go on the offensive. Defensive strategies keep you from losing the war, and avoidance strategies keep you out of the war, but neither of these two philosophies will enable you to win the war. If that is the goal of your organization, then an offensive strategy is not only necessary, it is inevitable.

"Attacking the competition" is the best way to describe organizations that subscribe to an offensive philosophy of strategy. Organizations with an offensive mind-set recognize the 10th rule of strategy: Advance and Secure. If the objective is market dominance, measured in terms of market share or market leadership (real or perceived), then the No. 1 company must be attacked and displaced.

The specific offensive strategy employed depends on the circumstances, such as the market, customers, environment and competitors. As expected, however, a warfare approach places considerable emphasis on the resources, strengths and weaknesses of the combatants. Therefore, the optimum offensive strategy is derived from following Rule 4 (Know Your Playing Field) and Rule 5 (Know Who You Are Playing Against). A SWOT (strengths, weaknesses, opportunities and threats) analysis of you and your competitors is an excellent way to begin. The objective is to use your strengths against the competitor's weaknesses.

The purest form of offensive strategy

This chapter will focus on three strategies that are primarily offensive: frontal assault, preemptive assault and encirclement. In addition, circumstances in which each could be considered the optimum choice and examples of firms that have successfully implemented such a strategy will be identified. Likewise, market failures directly related to violations of the 10 rules of strategy will be provided.

Chapter 14 will discuss broadening, the most extensively used offensive and defensive strategic weapon. We will tell you why it is so widely deployed and highlight some of the not-so-obvious shortcomings that can spell disaster.

Chapter 15 then will focus on flanking as a particular offensive strategy. While all of the offensive strategies warrant consideration in certain circumstances, flanking as an offensive approach has been consistently successful and provides so many valuable clues that it merits its own chapter.

Frontal Attack

Unfortunately, whenever someone considers developing an offensive approach to strategy, the initial thought is to attack without consideration of the strengths and weaknesses of the competition. Not surprisingly, such an assault usually is launched directly at the strength of the competition—e.g., its biggest market, strongest brand, most resourceful sales force, etc. Also not surprisingly, the losses are not only predictable, but sizable.

Those who have used a frontal attack, the purest form of offensive strategy, often ignore several rules of warfare. Most notably, they ignore Rule 8 (Concentrate Your Resources—i.e., focus your strengths against their weaknesses), Rule 6 (Surprise—competitors rarely are surprised when you attempt to enter via the well-guarded front door) and Rule 1 (Be a Leader—deluding yourself into believing the better people, better product myths is not showing great leadership).

Clearly, this is the highest-risk strategy if you do not have a significant resource advantage (3 to 1 over the competition at least—although a 10 to 1 advantage is preferable) at the point of attack. As noted previously, forget the Biblical story of David and Goliath. What the Bible doesn't disclose is that before the giant's encounter with David, Goliath had been destroying Israelites for months.

Remember the Rules

For those of you who want to use a frontal attack, be sure to amass your resources until you have the necessary advantage, adhere to the rule of concentration of your resources, and attack at the competitor's weakest point. In Operation Desert Storm, the frontal attack (ground assault) was not launched until late in the war, when the Allies had organized a numerically superior army and attacked a severely weakened and highly immobile Iraqi defense. Actually, the military leaders had been under great pressure to attack sooner. However, their belief in the rules of strategy led them to put up with the media, politicians and public opinion polls, rather than violate the rules.

The element of surprise is often lost when engaging in frontal attack. Given that most defending organizations have some turf that they consider inviolate, the defenses and radar usually are massive, well-focused and well-tuned. It is not likely that you will be able to surprise competitors in this, their valued and therefore most fortified territory.

This is a good place to recall our discussion of leadership. Remember, strategists don't win wars—they make sure wars are winnable. Sending under-resourced salespeople into the enemy's stronghold does little to ensure success. Don't confuse tactical leadership with strategic leadership. Tactical leadership focuses on morale—"We can win." Strategic leadership focuses on vision—"What do we want to win and how can this be accomplished?" Imploring your people to put forth their best effort

Losing customers' confidence

so "we can win" ignores the strategic leadership responsibility: having the foresight to recognize that a direct frontal attack not only may be ill-advised, but may be doomed to failure, as well.

The losses from these Kamikaze attacks are more than just the short-term losses of money—e.g., advertising dollars and inventory. You lose the confidence of your sales force. It will be more difficult to build morale for another (ideally, more thoughtful) attack. You also suffer the loss in confidence of the distribution channel that backed you in the battle—which you left holding the bag as you retreated. However, most importantly, you lose the confidence of your customers. Losing their confidence is equivalent to losing their business—maybe forever.

Don't Use IBM or AT&T as Models

Some marketers like to point to IBM and AT&T as models of successful frontal attacks. Be careful. IBM waited until Apple had developed the PC market and then used the resources of a multi-billion-dollar organization with thousands of employees to go straight at Apple and recapture the market. While enjoying success in the PC wars, IBM has stumbled in other markets. Many attribute IBM's woes of the early 1990s to the drain on energy and resources that resulted from directly engaging Apple in Apple's arena.

We discussed another example of a successful frontal attack: when AT&T amassed hundreds of its personnel from sales, R&D and central administration in New York City to call on thousands of its former customers who had switched their long-distance service to MCI or Sprint. The efforts of the AT&T assault troops resulted in the recovery of millions of dollars of business lost to firms that had not existed a decade earlier.

Even though AT&T's efforts represent a good example of a frontal assault by an organization with considerable financial and human resources, you have to ask why AT&T had to resort to this strat-

egy. The alleged argument of AT&T has been that it feared government action if it attempted to be more rigorous in defense of its formerly monopolistic position. Was it poor strategy or a violation of the rules of strategy? Did success breed complacency? Did the moral suasion of Judge Green, who presided over the breakup of AT&T, inhibit early defensive efforts? Or did AT&T underestimate the strength of the competitors and overestimate the loyalty of its customers? What do you think?

We are not saying, "Don't ever engage in a frontal attack." We are recommending that you refrain from launching a frontal attack unless you enjoy a significant resource advantage over the defender. While both IBM and AT&T did have such advantages, very few others have this luxury.

The Successes of Frito Lay and Others

In the consumer packaged products arena, consider the frontal assault strategy employed recently by Frito Lay (PepsiCo) as it attacked the regional and some of the weaker snack food companies. Using such tactics as heavy TV and print advertising, in conjunction with generous trade and consumer promotions, this giant was able to grab market share from its less-resourceful rivals. While the major regional players may enjoy leadership in their respective markets, they simply do not have the deep financial and human resource pockets afforded Frito Lay by its wealthy parent.

Recall our discussion of the lack of concentration evidenced recently by Nabisco, in general, and SnackWell, in particular. Nabisco got distracted and mistimed some large capital expenditures. These factors allowed rivals in Nabisco's two largest markets—cookies/crackers and nuts—to go right at the company. And they did. Keebler Co. and Fisher Nut Co. copied Nabisco's low-fat format, cut prices and increased promotional spending just when Nabisco was cutting back on promotions to help pay for $1.36 billion in capital expenditures. In this case, the leader was wounded and thus vulnerable to a direct assault from smaller rivals.[1]

An unfavorable risk/reward ratio

Remember, such frontal assault strategies are most effective when the attacker commands a significant resource advantage. Also, it is not total resources that are measured when calculating relative advantage or strength. Rather, it is the resource advantage at the point of attack that matters most. And even when an organization has a resource advantage at the point of attack, victory is rarely achieved without major damage being absorbed by the attacker.

Though the frontal attack is the first specific strategy discussed, it is by far the highest-risk strategy and should be used only in a few well-defined situations—when there is a significant resource advantage, a weak competitor, minimum resource exposure, and the opportunity for a swift and convincing victory. Because of the unfavorable risk/reward ratio of a frontal assault, we do not recommend it as a strategy of first choice within the offensive philosophy alternatives.

Why Do They Do It?

Even though this strategy is the least often recommended, it is often the first selected. Maybe it's the better people or better product fallacies that drive this decision. Perhaps it's the easiest to implement—no thinking, just go straight ahead into the competitor's market or the battlefield of his choice. Do not be dismayed if this is your initial reaction.

After conducting a two-day seminar on market strategy, we gave a group of marketing executives a case study on Burger King. Given the environment and the competitive array as described in the case, any reasonable cost/benefit analysis would not have supported a frontal assault on McDonald's kids market. What strategy do you think four of the five groups recommended? You guessed it! Go right at the heart of McDonald's strength—namely, the kids market that McDonald's owns.

When asked to provide a rationale for this strategy, the groups responded that the kids' market

was huge and that is where the greatest volume and market share gains could be realized. I guess we forgot to reinforce the concepts of profit (versus volume) and risk when attacking a formidable market leader like McDonald's head on.

When you consider the numerous examples of ill-fated frontal attacks by Fortune 500 organizations, the question raised so often is: "Why did they do it?" We have a number of hypotheses.

First, the frontal attack usually is directed at the biggest market—i.e., the most attractive in terms of size, growth and potential market share. Therefore, this market represents the greatest payoff opportunity, even if the frontal attack is deemed to be only moderately successful.

Second, it requires the least amount of strategic preparation or development—simply go straight at the competitor.

Third, it doesn't seem to require any deep understanding or appreciation of the relevant competitors. Questions regarding the strategic or competitive implications of frontal assaults usually are met with the response, "This is what we want. Let's go get it!"

Be Ready for the Counterattack

Another disadvantage of a frontal attack by the little guy against the giant is that you draw the giant's attention to a previously unrecognized or unchallenged competitor (you). For example, Six Flags had been satisfied with attracting those customers who would not have gone to Disney World—Disney leftovers. However, in the mid-1990s, Six Flags launched an aggressive advertising campaign targeting the "theme park powerhouse," the Disney Corp. *The Wall Street Journal* noted that Six Flags "jabs pointedly, making sharp and humorous comparisons with the venerable playlands of Disney."[2]

Disney responded with a series of counterattacks. "Some say Disney is being too thin-skinned," said *The Journal.* "Comparing Six Flags to Disney is like comparing a B-movie actor with Dustin Hoff-

Getting there first remains a key goal

man. They don't compete with each other."[3] But Michael Eisner, chairman of Disney, may have read our section on defensive strategy that maintains, "Crush them before they become an established competitor."

In all probability, Disney never would have attacked Six Flags unless provoked. If you attack, be ready for the counterattack.

What Else Can You Do?

If your organization's philosophy is to dominate the market or to be the market leader, the frontal attack has the potential to accomplish this objective. The only questions that remain pertain to cost and effectiveness.

Would another offensive strategy be as effective at a lower cost or a lower risk to the organization, its offerings and its personnel? A look at the remaining offensive strategies will assist us in addressing these questions.

Preemptive Strategies

In a phrase, preemptive strategies may be described as "beating the competition to the punch." Like flanking strategies, preemptive strategies may be used under either offensive or defensive philosophies. However, unlike flanking strategies, which focus on undefended or under-defended markets, preemptive strategies emphasize markets that previously did not exist.

It is this focus on creating segments from presently unserved markets that gives preemptive strategies a niche look. However, unlike niche strategists, whose objectives are market creation and ownership, preemptive strategists recognize that exclusive ownership probably is not possible. The key is getting there first—to set up a defense when the inevitable marketing battle begins.

While it is true that preemptive strategies may help you avoid a major battle by arriving at the unserved market segment first, with a preemptive strategy,

you must expect competition to follow. Therefore, the preemptor must continually anticipate and project the next customer need and the market evolution.

In this regard, Rule 5 (Know Who You Are Playing Against) is the most pertinent strategic rule. Organizing intelligence usually is thought of in terms of knowledge about the competitor—strengths, weaknesses, opportunities and threats. There are real risks in this strategy, just as there are real risks whenever one "steps out" from a position of comfort—namely, the middle of a large market—onto a stage of uncertainty. However, if the preemptor's intelligence network correctly reads the market, environment and competition, the risks are minimized and the rewards are maximized.

Who Has Gotten There First?

Consider the advantage to Duracell when it preempted Everready by introducing a battery tester. Duracell gave its customers the opportunity to determine when they needed new batteries, instead of waiting until the batteries actually went dead. Is this a value-added benefit to the consumer? You bet! Think of the advantage to Duracell. You have all those people buying new batteries long before they would normally have done so.

Similarly, Star-Kist preempted Three Diamonds when it marketed—using a dolphin logo—tuna that was caught in an environmentally friendly net. Of course, Star-Kist may have felt that the government eventually would impose regulations to this effect. Nevertheless, Star-Kist beat Three Diamonds to the punch. This is the essence of preemptive strategy.

Likewise, S.C. Johnson Co. preempted other aerosol product manufacturers by producing aerosol cans with no CFCs before the EPA ban. Why? For the simplest and the best reason: His customers didn't want CFCs. He was first and, more importantly, he was successful. This particular strate-

Ford has set the standard

gic orientation, in conjunction with S.C.'s sound management skills, resulted in profits growing from $30 million in 1965 to $250 million in 1988.[4]

You Determine the Variables and Standards

An advantage of the preemptive strategy is that it gives the aggressor the opportunity to determine the relevant variables and the standard of performance for the marketplace encounter. For example, when Domino's promised home delivery in 30 minutes or less, Pizza Hut not only had to deliver to the home (the relevant variable), it had to do it in less than 30 minutes (the standard of performance). Could Pizza Hut compete successfully with Domino's by continuing to make its customers pick up their pizza or by promising to have it delivered in 45 minutes? Of course not!

Remember our previous discussions of Southwest Airlines and Sega? With only a small share of the total market, Southwest's preemptive strategy caused the giants to play the game by Southwest's rules. Sega, on the other hand, is preempting Nintendo and other electronic game manufacturers by being the first to develop new entertainment options, such as virtual reality theme parks.

In the American automobile industry, Ford Motor Co. is preempting other car manufacturers by developing used car leases. While this may appear mundane, it represents a major paradigm shift for the industry. Besides the tremendous press coverage and consumer goodwill generated by "getting there first," Ford has set the standard for used car leases.

Counterpoint

There are negative factors in preemptive strategy. When Perrier preempted virtually everyone in the carbonated water category and became the yuppies' drink of choice, it promised pure water. When it was revealed during a product recall that it was "not so pure," the product was left to languish on the shelf.

Also, keep in mind that you may throw a party which no one attends. You may race to a new market and discover that you are both first and last, because there is no real market. This makes following Rule 3 (Get and Stay Close to the Customer) critical to this strategy.

Be reasonably sure before you move. This is why Rule 5 (Know Who You Are Playing Against) is so critical to the success of this strategy. This particular strategic option involves risk taking, courage and conviction.

Campbell Soup preempted most of the major food companies in making health claims with its very successful "Soup Is Good Food" campaign. Campbell was ahead of Healthy Choice and others now occupying leadership positions in the "good for you" food business. In fact, Healthy Choice may not have been a twinkle in ConAgra's eye. However, Campbell surrendered its seemingly preemptive position because of a lack of conviction, manifested by its capitulation to initial challenges to its health claims made by government regulators. It seems as though Campbell ignored or forgot Rule 7 (Focus, Focus, Focus).

Encirclement

This strategy involves covering all market segments with a variety of need-satisfying goods or services. Like flanking and preemptive strategies, encirclement strategies may be used either offensively or defensively.

Offensively, encirclement may be viewed as a multiple offensive flanking strategy, with the goal of exploiting a variety of markets either exposed or left vulnerable by the leader.

Defensively, encirclement may be used to stop any and all competitive moves, or to protect your flagship offerings from direct attacks.

Offensively, encirclement strategies focus primarily on Rule 9 (Be Mobile) and Rule 6 (Surprise). Given the resources necessary to surround a lead-

The pincer movement

ing competitor, the encirclement strategist must be able to deploy resources quickly and efficiently. Also, if the attacker has some human or financial resource constraints (what firm doesn't have limits?), this strategy runs the risk of violating Rule 8 (Concentrate Your Forces at the Point of Attack).

A good example of an offensive encirclement strategy was the effort of Seiko Watch, which captured the watch market that had been virtually owned by the Swiss watch manufacturers. Seiko created four different style groups (Seiko, Lorus, Citizen and Pulsar) for each of the major market segments. Then, within each style group, it offered hundreds of individual watches, totaling more than 2,300 different watch styles. Any style, any feature was offered by Seiko. Actually, with the quartz innovation in conjunction with an encirclement strategy, Seiko successfully challenged the Swiss for timekeeping leadership. It won the battle—and won the war.

Simultaneously, the Swiss had violated several of the rules of strategy. The word *complacency* best describes their meteoric fall from near-monopolistic ownership of the watch business. Fortunately, the Swiss learned their lesson, albeit the hard way, and returned to a position of importance in this business by flanking Seiko on the basis of style and fashion—by creating Swatch (see the section on offensive flanking).

Zippo must have taken a page from the Seiko book. That company took the hapless cigarette lighter that could be purchased for about $1 and made it into a thriving new business. Zippo realized that it made lighters, but people bought collectibles and mementos. So the company created more than 450 different models of lighter. It focused on attitude, lifestyle and fashion—not lighting cigarettes. In the declining market of cigarette sales, Zippo was able to encircle the competition and double its sales. Zippo won *AdAge*'s Smart Marketers Award in 1994, and the company deserved it.

A variation on the encirclement strategy is the pin-

cer movement—or "surround them on both sides." In this case, the approach is to get your products positioned on either side of the competition, then squeeze.

This is what L'Oreal, one of the world's largest cosmetic companies, does. It launches an innovation in a high-profit, luxury line of products, then relaunches a simplified line into the mass market.[5] L'Oreal was the only cosmetic company to employ this strategy. P&G and Unilever competed with it in the mass market, and Clarion and Estee Lauder competed in the upscale market. This pincer strategy allowed L'Oreal to take advantage of the boom of the 1980s and acted as a hedge against the recession of the early 1990s.

Does success leave clues? Both Lancome and Shiseido now offer both high-end and mass market cosmetic products.

Chapter 13 Clues

- If you are not bigger or stronger, don't attack your competition head-on.

- If you can't hit them harder, hit them first.

- Expect and prepare for a competitive response.

Chapter 14:

OFFENSIVE STRATEGIES, PART TWO—BROADENING

Broadening strategies are best exemplified by the classic product line extension activity. The broadening strategy is probably the most-used marketing strategy. It is often considered the least risky strategy, because you are not really leaving the protection of the fort to go out and fight the competition. You are just extending the walls of the fort a little bit.

If you make an incursion into the leader's domain, then broadening is considered an offensive strategic weapon. On the other hand, if you are the leader, this can be an acceptable defensive strategy (see the section on defensive broadening for examples).

Line extensions have been based on "brand equity." In essence, a marketer employing a line extension strategy is hoping to borrow or leverage the consumer- and trade-related value of one brand and apply it to another product. The objective is either to attack or to defend against competitors.

This strategy is analogous to jump starting a car. You use the energy in the battery of a first car to give a "boost" to a second car. In theory, once started, the second car can generate its own energy and continue running. And, of course, the first car can replace the lost energy it gave to the jump-started car.

When starting cars, this works. When starting brands, it rarely works as described. Either we

They all solved similar problems

drain the energy from the initial brand or we never keep the jump-started brand running.

Line Extension Criteria

Without going into too much detail regarding the rationale and use of line extensions, a few heuristics are in order. First, you must consider Rule 7 (Focus, Focus, Focus). How does the line extension under consideration contribute to your objective? What about Rule 2? Does it fit under the umbrella of the business you are in? Consumers must see the new product as a logical extension of the problems you have license to solve for them. Many marketers consider themselves invincible and lose sight of their objectives.

Two good examples of broadening via line extensions are Arm & Hammer and Bic. Arm & Hammer discovered that, besides being used in baking, its product could be used to eliminate strong odors. Therefore, it introduced very successful line extensions, such as refrigerator deodorant, carpet fresheners and room fresheners. All this made sense to the consumer, because they all solved similar problems: strong odors. Success!

But then Arm & Hammer went into body deodorant. Gillette made body deodorant, Mennen made body deodorant, but Arm & Hammer should not make body deodorant. As a matter of fact, using Arm & Hammer implied "strong" body odor. Failure!

Bic didn't learn from Arm & Hammer's mistake. It owned the consumer franchise for inexpensive disposability. Just think of all the things consumers want to be disposable: lighters, pens, razors and, of course, perfumes and after shaves. What? You don't want to wear Eau de Bic? No one else did, either. It failed, because perfume didn't fit. Just because you want to sell it—or just because it's easy to make or distribute—doesn't mean your customers see it as solving their problems.

It will be interesting to see if Levi's introduction of pants called Slates will be a line extension that falls under the umbrella of smart casual, or if it

fails as the Classics line failed years earlier. The introduction has been called everything from focused with attention to detail to a Keystone Cops development program. Wait and see, but if you want a pair, we think you should buy them soon, because you won't see them on the shelves very long.[1]

Remember what the president of Southwest Airlines said? "We dignify the consumer." Dignify consumers by showing that you believe they understand what umbrella your products fall under, or you'll be left out in the rain.

After you are comfortable that the proposed line extension satisfies Rule 7 (Focus, Focus, Focus), you need to specify the next criterion to measure the success of the line extension. Is it total volume, combined market share or profitability that you want to achieve? We think the success should be measured by profitability.

Some would argue that any line extension which cannibalizes volume or market share from the existing brand should not be considered. Our position is that cannibalization of sales is not, *de facto*, a reason to pass on the proposed broadening via a line expansion. If the extended brand has higher margins, profits will result. Even if you take all of the new brand's volume from the existing brand (no incremental volume), then this line extension will increase profits for your organization and should be evaluated against the other criteria.

Finally, consider the impact of line extensions on the target market for the new and the extended brands. What happens within the market—confusion, consistency, synergism? When AT&T launched an offensive strategy into what it perceived to be a logical line extension—from long-distance telephone service into computers—the marketplace responded very negatively. The marketplace perception of AT&T was that, as a computer manufacturer, it was a good telephone company. At the time, IBM was the perceived leader in computers.

Cannibalization of sales

Using its reservoir of goodwill

In the words of Marcio Moreira, vice chairman and chief creative officer of the advertising agency McCann-Erickson Worldwide, "A company has to have a vision for the brand that covers its equity—i.e., its past reservoir of goodwill with the customer—and covers what's expected and hoped for the brand at the moment." He adds, "That vision must also keep the product fresh in the consumer's mind to ensure that the brand has a future."[2]

A company that appears to follow the directive of Moreira is Chi-Chi's, with its grocery products. Using a memorable line, "When you can't get to the restaurant—get to the store," Chi-Chi's is properly using its reservoir of goodwill to keep the product fresh in the consumer's mind. This line extension strategy appears to satisfy the target market for the original, as well as the extended, concept of Chi-Chi's.

Broadening Without the Brand Name

Although brand-name line extension is the most common form of broadening, this strategy can be executed in a non-line extension mode.

One of the more visible and successful applications of broadening strategy without using the flagship brand name is within Procter and Gamble. For the most part, P&G has effectively used non-line extension broadening strategies—e.g., offering Tide, Bold and Cheer in the laundry detergent market—without incurring some of the downside risks associated with literal (same brand name) line extensions. However, even venerable P&G has line extended. Consider how many Tide options there are today. Do you think P&G has followed the rules?

Another example is Hormel Foods. Hormel wanted to capitalize on the growth of the ethnic market, particularly the Asian market. It quickly realized that it might have difficulty selling "sweet and sour" Spam. So, it moved (i.e., broadened) into this market by acquiring the House of Tsang, maker of Asian sauces. Hormel launched a number of new

products under the brand name House of Tsang.

We know what you are thinking. The new products were traditional, brand-name line extensions for the House of Tsang. True! However, for Hormel, they were not, since Hormel had no brand equity in the Asian market.

The Lesson From 7UP

The case of 7UP Gold is a good example of an offensive broadening strategy that was ill-conceived from the start. Despite its market dominance in the uncola market, 7UP always wanted to be in the cola-flavored or caramel-colored soft drink business. Its stated objective at the time was for 7UP Gold to capture only 1 percent of the domestic soft drink market in the United States. A 1 percent share would translate into approximately $350 million.

However, 7UP Gold was not an uncola. It was cola-colored and contained caffeine. Remember the 7UP promise, "Never had it, never will"? Guess what? Not only did 7UP Gold fail to reach its extremely modest goal of 1 percent of the market, the company publicly admitted to more than $50 million in losses. While this is important, the real loss to 7UP was to its flagship product. It lost millions of dollars in sales of regular 7UP. The market was confused. Was 7UP a cola or an uncola? Did it have caffeine or not?

This is a good example of success breeding complacency. 7UP's management team admits so. After their tremendous success with the previous line extension, Cherry 7UP, they felt invincible.

The 7UP Gold example underscores the downside risks associated with a failed line extension. 7UP and other major companies can quickly recover the lost marketing expenses. The real harm is the collateral damage to the flagship or mother brand.

Speedo is an example of another company whose offensive broadening went sour. Speedo was the top-of-mind company for racing-style swimsuits.

"Never had it, never will"

Promptly lost their shirts

It was almost like Kleenex for tissues and Xerox for copying. As in so many other companies, that wasn't good enough, so Speedo executives decided they could easily move into the skiwear market. That's right, skiwear. They created a line of Speedo skiwear and promptly lost their shirts. We think the growth paradox and a sense of complacency led to this expensive decision.[3]

Meanwhile, the jeans manufacturers have done a good job with the broadening concept. Lee Jeans introduced a line extension for pudgy people. It found that pudgy people have a hard time getting into their jeans and, once in them, they are frequently uncomfortable. Therefore, a new line was produced.[4]

Kellogg's, in its ongoing battle with General Mills for leadership in the cereal business, is another example of a company trying to leverage the equity of an old favorite into new markets. Kellogg's extended Rice Krispies with Apple Cinnamon Rice Krispies, Cocoa Krispies, Frosted Krispies and Fruity Marshmallow Krispies. It even extended the brand to include Rice Krispies' Treats. With the exception of Rice Krispies' Treats (see Chapter 17), the jury is out on the success of the rest of these line extensions.

It was a broadening strategy that enabled P&G to regain its leadership position in the bar soap market. P&G used the equity of the Oil of Olay brand to recover sales lost to Lever Brother's preemptive offering: Lever 2000. One analyst said, "No doubt, Olay, which is P&G's most successful bar soap launch since Ivory, is taking some share from Lever 2000." One month after its introduction, P&G had a 32.5 percent overall market share, compared with 31.5 percent for Lever. A year earlier, P&G had only a 27.8 percent share for the same time period, while Lever had 32.5 percent.[5] Lever is now in a position where it has to respond to Oil of Olay, and P&G must be ready.

More Than Just Line Extensions

Broadening, however, is more than just taking the name and image of one brand and transferring it to another category and target market. Broadening may be expanded to include any effort designed to capitalize on the strengths of the company.

Perhaps the strength is in distribution or category management or sales training. Again, as with any of the strategies, think in terms of what problems can be solved for the customer. For example, a manufacturer known for its sales training may be able to take this strength and broaden it to help solve the turnover and training needs of one of its major retailers. Do you think solving this pressing problem for one of your major customers might make a difference when you are seeking distribution (shelf space, displays, feature pricing, etc.)?

One special form of broadening is going international. Many companies seek to expand their brands to the global markets, but the traditional broadening strategy may not be appropriate. Many marketing giants have tried in vain to leverage their strong brand position globally, but with only marginal success. If you are looking to broaden globally, you will need more preparation than ever. Keep in mind that you may not have any leverage for your domestic brand in an international market.

Counterpoint

The underlying logic of the broadening strategy is that brand equity may be "used" by the new product. This is good logic, if consumers maintain their belief in branded products—if there really is equity in the brand.

Recently, there have been numerous examples of strong branded companies that have been unable to jump-start weak new products. What about Coca-Cola and New Coke, or Fig Newtons and Grape Newtons, or Campbell's and Super Stars dry soups?

Experience suggests that almost 9 in 10 line extensions are likely to fail. It may be that the kind

Going international

Erosion of brand loyalty

of brand loyalty we've come to know and love is a thing of the past. As consumers become more educated about products—from government, schools, special interest groups, such as Consumers Union—they recognize their own ability to judge product quality. Furthermore, as consumers more frequently recognize that the branded companies often make the unbranded products, they are more likely to ask, "Why pay more for the same thing?"

Or it may be that consumers are looking to simplify, not complicate, their decision-making process. For example, there are now more than 400 types of cigarettes on the market. Camel alone comes in 11 variations. Does the shrinking pool of American smokers really need more smoking options? Do these line extensions satisfy the criteria we have outlined? What do you think? Success leaves clues—and so does failure!

Even the private-label marketers have infiltrated the market by creating "premium" label products that compete with branded products in quality and price. Sam's Choice, President's Choice and Europe's O'Lacy's are examples of private premium labels.

This apparent erosion of brand loyalty is underscored by the recent performance of brands once perceived as invincible. Coke, for example, had a scant 0.4 percent increase in sales from February 1992 to February 1993. During the same period, private-label soft drinks increased by 6.1 percent. Kellogg's cereals experienced a 3 percent increase, while private labels jumped 7.3 percent. And while P&G's Pampers had an acceptable 6.1 percent increase, private-label diapers soared a whopping 18.2 percent.[6]

However, the No. 1 firm in a category still may be able to use the broadening strategy. According to Les Pugh of Salomon Brothers, "Only the elite will flourish." Or, as Steven Vannelli of KJMM Investment Management asserts, "The company that will really suffer is the No. 3 or No. 4 in any product area—any company that doesn't have the No. 1

market share."[7]

The message: Make sure your battery is fully charged before you try to jump start something else.

Chapter 14 Clues

- Stay under your umbrella.

- Existing brand equity is a valuable asset—don't waste it.

- Don't let the pressure to grow adversely affect your extension strategies.

- Don't let your capabilities (R&D, production, marketing, etc.) solely dictate your line extensions. Remember to continue to dignify the customer.

Continue to dignify the customer

Chapter 15:

OFFENSIVE STRATEGIES, PART THREE—HIT THEM WHERE THEY'RE NOT

To overcome some of the shortcomings of the frontal attack, generals discovered that they could have a similar offensive result by starting the battle at a point that the competition did not anticipate—where it therefore was not prepared to do battle. This makes it easier to maintain Rule 8 (concentrate your forces at the point of attack and concentrate your strengths against your competitor's weaknesses), since fewer enemy soldiers are confronted in a flanking operation. The undefended or underdefended flanks have been a favorite target of generals for centuries because of the high success rate of this strategy. If, in fact, success leaves clues, this strategy should be a favorite of marketing generals, as well.

Again, consider the case of the Cape buffalo. Besides man, there is only one other animal that regularly kills this mighty African beast. Perhaps a lion or a rhinoceros, you say. Nope. Neither of these two feared beasts can accomplish what a pack of hyenas can do by employing a flanking strategy. The initial attacks and half-attacks are aimed, literally, at the water buffalo's flank. When the buffalo whirls to defend its lateral flank, it exposes another flank—its neck and underbelly. Efforts by this much larger and stronger animal to pro-

Drive-up airport check-in

tect its many exposed and uncontested areas require the Cape buffalo to spin about continually and expend a considerable amount of its energy defensively. The hyenas use their instincts to conquer the buffalo by going after uncontested territory, thereby avoiding what would be a swift and mortal defeat if they were to engage the water buffalo head on. It is this concept of exposed or uncontested markets that provides the foundation for flanking strategies.

Flanking strategies may be offensive weapons when they are used to attack the leader via entry in uncontested or slightly contested markets. They may be defensive strategies when employed to shore up a weak or vulnerable position or to block a potential flanking attack by a competitor. While the reasons for employing this strategy may differ, the focus on uncontested or underdefended markets is the same.

Consider Virgin Atlantic's flanking attack against British Air and the major U.S. airlines—offering service from London's Heathrow airport to the United States. Virgin Atlantic realized that the most stressful time for travelers is not when they're on the plane. That's when they're relieved. They are stressed out when they are getting to the airport. They are always running late. They are worried that there is going to be a line at the ticket counter.

Virgin's response was drive-up airport check-in at Heathrow. Boarding passes are issued electronically by a limo driver. Once at the airport, the car is met by a porter, who asks the passenger security questions and collects the luggage. After being cleared, the passenger rides in the limo up to the second floor, disembarks and crosses on a covered bridge into the terminal near the security and immigration desks. It took Virgin more than a year to secure the space and work out the details.

This is not the traditional, easy-to-respond-to fare war. Competitors will have to expend considerable energy and resources to match Virgin. By then, Virgin will have established its beachhead

in the target market.

Unlike the frontal attack, an offensive flanking strategy is a way to create a presence in a market without the risk of significant losses. Would Miller Brewing ever have achieved the market share it captured from Anheuser-Busch if Miller had mounted a direct attack on Budweiser? By using a series of well-conceived and well-executed product and promotional modifications, Miller successfully outflanked Bud with Lite beer. Several years later, Miller again flanked the leading beer company, when it introduced Miller Genuine Draft.

Unfortunately, Miller appears to have forgotten its formula for success. Miller thought it could compete with a hodgepodge of brands. Concentration would dictate that Miller slow down on the steady rollout of new products and instead spend aggressively on a few core brands.

In 1996, when Miller attempted to reflank Anheuser-Busch with its new would-be flagship, Miller, consumers experienced a real identity crisis. With a name as humdrum as just plain Miller beer, consumers didn't realize that it was a new product. Many thought it was repackaged Miller High Life or Genuine Draft.

Miller's successful flanking efforts had brought it within reach of the leader, Anheuser-Busch. But, since then, Miller has experienced a significant reversal of fortunes. Its market share for the most recent 12 months (mid-1995 to mid-1996) reflects this. Miller's share slipped 0.4 percent, down to 23.9 percent. During the same period, Anheuser-Busch's market share grew 0.7 percent to 40.3 percent.[1]

Rule 6 (Surprise) is essential in launching a successful offensive flanking strategy. Often, the flank is exposed because there are insufficient resources to cover all uncontested markets. However, in many cases, the resources are available to the defender, who may be following a counteroffensive strategy (see Chapters 16 and 17 for more on defensive strategies). The defender may be holding resources

Miller outflanked Bud

Tylenol had an exposed flank

in reserve until the company determines when and where a challenger will initiate a flanking attack. If, as a challenger, you intend to use a flanking strategy, you must surprise the enemy. The hyena hides in the bushes in an attempt to surprise the powerful Cape buffalo.

Bristol-Myers' low-price-based flanking strategy for Datril ("a buck a bottle less") might have worked, if it had surprised Johnson and Johnson's Tylenol. Unfortunately, we will never have a definitive answer. (Bristol-Myers surprised J&J only in the test market. J&J then responded and precluded Datril from ever gaining a significant share.) However, a post-mortem focusing on the "why" would seem to support the perception that Tylenol had an exposed flank in terms of its relatively high price, and it would have been very vulnerable at both the distribution and consumer levels, if Datril had been able to establish a beachhead.

The 4 Ps and Flanking

To demonstrate the creative possibilities in offensive flanking, we have chosen to present it in the context of the traditional "4 Ps"—Product, Price, Place and Promotion. With offensive flanking, you are limited only by your imagination.

A recent example of successful offensive flanking was Nestle's entry into the baby formula market, long dominated by Abbott Laboratories (Similac and Isomil) and Bristol-Myers Squibb (Enfamil and Personae). While the battlefield for the formulas had been maternity wards and pediatricians, Nestle pitched its Carnation Good Start directly to consumers with a TV and print advertising campaign. It started a new fight for consumers in a battlefield unfamiliar to the leaders. Do you think this flanking strategy worked? You be the judge. Nestle's sales of Carnation baby formula increased 79 percent, while the market leaders lost a combined 4 share points—in a $2.4 billion market.[2]

Do you think Nestle could have had the same result by trying to convince doctors to recommend the product—after Bristol-Myers' and Abbott's

armies of detail persons had finished with the doctors? Not likely!

At this point, you might think that a flanking attack is recommended when companies just don't have the total resources to orchestrate a frontal attack. Not so. Nestle is the world's largest food company and has the resources to go head-to-head with anyone. But it also has good strategists who understand that the best way to beat the enemy is to do it with minimal effort, resources and, of course, losses.

Another example of successful offensive flanking using distribution channels comes from the computer industry. Dell Computers did not have the resources necessary to compete in the traditional computer distribution channels (mass merchandisers and consumer electronics stores). Consequently, Dell pioneered direct marketing channels for computers. It used magazine ads to sell direct to consumers, and it was a great success. Is it possible that Dell, a manufacturer of sophisticated computer equipment, learned from the clues left by a highly successful direct marketer of records and tapes—Columbia Records and Tapes? What do you think? Today, direct mail accounts for almost 25 percent of all U.S. computer sales.[3]

Another distribution flanking success story is Science Diet dog food. With the "dog eat dog" competition in traditional pet food channels (supermarkets), Science Diet flanked the leaders by distributing through pet stores, feed stores and farm stores.

Brenda French must believe success leaves clues. She used Tupperware's success model to create a profitable in-home women's apparel business. She took her French Rags label out of department stores and into living rooms. She flanked the big fashion houses by going where no designer has gone before.

Of course, distribution channel options are not the only flanking alternatives. One innovative example of flanking involves Lee Pharmaceutical's

Using distribution channels

Giving American workers jobs

new version of Zip, the depilatory. It flanked Nair and other hair removal products by developing the first microwaveable depilatory. Similarly, others in the hair care and beauty products business are considering developing microwaveable products, such as conditioners and styling gels.[4]

Toyota successfully found uncontested ground, but it required a huge investment. Toyota wanted to be the first foreign manufacturer to be recognized as a U.S. company. It would shift its production from Japan to the United States, building more than 1.2 million cars here. This Americanization of Toyota aims to remove the last shreds of resistance that some consumers, especially blue-collar Midwesterners, still have to foreign car companies. It is not just building cars here for production economies or tariff reasons, but to make "made in America" a theme for the company. Toyota would like to be the third-largest car manufacturer in the United States.

Its flanking strategy seems to be working. According to *Time* magazine, George Taylor, who fought the Japanese in World War II, recently traded in his Chrysler for a Toyota. He said, "The way I look at it, the Japanese are coming over here and giving American workers jobs, while American companies are closing factories and taking jobs overseas."[5]

In the early 1990s, Kimberly-Clark used offensive flanking to get additional share points in the highly competitive disposable diaper business without going head-to-head against giant P&G. Kimberly-Clark created a new category of diapers when it introduced Huggies Pull-Ups—for children "almost out of diapers." According to *The Wall Street Journal*, P&G was caught by surprise (Rule 6) and didn't respond quickly. It showed in the performance; Huggies had approximately 10 percent of the market and $423 million in sales in 1992. The exciting part is that this represented a 37.9 percent increase in sales over the previous year.[6]

Another example of flanking via product modification and precision target marketing comes from

Suntory Water's 10-K. This sports drink is trying to flank the big guy, Gatorade, with a drink that tastes good and is targeted to an audience that Gatorade has taken for granted—children. By following Rule 3 (Get Close to Your Customer), Suntory Water has concentrated its advertising dollars on 6- to 12-year-olds. While Gatorade spent more than $21 million in total advertising, Suntory Waters intends to spend almost that much just in the children's market.

Will Suntory Water be successful in the long run? Only time will tell. What we do know is that in the past decade, over a hundred beverages have stepped up to challenge Gatorade on its own turf: athletically active men. The results of these frontal attacks are obvious: Gatorade has a 90 percent share of the $1 billion sports drink market.

Even price may be used as a flanking variable. Look at MCI's "Friends and Family" campaign, launched in March 1991. It offers discounts to groups of customers who frequently phone each other. Reducing price to the customer is not necessarily an optimum flanking tactic. But it was in this case, because of the creative way in which MCI turned an AT&T weakness into a relative advantage. MCI discovered a flank that AT&T could not defend: its inability to link accounts of customers from all over the country. This is ironic, because when AT&T negotiated its deregulated rules of operation, it considered its billing arrangement with regional operating companies (RBOCs) a cost-saving advantage. While using the RBOCs to do its billing saves the company money, AT&T does not have the ability to link accounts. Credit MCI with some great creativity.

Was this a success? In 1990, MCI's market share was 13 percent, and its stock traded at less than $18. Less than two years after introducing "Friends and Family," MCI signed up its 10 millionth customer and had a market share of 17 percent and a stock price of $40 per share.[8] We would call that a success.

Konica, a manufacturer of photographic film, outflanked competition by creating a product spe-

A campaign targeting women

cifically for photographing children. While other leading manufacturers offer film with the same technical standards for everyone, Konica targeted its products to parents. It may sound like a narrow flank—until you think about the subjects of most of your pictures in the last 10 years.

Even the monolithic automobile companies are using offensive flanking. Ford, which, as we all know, has gone head-to-head with GM and Chrysler, has gone after the college student market. Taking a page from the Japanese marketing book, Ford has begun an advertising campaign on MTV. According to *USA Today*, Ford has focused on college-age students in the hope that it can tap into a potentially lucrative market.[9] Not to be outdone, Chevrolet has initiated a campaign targeting women. Which flank will Chrysler pursue?

Another good example of offensive flanking comes from the previously mentioned Swiss Watch Co. (Swatch). Although the Swiss watch industry was successfully encircled by the Japanese, Swatch learned from the industry's violations of the rules of strategy. The Swiss Watch Co. recognized that the Japanese were strong in reverse engineering, copying and improving upon technology. They were not considered leaders in fashion design. Swatch employed a flanking strategy by offering fashion accessories that also give the time of day. How would you describe Swatch's new business? Like Seiko, Swatch makes watches (production orientation); however, it is *not* in the timekeeping business. Instead, it is in the "cheap chic" business (market orientation).

Another classic battle rages in the tea wars. Tetley, a perennial challenger with the same old product, has watched Celestial Seasonings move to the No. 2 position with herbal teas, while Tetley remained at No. 4.[10] Tetley attempted to outflank the leader, Lipton, with a round tea bag—offered with an explanation of why round is better. Although Lipton responded, it did so by making fun of the new product, just as Ray Kroc's antagonists made fun of the 15-cent hamburger and Fred Smith's adver-

saries predicted his Federal Express would never get off the ground. It appears that Tetley has not been dissuaded by Lipton's efforts. Tetley has committed resources in support of this flanking move and has earmarked hefty advertising budgets for the round tea bag. Only time will tell whether its strategy is successful—unless you read tea leaves.

Whittle Communications has made its reputation by flanking via advertising and promotion. While everyone else is trying to break through the clutter of traditional mass media, Whittle is reaching its target audiences without the interference of competing advertising messages. Whittle's flanking use of advertising ranges from in-school efforts (Channel One) to in-doctor's office efforts (Medical News Network).

What Problems Do You Solve for Your Customers?

Remember, you define your marketing strategies in terms of the problems you uniquely solve for the customer. Then you test these possible strategies against the relevant competitive realities.

Did you ever send flowers to a friend or relative, only to discover that what he or she received was not what you ordered? This is a common problem that 800-FLOWERS intends to solve. Call it the "War of the Roses," as the 800 number upstart attacks the comatose leader FTD. Calling a single 800 number to order flowers is not only convenient, but also reliable. And, for Jim McCann—the entrepreneur who developed the concept—it's profitable, as well.

What problem do thousands of Americans have every morning? Remembering to take their multi-vitamin pill. One company outflanked the big guys, including Miles One-A-Day, with a single-serve package available at convenience stores right next to the coffee. When the single-serve idea was presented to traditional vitamin companies, like Miles, it was pooh-poohed with the notion that it's difficult enough to sell a bottle of a hundred tabs, let

A foothold in the market

alone one at a time. Besides, do you know how much more you would have to pay per pill if it were purchased singly? The concept was carried off by more innovative companies. Even though the big guys still make more money than the flanker, the flanker makes a nice profit and, more importantly, now has a foothold in the market.

We couldn't complete a chapter on offensive flanking without an example from the undisputed kings of flanking, the Japanese. One of the best examples is the case of Nissin Foods, maker of Ramen noodle soup. It entered the U.S. market with a very low-priced dry soup, Oodles of Noodles. Not really trying to get the best shelf space, next to the Lipton or Campbell's, Nissin was satisfied with the lowest shelf, almost on the floor. No one at the "big" soup companies was concerned with this new competitor. After all, they believed, it wasn't even as good as their soup. The strategy was, "Let them be (on the bottom shelf)." Today, however, the situation is quite different. All the big soup companies are trying to come out with a new Ramen noodle soup to compete with the leader, Nissin. Today, Ramen has more than 20 percent of the dry soup market and is still growing. A great flanking strategy!

Remember, not all product flanking has been successful. Any marketing strategy must begin by solving specific customer problems. Flanking to an uncontested position—but not solving a problem—will surely result in failure.

Keep On Moving!

Keep in mind that a flanking strategy is used most often to establish a beachhead from which to continue the offense. The flank is the beginning of an offense, and mobility is the key. Pursuit is essential to successful flanking. Just imagine if Eisenhower had arrived at Omaha Beach and announced, "We're here. Set up camp and dig in." As we know, he had a plan to move out from the flank once he was successful. Marketers must do

the same.

One of the best examples of a company that has used flanking and followed the keep-moving principle is Sprint. Under usual circumstances, you would say it didn't stand a chance, but Sprint management wasn't usual. Sprint kept finding flanks it could occupy until AT&T would arrive on the scene with the cry "me too." Then Sprint would move to another location and cry "so what?"

It all started with the "you can hear a pin drop" campaign. While AT&T and MCI were fighting over who could charge less, Sprint talked to consumers about its fiber-optic system and how much better the sound was. When AT&T finally got a wake-up call and said "we all have fiber optics," Sprint moved to simplified billing. No one knew how much a call really cost, because it varied so much by the location called, the time of day, etc. Sprint said—again, successfully—only "a dime a minute." This was more difficult for AT&T to match, because it required changes to the billing system software. When AT&T finally arrived on the scene, Sprint simplified its billing even further, with the 10 cents a minute anytime anywhere program. The company followed that with the Fridays are free for small businesses, and 10 percent cash back for customers that stayed with the company for one year.

Sprint has only 9 percent of the long-distance market, but its strategies have kept it in a fight with giants and it is holding its own. Wall Street agrees, as the company's stock price rose 40 percent between mid-1995 and mid-1996.

But there is one more lesson we should learn from Sprint: A good strategy has little value if it is poorly executed. With far fewer resources, it was able to get its messages through the clutter to have an impact on the consumer. Almost everyone has heard of the "you could hear a pin drop" or the Candice Bergen "Dime Lady" commercials. Sprint was also rated No. 1 in customer satisfaction surveys by J.D. Power and Associates. The company

A fight with giants

Sit on the beach and get wiped out

did a great job of getting new customers—and a great job of delighting them once it had them. Good marketing, and good business.[11]

Rule 9 (Be Mobile) and Rule 10 (Advance and Secure) must be followed if you are to achieve success via a flanking strategy. Don't be surprised by the competitor's response. When you flank, you need to protect this newly conquered market, as well as have a plan to move ahead and pursue the larger market. The archives of business failures contain countless examples of companies that established a beachhead—only to sit on the beach and get wiped out because they did not achieve security, they became immobilized, and they never advanced from the site of their original landing.

Let's continue the Dell Computer story. As previously discussed, Dell was a wonder company that used the offensive flanking strategy of picking a different channel of distribution—one that the other major computer companies ignored. Dell became one of the fastest-growing and most profitable computer companies. However, Compaq, one of the computer companies hurt most by Dell's success, mounted a counterattack. As Compaq's CEO Eckhard Pfeiffer said, "There is nothing left in Dell that is superior to (us)."[12]

But while Compaq counters Dell's flanking move in the direct response channel, Dell is mounting an attack in other channels. It is adding more retailers and winning more placement in computer superstores. We will see if Dell has followed Rule 10 (Advance and Secure). Will it be able to withstand Compaq's charge at its main fort (direct response) while it is out fighting in the new channel?

Want another example? Just look at Staples. It outflanked all the small, independent stationery stores, each of which enjoyed a virtual monopoly on local business supplies. Thomas Stemberg created a national discount office supply system, which grew to a whopping 174 stores and $800 million in sales.

But how did Staples change? Not much at all. The

result is that the competition jumped in with a similar offering. According to a *Forbes* article in 1993, "Analysts began the death watch for this Cinderella story."[13]

Where Should You Flank?

The previous examples are simply a few of the many ways that a challenger can employ offensive flanking to move up the category ladder. In fact, if you have conducted an appropriate SWOT analysis, the flanking opportunities are limited only by your imagination. Remember, once someone else has shown you a flanking example in your industry, it's too late for you. You must be first.

While we cannot tell you where to flank in your industry, recall that success, in fact, leaves clues. Consider every aspect of the marketing mix: product, pricing, package size, distribution, etc.

For example, look at how Close Up modified its ingredients to outflank Crest and Colgate. It created a product to satisfy young adults' desire for fresh-smelling breath when they are engaged in passionate "lip locking."

Similarly, Lean Cuisine outflanked the traditional frozen meal manufacturers by satisfying the group that wanted less, not more. As you can appreciate, this took courage, since Hungry Man was the category leader. It appears that the boldness and decisiveness in this category belonged to the challenger.

Speaking of how "less is more" may represent a flanking opportunity, consider the huge success enjoyed by Tic Tacs. Tic Tacs outflanked other candies by making a product as small as possible, while creating innovative packaging that made the flanking viable. The category leader, Lifesavers (Planters), let newcomer Ferrero, an Italian chocolate manufacturer, gain a foothold in the U.S. market. Is Ferrero satisfied selling just Tic Tacs? Ask German candy makers, who have watched the Italian company cross their borders to become the largest candy company in Germany.

Using the high-price position

How did Planters respond to the Italian challenge? With a "me too" product called Holes. What does the word Holes connote to you? Do you think its success matches Tic Tacs?

One closing comment on Tic Tacs: What kind of candy do you think costs $25 per pound? Godiva or imported Belgian chocolates? Chocolate-covered strawberries? No, Tic Tacs. Go figure!

Did Haagen-Dazs and Orville Redenbacher see the same clues as Tic Tacs? They too used the high-price position to outflank the leaders in their respective categories. Who at Jiffy Pop would have believed a dominant market position could be obtained by the highest-priced popcorn? We're sure that while Orville was selling his high-priced popping corn, the competition was trying to figure out what it could do so it could charge just a little less. After all, it's only popcorn! Haagen-Dazs followed the same script.

Outflanking the competition via low price also represents a viable strategy. Nevertheless, we illustrate this approach with examples reluctantly, because it usually is the only option considered— or the first, second and third option normally advanced. However, one very successful example of outflanking with a low-price strategy comes from Mr. Day of the Sunshine State. Day wanted a chain of motels, but realized the Marriotts and Holiday Inns of the world would be strong defenders of the traditional overnight lodging market. He outflanked with a low-price strategy at Days Inns. This may have been a wake-up call to Bill Marriott, who then responded with one of the most innovative strategies in the overnight lodging business (see defensive encirclement).

Another example of an upstart taking on the giants by finding a vulnerable pricing flank is Michelina frozen entrees. Entrepreneur Jeno Paulucci proudly admits, "I haven't spent a penny on media or couponing." Instead, all of his limited marketing dollars are spent on trade promotion, enabling him to sell his frozen entrees for about

$1 (less than half of the competition's price). Mr. Paulucci must understand the value of Rule 8 (Concentrate Your Resources). Each of the major competitors (Nestle, Philip Morris and ConAgra) has acknowledged the presence of Michelina by offering its own low-price versions, but they are unable to match the low price of the Italian upstart. Is Paulucci successful with a concentrated flanking strategy? During 1993, Michelina's sales increased by 63 percent, outselling ConAgra's entire Healthy Choice entree line.[14]

Keep in mind the sustainability of this flank. The giants can't come out with a branded version at a low price level without adversely impacting their flagship brands. If they come out with a new brand, they give up the branded value and they are in the same playing field as Michelina. If the giants try to fight a price war, they lose big time, since they have a bigger base of existing business that they will be discounting. And they're never going to get those dollars back.

Remember the TV ads of diners on the beach in Australia. They had to take a boat to get there, but they didn't need to take American Express, because the restaurant only took VISA. The titans, VISA and American Express, went head-to-head, trying to convince upscale users to take one over the other. But while the two duked it out, MasterCard outflanked them. It targeted the middle-class market by offering rebates, frequent flyer miles and corporate sponsorships. MasterCard formed alliances with GM (offering 7 million cards) and AT&T (offering 12 million cards).

Now we know VISA and American Express may be top-of-mind, but MasterCard is quickly emerging from the pocketbook. In fact, MasterCard had the greatest increase in charge volume in 1993 (MasterCard was up 23 percent, VISA was up 16 percent, and AmEx was up 10 percent).[15]

Look at what Head did with oversized tennis racquets. How about Avon taking on the mass merchandisers of costume jewelry by going door-

A remarkable achievement for an independent

to-door? What about *USA Today*'s launch of a national newspaper at a time when metropolitan newspapers were suffering declining readership and advertising revenues? And don't forget Hanes, the manufacturer of L'Eggs, which had the vision to see the changing social norms (women working full-time) and radically alter its distribution efforts to emphasize supermarket sales.

A couple of closing examples of innovative offensive flanking are provided by W.L. Gore & Associates and Health Valley Foods. W.L. Gore & Associates, the maker of Gore-Tex fabrics, created a new product in a tired category, dental floss. Gore-Tex recognized the fatalism of taking on floss giants Johnson and Johnson and Gillette's Oral-B division head-on in their strongholds—supermarkets and drug stores. Instead, the company sent samples of the new product, Glide, to dentists, who dispensed it free to their patients. After the free sampling ended, many dentists started buying Glide, because patients liked it so much. In addition, Gore sold directly to consumers via an 800 number (what a database for future product launches!). As a result of its efforts, Glide developed a positive reputation and a core of dedicated users before it even entered the battle at retail.

Health Valley Foods, a maker of health cereals, soups and snacks, first sold just to health-food stores, ignoring supermarkets altogether. It developed a bond with consumers in several ways. The founder, George Mateljan, often personally answered letters of complaint and inquiry, and consumers were able to get friendly advice on healthy eating by calling an 800 number (which built another customized database). Soon, Healthy Valley had enough customer loyalty to move into supermarkets—a remarkable achievement for an independent operating in a mass-consumption category, such as cereal. Since 1989, its sales have doubled, to more than $100 million.[16]

Keep in mind there is a difference between looking at successful clues and looking at your competitor's success. Emulating your competitor

makes you No. 2, at best. Discovering successful clues can make you No. 1. Remember, success leaves clues. Find them—then use your imagination to apply them to your business. Then we'll be telling the world about you.

Chapter 15 Clues

- Know each competitor's vulnerability (exposed flank).

- Hit them where they're not.

- Be prepared to pursue after you hit them where they're not.

- Be ready for the competitive counterattack.

Pursue after you hit them

Chapter 16:

DEFENSIVE STRATEGIES,

PART ONE—CONCEDE

NOTHING!

"Stop all competitive thrusts into your markets, no matter how small they may appear," is the best way to characterize organizations that subscribe to a philosophically defensive strategy.

Organizations with a defensive orientation respect all of the rules of strategy, but they give particular weight to selected rules.

Rule 1 (Be a Leader) recognizes that the trade and consumers (via their shelf space and dollar allocations) have voted you the one that others must beat. This is not merely a beauty contest. The leader has earned a position of distinction that must be respected internally and vigorously defended.

Rule 7 (Focus, Focus, Focus) highlights those decisions and actions that have resulted in the leader reaching and holding onto first place.

Rule 8 (Concentrate Your Forces at the Point of Attack) underscores the fact that total organization resources are less important than the resources deployed at the point where aggressors may launch an assault. For Rule 8 to be followed, Rules 2 and 5 (Know What Is Under Your Umbrella and Know Who You Are Playing Against) must be adhered to without compromise. Category

Remember "King of the Mountain"

leaders must know where the attack is most likely to occur, when, on what basis, the strength of the attacker, likely contingency plans and anything else that will enable the company to beat back the competition without incurring significant market (volume and market share) and/or financial losses.

Finally, Rule 10 (Advance and Secure) mandates that leaders solidify their current position before attempting to leverage their strengths in untested waters. There is a tendency among organizations that achieve leadership positions to assume that the effort necessary to reach the summit is less critical than that required to stay at the top. Remember "King of the Mountain"?

Just as in offensively oriented organizations, the leader who intends to defend may pursue a variety of strategies—depending on the market, customer, environment and particular competitive situation.

Leaders Who Ignored the Rules

What happens when you're the market leader and you ignore the rules? A review of a couple of former leaders in two big businesses—Mercedes-Benz in the luxury automobile market and Sears in the retail business—will give us clues. There is a lot to learn from a review of their failed strategies.

Let's look at Mercedes first. The company's product had long enjoyed unofficial acceptance as the world's best serial production car. For many years, its image allowed it to price its cars on a "cost-plus" basis, because the demand seemed relatively insatiable and Mercedes thought it had no real competition.[1] Mercedes seems to epitomize the phrase, "Success breeds complacency."

Not only did Mercedes violate the charge of leadership (Rule 1)—to be a preacher of vision and a lover of change—it also failed to properly organize intelligence (Rules 4 and 5). Perhaps it wasn't a failure to gather market and competitive information, as much as it was a dismissal of what the

market wanted and how competition was doing that led to its downfall. As early as 1987, Mercedes was unseated by Acura as the No. 1 model in customer satisfaction. But perhaps the greatest blow to Mercedes occurred in 1992, when BMW outsold and outproduced Mercedes for the first time ever.[2]

How did BMW do it? It would be an oversimplification to suggest that BMW followed the rules. However, the rules that were most abused by Mercedes were adhered to by BMW. In addition, BMW appears to have done a better job than Mercedes of staying close to the customer. While Mercedes boasts that its product is "engineered like no other car in the world," BMW claims its car is the "ultimate driving machine." Maybe consumers are more interested in driving than in engineering. Or maybe consumers are less concerned about what you make and more concerned about what problems you solve for them. Sounds simple, doesn't it?

Let's go back to Sears, where America used to shop. For decades the leading American retailer, Sears has been relegated to an also-ran position behind Wal-Mart. Sears sold the Sears Tower and many of its non-retailing businesses. During the mid-1990s, Sears eliminated almost 100,000 jobs, closed 113 stores and discontinued its big catalog.[3]

Sears violated just about every one of the 10 rules. It lacked vision. It rested on its tradition and refused to change. It failed to maintain its objective, take the offense, stay mobile and achieve security. Violating Rule 3 (Get and Stay Close to the Customer) was probably the greatest single contributor to its downfall. It paid little attention to changing consumer needs and the alternatives offered by the discounters and specialty stores—until it was too late.

As noted previously, Sears is beginning to return to health. How? By following the rules that it ignored for so many years. Rules about leadership,

The "ultimate driving machine"

"Recognize that the game has changed"

determining what business it is in, getting and staying close to the customer, focusing, concentrating its resources and being mobile.

Sears CEO Arthur Martinez, the leader who brought Sears back from its near-death experience, says it best: "A hallmark of great companies is an ability to recognize that the game has changed and to adapt."[4]

However, no one believes Sears will ever dominate—let alone be considered the leader in—retailing again. It's not so much that Wal-Mart took away the mantle of leadership. This leader gave it away via its complacency.

Success leaves clues. Don't ignore the lessons learned from failure, as painful as they may be.

As an aside, did you ever wonder what happened to Pan Am's blue-globed logo—the symbol of what was once considered the world's best airline? In December 1993, two years after the company put an end to 62 years of flying, the Pan Am name was sold for $1.3 million in U.S. bankruptcy court in New York City. Even as the gavel hit the wood, an ex-Pan Am spokesman said, "I'm pleased the estate realized the good value for what was and still is a good name. I hope the owners respect how that name was brought to greatness and will respect everybody who was associated with it."[5]

We hope the new owners of the Pan Am name also remember how the company fell from grace, and do not repeat the same blunders.

Another American icon, McDonald's, permitted its success to breed complacency. Lifting prices too high, too fast and scoffing at low-cost competition contributed to a decrease in customer counts and profit declines in its U.S. restaurants in the early '90s. Admits Jack Greenburg, vice chairman and chief financial officer, "We got spoiled by our success. For a while we said, 'We don't have competition.'"[6]

McDonald's woes have continued. In 1996, the firm witnessed negative domestic store sales, while U.S.

operating income and margins have fallen off, as well. In areas that McDonald's once dominated, there is evidence of slippage. A 1995 Restaurants and Institutions Choice in Chains survey of 2,849 adults gave McDonald's low marks on food quality, value, service and cleanliness. Top honors went to Wendy's. In late fall of 1996, only 12 days after the introduction of the Arch Deluxe, Greenberg was installed as McDonald's U.S. chairman. On him will fall much of the responsibility to continue McDonald's 126 consecutive quarters of record earnings.[7]

What Are You Defending?

The various strategies that fall under the defensive umbrella are designed to concede nothing. Usually, the concessions we refer to here are sales volume and related market share. If there is any concession to be made by defenders, it is in terms of short-term profits.

While these defensive strategies normally are employed by market leaders, they represent a viable alternative for any firm unwilling to make marketplace concessions. This would include, for example, a No. 2 brand defending against the No. 3 player, which is seeking to overtake and occupy the No. 2 position in the market. What this underscores is the variety of strategies that a marketer might simultaneously pursue, both within and between strategic philosophies. A challenger might follow a number of offensive alternatives in pursuit of the leader or the next brand on the ladder while vigorously defending its current position.

This chapter and the one that follows will discuss the six strategies available to leaders or others who plan to defend their current positions. First, we will detail the pure defensive and defensive flanking strategies. Then, in Chapter 17, we will concentrate on preemptive, encirclement, broadening and counteroffensive defensive strategies.

We will identify the circumstances in which each

The "success formula"

would be considered the optimum choice. Additionally, examples will be presented either directly from the consumer packaged products markets or from other marketers whose successes leave real clues to consider. Finally, you will note that two-thirds of the defensive strategies (four of the six) are familiar, in that they are the same as—or very similar to—those noted under an offensive philosophy. The basic differences are the philosophical underpinnings of these alternatives and the context in which you consider employing such strategies.

Defend, Defend, Defend

The philosophy underlying this most basic strategy is, "It is cheaper to defend market share than it is to win it back." This phrase captures the essence of Rules 1 and 7 (Be a Leader and Focus, Focus, Focus). Firms in this position should never forget that they lead someone, even if they're the No. 4 brand leading "all the others." Also, firms in leadership positions tend to forget that it was their focus or the religious adherence to their objectives that permitted them to reach this position. Unfortunately, success breeds complacency. Or, in the words attributed to Malcolm Forbes, "The greatest obstacle in business is success."

Prepare to move. So many firms get to the top and think they have finally learned the "success formula." So, they are unwilling to change anything. An example of this thinking occurs in the convenience store industry. For the most part, these very successful chains are still oriented toward the recipe that allowed them to prosper at the expense of supermarkets. This recipe focused on the sale of cigarettes, newspapers, dairy products and, to some extent, deli items. Will these be the reasons for their success in the future? If not, then they must be prepared to change something— or relinquish their leadership mantle to a marketer that better serves customers' ever-changing needs.

The principle best associated with a pure defensive strategy is to ensure that the "fort"—or market offering—is prepared for the attack. Rule 10 (Advance and Secure) and Rules 4 and 5 (Know the Playing Field and Know Who You Are Playing Against) provide the bases for fulfilling this principle.

Gatorade appears to have followed these rules. Every time it has made an advance or improved its market position, Gatorade has secured this spot before moving to the next position. New flavors, containers (size and composition) and distribution channels were sequentially developed, introduced and made secure before the next advance. Remember, while marketing is a race with no finish line, the later stages of any race both build and depend on earlier efforts.

Has Gatorade been successful in applying the rules of strategy? Recall that in the past decade, more than 100 beverages have challenged Gatorade on its own turf—athletically active men. These Gatorade "wannabes" violated Rule 8 (Concentrate Your Resources) by not directing their strengths against Gatorade's weaknesses. Instead, these rival drinks mimicked Gatorade's sweaty jock advertising and its distinctive watered-down, citrusy flavor. Most have been quickly benched. Gatorade still owns almost 90 percent of this billion-dollar market. Do you think it has been successful? Do you think the rules might work? Not only does this story underscore the importance of defending market share, it also points out the folly of a frontal assault. (In contrast, consider Suntory Water's successful 10-K assault on Gatorade via the children's market, discussed in the offensive flanking strategy section.)

Always block competitive moves. Learn from the Xindu Indians, a fierce tribe that lived in the rain forest of the Amazon River for hundreds of years. Christian missionaries were killed when they crossed an imaginary line that marked the Xindu's territory. If you did not know the history of the Xindu, you might be tempted to label them *bar-*

Sweaty jock advertising

"We will crush Yamaha"

barians. However, a hundred years before the arrival of the missionaries, another group of Indians had paddled down the Amazon and camped in the Xindu's lands. Seeing no problem with this, the then-peaceful Xindu did nothing. To make a long story short, the visitors eventually attacked the village under the cover of darkness, killing the men, raping the women and kidnapping the children. Realizing they never should have allowed the intruders to step off their canoes, the Xindu vowed this would never happen again. Thus, this seemingly barbaric act had a history behind it that warranted (from the Xindus' point of view) their defense against all intruders, regardless of their intent.

No matter how small a base the competition wants, *stop them!* And no matter how small a market share you are willing to concede, *don't!*

Consider the reaction of Honda to Yamaha's statement that it was going to replace Honda as the No. 1 manufacturer of motorcycles in Japan. "Yamaha has not only stepped on the tail of a tiger, it has ground it into the earth. Yamaha *wo tsubusu!*" This phrase has a number of meanings, including, "We will crush [break, smash, squash, butcher, slaughter or destroy] Yamaha."[8]

Remember the case of Honeywell, defending its position in the navigation industry. The company pulled out all the stops to keep Litton from getting a foothold. Executive memos exhorted Honeywell marketers: "Let's keep them out. ... Stomp on them. ... Let's attack now while they are strength thin."[9]

Conversely, look at Campbell Soup and Lipton and their reactions (or lack thereof) to the entry of Nissin Foods' line of Ramen noodle soups. They did virtually nothing. Campbell and Lipton were willing to give up a little market share. Ramen's share of the soup market soared from zero to more than 20 percent.

What happened to Honda and Yamaha in the Japanese motorcycle market in the early 1990s? Honda's share went from 38 percent to 43 percent

of the market, while Yamaha plummeted from near parity with Honda (37 percent) to 23 percent. There are no coincidences.

In 1993, the Marlboro Man ignited a U.S. tobacco-industry price war. Burned by surging sales of cheap discount brands, including some of its own, Philip Morris slashed the price of Marlboro and its other premium brands by 40 cents a pack. This bold action has been referred to as "Marlboro Friday." Before the price cut, Philip Morris made about 55 cents on every pack. Obviously, its deep discounting represented a lot of lost profit. The estimated income drop for 1993 alone was approximately $2 billion when discounting and other promotional efforts were taken into consideration.

Philip Morris knew that the generic, private-label and value-priced brands were taking aim at the leader. In the words of the chief of RJR Nabisco's tobacco unit (Philip Morris' chief competitor), Morris' move represented "full-scale war."[10] Philip Morris knew that even the loss to the bottom line of $2 billion was cheaper than the billions that would be required to win back lost market share from the low-priced rivals.

Do you think following the rules pays? Only nine months after its market share gambit, it became clear that the price-cutting maneuver had worked. Marlboro's share of the cigarette market, which fell to 20 percent on "Marlboro Friday," had rebounded to 25 percent—the highest since 1989. Furthermore, its stock, which dropped to $45 per share, rebounded to $57 per share.[11]

Initially, how did Wall Street respond to Marlboro's bold moves? It was horrified! Many less strategically oriented firms would have surrendered their objectives and changed their tactics to accommodate the Wall Street bankers (who, by the way, know little about marketing). But Philip Morris followed Rule 7, stayed the course and the results speak for themselves. Success leaves clues!

Another Philip Morris company, Kraft General Foods, demonstrated its commitment to defend-

"Full-scale war"

Dockers were an instant hit

ing its leadership position in the cheese market a few years ago. At the time, Kraft USA owned almost half the market (47.2 percent).[12] Kraft used every possible marketing tactic—from direct price cuts through aggressive promotional spending to innovative packaging and a variety of new products—to signal its main competitors that the giant of this $5.15 billion market would no longer tolerate volume and market share erosion. Costly strategy, yes. It is estimated that the profit margin slippage in Kraft's cheese business in 1992 was in the tens of millions of dollars. On the other hand, consider that a single share point lost is equivalent to more than $50 million in revenue. Remember, it's cheaper to defend market share than it is to win it back!

Just ask Joe Haggar III about the cost of winning back customers. The Haggar Co. owned the pants category that lay between blue jeans and suits. In fact, it was Haggar that coined the expression "slacks" to mean pants worn during slack time—i.e., between more formal and casual wear. But, in 1986, Levi Strauss attacked the category with Dockers. Dockers were an instant hit, because—like Haggar a half a century before—they addressed a new market. Haggar's response was weak, and its sales reflected its failure to follow the rules governing defensive strategies. Joe Haggar III has the unenviable task of trying to win back folks who were previously Haggar customers. In 1993, he announced Haggar would spend $20 million on the marketing of his new competitive strategy. This figure is 10 times higher than the amount spent on all previous Haggar defensive efforts.[13]

Another example of a defensive strategy is Microsoft giving its software to competitors. You may remember this, as it was also an example of surprise. As a defensive strategy, it was beautiful. Microsoft had software that it wanted to be the industry standard. If it became the standard, the company wouldn't have any other development costs involved in creating different software for its products.

How would you ever convince your competitors to make your software their standard? Give it to them! As one industry analyst noted, the transfer of rights is "not altruistic." Of course it is not altruistic; it is great strategy—something many executives don't understand.[14]

Defensive Flanking

Offensive flanking is designed to avoid a major battle by moving into uncontested markets. Defensive flanking is used to shore up weak defensive positions or to block a potential offensive flanking position sought by a competitor.

The key rules governing a defensive flanking strategy are applicable to category leaders, as well as to firms high up on the competitive ladder that are unwilling to concede anything to real or potential challengers. As with offensive flanking, it is important to concentrate your forces at the point of attack (Rule 8). However, the concern here is to maintain a vigil—i.e., to understand your weaknesses (exposed flanks), which a potential aggressor may target in an effort to overthrow your organization. Organized intelligence (Rules 4 and 5) is designed to mitigate the risk of a surprise attack on an unprepared or underprepared front. Adherence to Rule 10 (Advance and Secure) represents the essence of defensive flanking.

Remember the underlying philosophy of all defensive strategies? Concede nothing! By design, defensive flankers often will have lower short-term profit objectives, since they are there to protect the fort or flagship from incursions by would-be market leaders.

Consider the strategy employed by Thompson Medical, marketers of Slim Fast. When the Ultra Slim Fast formula became available, conventional marketing wisdom would suggest that regular Slim Fast be replaced by this new and improved product. However, Thompson Medical recognized that the removal of regular Slim Fast would create a flanking opportunity for competitors in this mar-

Still an open market

ket. In addition, it wanted to shore up the position of Ultra Slim Fast. Therefore, Thompson used the original or regular Slim Fast as a defensive flanker, denying competition critical shelf space and occupying the low-price segment of this market.

Since the original Slim Fast was priced very low, this represented a real barrier to competitors, who realized that in order to make any inroads into the low-priced segment they would have to be priced below regular Slim Fast. Spreadsheet analysis suggested this would not be financially feasible.

This left competitors with few alternatives, other than a frontal assault on Ultra Slim Fast, Thompson Medical's strongest, most defensible position. Remember the rule of thumb: "Big fish eat little fish." Because Thompson Medical followed the rules, it is still "king of the mountain." Again, there are no coincidences.

This may be what Starbucks had in mind with its strategy to go after sales in supermarkets. Where is the one area that is still an open market for the high-quality coffee associated with Starbucks? It is supermarkets. Of course, they have the big bins of whole coffee beans, but they are sold in usual supermarket fashion—there is little service, except in those cases where there is no service.

Starbucks can stake a position in supermarkets, not only selling beans, but also opening up coffee bars. Starbucks is focused on being "the brand on a worldwide level," says Senior Vice President of Marketing Scott Bedbury, and this would require a presence—and possibly a dominance—of the supermarket coffee section. To be successful, Starbucks doesn't need to make the Maxwell House drinker, a bottom-of-the-line coffee drinker, into a Starbuck's coffee drinker. But it does need to there when a drinker considers stepping up to a different, strong and high-quality coffee. Taking the supermarkets is mandatory for Starbucks.[15]

Even though Philip Morris used deep price cuts to defend against the frontal attack of the cigarette

discounters, it also showed its adeptness at defensive flanking by launching the Marlboro Adventure Team campaign. Here's how it works: Smoke enough Marlboro and Philip Morris will send you free outdoorsy paraphernalia emblazoned with the Marlboro logo.[16]

Do you think smokers of no-name discount cigarettes would want to wear a windbreaker with the initials GPC (generic price cigarette) on it? Another advantage of this defensive strategy is that it enables Marlboro to gather the names and addresses of millions of smokers. Any direct marketing opportunities here? You bet!

In an earlier chapter, we discussed the offensive encirclement strategy of PepsiCo, when it attempted to surround McDonald's with a variety of appetite-satisfaction opportunities. Conventional wisdom viewed the positioning of Taco Bell, KFC and Pizza Hut as satisfying different palate options: Mexican, chicken and pizza, respectively. One could argue that these restaurants also were positioned versus a time-of-day eating pattern. Taco Bell was positioned primarily for lunch, KFC for dinner and Pizza Hut for dinner and later in the evening.

McDonald's recognized its exposed flanks—i.e., it was hamburger-centered and breakfast- and lunch-oriented. The company that led the industry in creating the fast food breakfast has been confounded when it comes to what to serve at the end of the day. It once saw pizza as the centerpiece for dinner, but the test market results forced it to position pizza as a specialty item for such on-the-go locations as airports, train stations and shopping malls.[17] This seems like a good avoidance or niche strategy, which will be the focus of the next chapter.

Enter Arch Deluxe, the new sandwich designed to woo older customers. Now McDonald's can boast of having a real burger for adults. The question is whether this focus and concentration on what got it to its position of leadership today—namely,

McDonald's recognized its exposed flanks

Adding drive-through windows

burgers—is a good defensive flanking strategy or continued burger myopia. In addition, regardless of its press releases to the contrary, the Arch Deluxe takes it away from its core audience—kids—and potentially cannibalizes its original products. Again, we raise the question: Good strategy, or simply the romantic courting of adults?

More recently, McDonald's announced that Wal-Mart shoppers can order a burger and fries in the check-out line. Why should McDonald's allow a potential customer to leave Wal-Mart and drive to a competitor?[18]

Do you want another example of defensive flanking? As reported to us, Tropicana was able to determine that Minute Maid was using its profits from its frozen juice concentrate to fund a low price point on Minute Maid cartons, thereby offensively flanking Tropicana. Tropicana decided to spend against its own 12-ounce frozen concentrate to protect its potentially exposed and highly profitable carton business. This defensive flanking strategy gave Tropicana the license to lose money on its concentrates to protect its carton flagship.

Drug store chains—in an effort to defend against the loss of customers to supermarkets and Wal-Mart, which took away business by offering over-the-counter medicine and in-store pharmacies—have begun to be more aggressive in defense. In addition to changing the look of their stores and installing computer systems to link pharmacy counters, drug store chains are offering customers such services as flu shots and cholesterol screening—and adding drive-through windows. Their acknowledged goal is to be perceived as the family's friendly health-care provider. It's certainly a commendable approach, but why did they and other leaders wait so long? Complacency![19]

Pure defensive and defensive flanking strategies recognize that the company has worked hard to earn an advantage over competing firms. The positive results of such efforts should not be surrendered easily to challengers. The point we made

earlier bears repeating: It is cheaper to defend market share than it is to win it back.

Chapter 16 Clues

- Concede nothing.

- Don't allow yourself to become complacent.

- Remember, it is far less expensive to defend your market than it is to win it back.

- If you're defending, you generally have the advantage. Use it.

Chapter 17:

DEFENSIVE STRATEGIES,

PART TWO—

In this chapter, we will continue our discussion of alternative defensive strategies. In particular, we will identify the conditions most conducive to the adoption of preemptive, encirclement, broadening and counteroffensive strategies. In addition, we will provide examples of successful applications of these defensive strategies.

Preemptive Strategies: Getting There First

You may recall from the offensive chapter that preemptive strategy means, simply, "getting there first." This is the most aggressive of the defensive strategies. In effect, you are beating the competitors who are pursuing you to the punch. Do not confuse aggressiveness with the actual engagement of the pretenders to the throne. Often, by "getting there first," you may preclude a flanking move by competitors and, as a result, you may even avoid a battle.

While defensive flanking is intended to shore up a weak position or block a competitor's potential flanking position, preemptive strategies require the leader to understand and anticipate where the market is going—and to be the first one to offer the market a bundle of need-satisfying attributes. Obviously, Rule 5 (Know Who You're Playing Against) is instrumental in preemptive strategies.

Defensive strategies are not merely passive

However, the focus is not solely on the competition. Instead, the emphasis is on discerning which needs of the target market are not being satisfied, then designing the appropriate marketing mix to fill these unsatisfied and perhaps even unrecognized needs.

Some Big Companies That Got There First

Consider Procter and Gamble's Big Two of laundry detergents, Tide and Cheer. P&G was not content to watch its leadership position be eroded by Lever Brothers and Arm & Hammer. It recognized a defensive preemptive opportunity in superconcentrated soap powders and was the first to introduce the new generation of "ultras" in powdered form. Ultra Tide is the No. 1 brand by far, with a 21 percent share, and Ultra Cheer has maintained its No. 2 position in the market.

P&G's preemptive strategic efforts have kept the sparkle in an otherwise lackluster detergent business (1992 sales equaled $4 billion). Detergent sales have been flat in recent years. In 1970, the typical household washed almost 10 loads of dirty clothes every week. Twenty years later, the average weekly laundry tally had declined to just six loads, albeit larger ones.[1]

The key point of this example is that defensive strategies are not merely passive. The leader does not stay the leader without doing something. P&G realized the long-term value of the earnings stream generated by its category leaders. The consumer environment was changing, and competition was becoming more aggressive. P&G recognized these phenomena and preempted Lever and Arm & Hammer in a category in which P&G would have been vulnerable if it had done nothing.

Consider the preemptive efforts of Dial soap. Dial recognized that the personal care market for children was sizable ($260 million) and growing rapidly (at a rate of about 12 percent a year). By focusing on children as users of the soap and parents as the buyers, Dial developed an antibacte-

rial soap in the shape of a crocodile and called it—what else?—"Croc O Dial."[2] Dial realized the constant parental concern that children catch most colds through the spread of bacteria. Likewise, it knew that children aren't looking for antibacterial soaps; they are looking for fun things to play with in the bathtub. The product's goal: to help make the chore of bathing a fun time, and help parents feel good about pampering their children with a fun product that is also good for them—a positioning most marketers would fight a crocodile for.

We think the previously discussed successes of Duracell's introduction of the on-pack battery tester and Star-Kist's appropriation of the dolphin-friendly tuna logo are worthy of comment here, as well. In both of these cases, one could argue that these firms incurred unnecessary production and marketing expenses. After the dust settled, however, these two leaders had an even tighter hold on the reins of leadership in their respective categories and markets.

Duracell used the product portion of the marketing mix to preempt Eveready. Star-Kist used a combination of product (modification of fishing methods) and communications variables to distance itself from the "school" of competitors. Other tactical approaches to preempting the competition include:

- filling the product line;

- blocking channel access;

- raising buyers' switching costs;

- raising the cost of gaining trial purchasers;

- increasing capital requirements;

- creating the specter of overcapacity; and

- foreclosing alternative technologies.

Seiko followed a filling-the-product-line approach when it brought to market more than 2,300 models of watches. This multiple preemption (also discussed under encirclement) left little territory uncovered and thus little opportunity for would-be

"Buy one, get one free"

competitors.

Heinz, in its battle for supremacy of the catsup market, preempted Hunt's on several fronts. First, via product modifications—specifically the "thicker Ketchup" and the squeezable bottle—it was able to stifle Hunt's assault on Heinz's catsup leadership. Eventually, Hunt's matched Heinz on the thickness and packaging issues. However, the best Hunt's could do was say it was just like Heinz. Simply another "me too" product attempted to go head-to-head with a deep-pocketed leader.

In addition to these product innovation preemptions, Heinz blocked Hunt's access to the retail channel by the use of significant trade allowances. It also raised buyers' switching costs and raised the cost of gaining trial purchasers by flooding the consumer market with generous coupons and "buy one, get one free" promotions. Loyal Heinz buyers were discouraged from switching, because the company made it attractive to remain with Heinz Ketchup. Similarly, prospective catsup buyers who might have purchased Hunt's were attracted to Heinz's offer, loaded their pantries with Heinz Ketchup and were, in effect, taken out of the market by the time Hunt's consumer promotions were launched.

As an aside, Heinz recognized that loyalty also describes the phenomenon of marketers being true or loyal to the promises made to their customers. If marketers are true to their word, their reward is that the customers will continue to purchase and use their products.

One might argue that Heinz's use of trade and consumer promotional allowances is not strictly preemptive in the sense of getting there first. Perhaps these approaches are more appropriate to a purely defensive strategy. Correctness of strategy classification is not the objective of this book. Rather, we want readers to recognize the difference between merely cutting price to stop competition and using strategy—how the strategy of getting there first or avoiding the fight permits a myriad of potential tactics to accomplish the

leader's objectives.

By the way, after Hunt's multiple assaults on Heinz, the gap between Heinz and Hunt's actually widened. In fact, the only thing to slow the growth of Heinz Ketchup was the shift toward Mexican entrees and the rapid growth of salsa. Perhaps Heinz was guilty of focusing on what it makes—Ketchup—rather than on what the market wanted—a condiment to complement its changing eating patterns. This underscores the need to organize market intelligence in terms of what problems you can solve for the customer, as opposed to simply measuring reactions to competitive alternatives to the products you currently market.

What about the efforts of P&G, as it preempted Unilever and L'Oreal by being the first to market aggressively to the Russians? How did P&G go about the Russian launch? By following Rules 4 and 5 and conducting the same painstaking market research in Russia that it does in the United States. In addition, P&G preempted its major household and personal care competitors by marketing to consumers via professionals and institutions. It introduced Wash & Go to hairdressers and its European version of Crest, Blendax, to dentists. Samples were given to elementary school children, and the company even sponsored an oral hygiene contest for students.

How about profitability? After 18 months there, the products were still unprofitable. But remember the position of P&G: It intends to be the leader in Russia. Short-term profits, therefore, are being exchanged for potential long-term dominance (Rule 7: Focus, Focus, Focus). P&G figures that the Eastern European consumer market will amount to $8 billion to $10 billion by the end of the decade, and it hopes to capture a third of that.[3]

In 1992, IBM had 52 percent of the $22 billion worldwide market for mainframe computer systems. That's the good news. The bad news is that total mainframe revenue worldwide sank 15 percent the same year, primarily because customers

The first to market aggresively to the Russians

"Keep Borders out"

were rapidly replacing $20 million mainframes with networks of PCs selling for less than $5,000 each.[4]

In an effort to turn the business around, IBM recognized the need to identify new markets for mainframes that PCs can't penetrate. Currently, IBM is considering a number of markets in which it will be able to preempt the PC makers, including movies on demand, two-way learning and health care, such as the storage of X-ray and ultrasound images of patients' organs. In effect, IBM is opting not to engage the PC providers directly on their battlefields and strengths. Instead, it plans to occupy a market that PCs have little chance of taking.

Strategically, IBM is showing not only restraint, but also wisdom in not giving in to an instinctive response to continue battling PCs on their own turf—with the false sense of security that it would be successful because it is IBM. Even IBM executives admitted that they could have done better than they did in defending against PCs. But that battle is lost. IBM is learning that it costs more to win market share back than it does to protect it in the first place.

Barnes and Noble, the scrappy New York-based chain that dominates U.S. booksellers, preempted Borders when this challenger attacked the company in Manhattan. Manhattan real estate people watched in amazement in the mid-'90s as Barnes and Noble snapped up the leases of the defunct Conran's home-furnishings stores—including one only a block down Broadway from a popular Barnes and Noble store on the Upper West Side. Barnes and Noble says it was considering the site for an all-music store, but dropped the plan.

New York real estate pros tell a different story. They say that when Borders sniffed around the Upper West Side site, Barnes and Noble bought the Conran's leases "to keep Borders out" of the neighborhood. Expensive? Certainly. Cheaper than attempting to win back lost business? Most definitely.[5]

Recognizably the king of defensive preemption is Gillette. CEO Alfred Zeien encourages Gillette to eat its young by cannibalizing current products. States Zeien, "They know that if they don't bring out a new zinger, someone else will." Beginning with the Blue Blade and proceeding through the Trac II, the Atra, the Sensor and now the SensorExcel, Gillette has purposely attacked itself and cannibalized earlier hits.

Does this strategy really work, you ask? Gillette commands 68 percent of the U.S. market in wet shaving, 73 percent in Europe and a whopping 91 percent in Latin America. Earnings since 1990 have increased 17 percent annually, return on equity is nearly 33 percent, and profit margins are about 12 percent. Any other questions?[6]

How about an example from the company that revolutionized the retailing of children's toys, Toys 'R' Us? During the Christmas 1993 selling season, it "got there first" by issuing $491 worth of coupons in the newspaper on Sunday, November 7. These discounts, good only for the month of November, persuaded customers to shop Toys 'R' Us before doing their usual Christmas shopping at their usual store.[7]

Encirclement: Take Away Every Viable Competitive Option

Recall the use of encirclement as an offensive strategy by PepsiCo. It used Pizza Hut, Taco Bell and KFC to take share from McDonald's.

The concept of encircling the competition is the same, whether it is being done for offensive or defensive reasons. The real strategic decision is the choice of a particular strategy given the organization's objectives, competitive position and other contextual factors.

Some would argue that encirclement, either offensive or defensive, is nothing more than multiple flanking. While the outcome of each of these strat-

A multiple preemptive strategy

egies may be the same, the objectives are significantly different. Under an encirclement strategy, the goal is to surround something completely. In the case of offensive encirclement, for example PepsiCo vs. McDonald's, the goal of PepsiCo was to provide every major appetite satisfaction alternative to the Big Mac.

Defensively, an encirclement strategy may be used to protect the flagship brand from a direct assault by a major challenger (PepsiCo vs. New Age beverages and Lipton Soup vs. Campbell Soup). Likewise, defensive encirclement may be used as a multiple preemptive strategy to protect and expand one's leadership position (Helene Curtis vs. Procter and Gamble, Carnival Cruise Lines vs. Princess Cruise Line and Royal Caribbean Cruise Line).

Protecting Flagship Brands

PepsiCo has learned from its offensive encirclement of the Golden Arches and appears to be using a similar strategy to defend against the non-cola offerings that want to take share from Pepsi and Diet Pepsi. Recently, Pepsi introduced Crystal Pepsi, Lipton Iced Tea (a joint venture with Lipton), Ocean Spray (juice in single-serving cans and bottles distributed by Pepsi), All Sport (a Gatorade wannabe), H2OH! (bottled water) and Avalon (a Canadian water distributed in the United States by Pepsi).[8]

Craig E. Weatherup, CEO of Pepsi-Cola North America, appears to be following Rule 7 religiously (Focus, Focus, Focus) when he indicates that Crystal Pepsi is just one part of his plan to transform Pepsi-Cola into a "total beverage company."[9] Unfortunately, Pepsi failed to follow the rules regarding line extensions (Chapter 14 and this chapter), and Crystal Pepsi has been a real marketing flop.

In the dry soup business, Lipton is the category leader. Through its competitive intelligence activity (Rules 4 and 5), Lipton learned that Campbell Soup was about to attempt another entry into the dry soup market. Since Lipton had achieved the

security (Rule 10) of its regular instant dry soup business, it wanted to make Campbell Soup attack Lipton at its strongest position (Rule 8): regular instant soup. However, Lipton recognized that Campbell would avoid a direct assault and would pursue an offensive flanking of Lipton's regular instant soup business.

Consequently, Lipton encircled its regular dry soup business with a variety of product offerings in niche-sized market segments. Every conceivable segment-satisfying alternative was developed, including cup of soup, gourmet, hearty, diet, sauces and gravies, etc. This defensive encirclement left Campbell with no alternative. It had to try to enter via the traditional or regular dry soup business that Lipton owned and still owns today.

Expanding Leadership Positions

Consider Helene Curtis Industries Inc. (HC) in the hair care market. Originally a maker of mudpacks, HC ranked 28th among U.S. hair care marketers as recently as 1983. In less than a decade, HC moved ahead of Procter and Gamble (P&G) in the $4.5 billion a year industry. HC's rise to the top was based on an offensive encirclement with the introduction of three major brands: Salon Selectives (No. 2 in the market), Finesse (No. 3), and Vibrance (which reached No. 8 in less than a year after its introduction).[10]

HC used brand encirclement strategy to get to the top, and since has used category and distribution encirclement to protect its leadership position. While P&G concentrates on the shampoo business, HC now sells twice as much conditioner and more than four times as much of the styling goop and hair spray as P&G. In fact, the non-shampoo business represents almost two-thirds of all HC sales. Likewise, even though P&G and HC are fairly close in sales through food and drug retailers, HC has forged partnerships with mass merchandisers, such as Wal-Mart and K-Mart. These mass merchandisers now account for more than 30 percent

of total dollar sales of hair care products, and this number is growing at the expense of food and drug retailers.

Carnival Cruise Lines Inc.—the owner of Carnival Cruise Line (nine ships), Holland America Line (five ships), Windstar Cruises (three ships) and Seaborn Cruise Line (25 percent owner, two ships)—has used defensive encirclement to cruise through sluggish economic waters, sharklike competitors and turbulent winter weather.[11] Carnival's performance underscores its adherence to the rules of strategy, particularly Rules 1, 7, 8 and 10 (Be a Leader; Focus, Focus, Focus; Concentrate Your Resources; and Advance and Secure). Recently, Carnival acquired its own airline. When should the vacation fun begin? When you board the ship? While its rivals fretted about overcapacity, Carnival added four new ships in 1994. Carnival has been strong and aggressive in protecting its leadership position, and is negotiating to acquire additional cruise lines—most notably, Celebrity.

Broadening

Broadening involves extending the territory of a particular company by moving the walls or boundaries of the organization's fortress further out.

AT&T and 7UP learned the hard way that broadening into computers and cola soft drinks, respectively, did not bring the success each had anticipated. These two companies were extending into areas in which neither was the leader, nor did the market believe (apparently) that they represented viable alternatives to the market leaders.

Nonetheless, even retailers can use defensive broadening. Look at what OfficeMax has done. It is in a real fistfight with Staples and Office Depot. Like a good underdog, OfficeMax is taking defensive steps to protect its position. While its competitors have been trying to merge and battling antitrust watchdogs, OfficeMax has announced that it will purchase as many available sites as it

can to block the competition. You can't sell if you don't have good locations. OfficeMax may not even build stores in every new location it purchases, but it won't let the competition have them.

It also will aggressively go after every aspect of the small business home office market. OfficeMax plans to be the one-stop location for any of this market's needs, via the store-within-a-store concept. It will offer a FurnitureMax and a CopyMax within the traditional OfficeMax.

The concept of defending by preemptive attacks on uncontested locations is bold, and so is Office-Max's chairman, who said, "No one wants to be No. 2. ... Lots [of No. 2 players] have moved on to No. 1."[14]

Beware of Line Extensions

Many leaders get to the top, fall in love with their offerings, concepts, name, etc., and fall into what Ries and Trout refer to as the line extension trap. Of the 15,000 to 20,000 food, household and personal care products launched annually, nearly 70 percent are line extensions—new flavors or repackaged versions of existing products. Examples of recent line extensions by market leaders include Kool-Aid Ice Cream Pops, Nabisco Cranberry Newtons, Snapple Peach Iced Tea, Chocolate Cool Whip and Starbucks Ice Cream.

The obvious reason for a leader to use line extensions as a viable defensive strategy is the efficiency factor. Bringing a new food or household product to market and promoting with a national advertising campaign can cost companies $50 million or more. According to John Loden, author of *Megabrands, How to Build Them, How to Beat Them*, only 1 in 10 of these new products achieves revenues of $15 million or more.

By comparison, the $50 million launch of a new product can be halved by adding a variety to an existing brand or parlaying a brand name into a new category—for example, we mentioned that Hershey, maker of Reese's peanut butter cups,

A real fistfight with Staples

Ritz Bitz line extensions

branched out into Reese's peanut butter.

While taking advantage of the investment in the flagship brand increases efficiency, it has a tendency to violate Rule 7 (Focus, Focus, Focus). As you cloud the target market's perception of what your offering really is, you run the risk of commoditizing the brand. If this happens, the branded leader becomes an easier target for generic and private-label alternatives.

Another reason for the proliferation of brand extensions is the risk/reward factor. Bob Messenger, editor of *Food Trends*, labels it the "chicken syndrome." He says, "Marketers are basically cowards at heart. The mind-set is that it is far safer to leverage a current brand than venturing into the unknown. So they take the safe route."[12]

Alfred Zeien of Gillette scorns the approach of attaching superficial frills to existing products and labeling them innovations. He dubs the practice "putting blue dots in the soap powder."[13]

Of course, even the so-called safe route is not without its potential perils. As consumers try new products that have been launched via line extensions, they may not like these broadened products and, consequently, may lose interest in the other products under the brand name. Casting a wide net decreases your focus, runs the risk of consumer alienation and could destroy the company's image and brand equity.

On the Other Hand

Despite the cautionary note, there are some very good examples of brand extensions in the consumer packaged products area. Nabisco began parlaying its 58-year-old Ritz crackers into Ritz Bits line extensions in 1987. By 1992, five extensions accounted for more than 40 percent of Ritz's overall $500 million annual revenue.

Likewise, Kellogg's is enjoying success with Rice Krispie Treats, a cereal version of a 50-year-old snack recipe. When it was introduced in January 1992, the cereal began selling so fast that the com-

pany had to take out full-page ads in major newspapers to apologize and explain the reasons for shortages.

Another leader that successfully used line extensions or broadening to protect, as well as to expand, its position was Quaker Oats, which began rolling out its flavored rice cakes in 1991. The new flavors, including nacho cheese, have boosted annual revenues by 50 percent.

Quaker enjoyed similar success with a low-calorie version of its Aunt Jemima syrup.[15] In fact, Aunt Jemima is a good example of successful broadening. It originally made pancake mix and syrup, but soon recognized that it was in the breakfast appetite satisfaction business. Consumers didn't necessarily want pancake mix or syrup; they wanted great-tasting breakfasts. Now, Aunt Jemima makes frozen waffles, pancakes and French toast, as well as light pancakes and waffles and other good-tasting breakfast entrees. Do you think the company knows what business it is in? Do you think it solves consumer breakfast problems? Do you think it is the leader by coincidence? Remember what we said about coincidences.

Counteroffensive: Take a Blow Then Give a Blow

This primarily defensive strategy is less aggressive than the others previously discussed. In effect, the leader or defender waits for the aggressor to make the first move, then hits the attacker even harder.

Several rules are pertinent to the counteroffensive strategist. Rules 4 and 5 (Know Your Playing Field and Know Who You Are Playing Against) are primary. The leader needs to have access to significant intelligence so that he or she can anticipate the attack.

Rule 10 (Achieve Security) comes into play to minimize the number of fronts on which the leader is vulnerable to attack. However, rather than try to fortify all fronts, security is achieved and the ra-

Nabisco countered with Teddy Bears

dar is in place to monitor the points of potential attack.

Rule 9 (Be Mobile) comes into play when the exterior defense mechanisms indicate an attack is forthcoming. In order to be successful in employing a counteroffensive strategy, the defender must have reserves prepared and available when the attack comes.

Remember the Pioneers

This particular strategy may be considered a substitute for a purely defensive strategy and is particularly useful when a number of fronts are susceptible to attack.

The other situation that calls for a counteroffensive strategy is when there is significant risk associated with developing new markets (stimulating primary demand). The leader can let the offensive-oriented competitor develop the category (via flanking, broadening or preemptive strategies) and then employ a counteroffensive strategy to provide the target market with a differential advantage.

Remember the pioneers? The people in the first wagon trains suffered the hardships associated with charting new territories. The wagon trains that followed reaped the bounty of the life-giving labors of the original pathfinders.

Some good examples of counteroffensive strategies from the food marketing arena include Nabisco, Duncan Hines and McDonald's. When Sunshine Bakers introduced Granny Bears, Nabisco countered with Teddy Bears. Likewise, Duncan Hines quickly countered Hershey's ready-to-spread frosting with a Duncan Hines alternative. Finally, when Burger King pioneered breakfast, McDonald's responded swiftly and forcefully with the Egg McMuffin.

Another good example comes from the cookie wars. Nabisco is the leader of the cookie market, with a variety of treat-satisfying options. It allowed P&G to introduce, develop and fund the "soft cookie"

market, under the brand name Almost Home. Nabisco observed with vigilance, then introduced its own version of the "soft cookie" and managed not only to protect its many offerings, but also to expand this new cookie category.

Chapter 17 Clues

- Don't let the competition get there first. Attack yourself.

- Have your wagons circle the competitor's camp.

- Remember, there is only so much equity in any brand—even the leader. Use it wisely.

- If you can't protect every brand, wait to see where they attack you, then be strong and swift in defense.

Circle the competitor's camp

Chapter 18:

AVOIDANCE STRATEGIES,

PART ONE

Sun Tzu sagely advised, "When the other team is sharp, never attack. Those who win one hundred triumphs in one hundred conflicts do not have supreme skill. Those who have supreme skill use strategy to bend others without coming to conflict."[1]

In other words, brilliant strategists rarely go to battle.

The Goal Is to Win Wars, Not Battles

Why do most marketers want to jump into battle? Is it part of the American spirit to engage in competition? We have competed our entire lives, since our days in T-ball, Little League and soccer. Our educational system rewards competition and punishes collaboration. Places in the best universities and graduate schools and entry-level jobs are awarded to those who perform better than their colleagues. Unfortunately, performance has become a relative measure. As a result of this conditioning, we thrive on competing head-to-head with the best.

Perhaps it is left over from our colonial days, when we broke away from England. The irony is that our founding fathers actually were avoidance-oriented. They chose to leave their native countries, rather than fight the religious and political battles

"War means winning"

that confronted them in Europe.

Perhaps it's an ego thing. My ideas, my products, my strategies and tactics are better than yours and I intend to prove it to you. How? By having the biggest market share, the most-recognized brand names, the most-recalled advertisements and the fastest track to the CEO's office. After all, war means fighting, and if you can't stand the heat, get out of the kitchen. As you know, most people forget the second-place finishers and also-rans in nearly every sporting event.

We don't disagree entirely with these assertions. In fact, we heartily support the notion that winning is everything. Let's not confuse our objectives with our strategy. Surely, we all want to win—i.e., achieve our personal and professional goals. There is little argument here. The emphasis in this chapter is on the strategies that will allow us to win without incurring the losses associated with directly engaging the enemy. We would like to modify the phrase "war means fighting" to "war means winning."

Remember the heading of this section, "The goal is to win wars, not battles." Note the absence of terms like *fight*, *engage* and *directly compete*. We will introduce strategies that will enable you to win by avoiding rather than engaging.

Perhaps it is un-American not to have your nose bloodied, knees scraped or head aching from playing or studying to beat out your peers. If you feel this way, go to a boxing match or a basketball or football game and vicariously experience the thrill of direct competition. Then return to the corporate battlefield and figure out how to win without stepping on the opponent's turf.

Retreat

Most business managers abhor the word *retreat*. However, few business leaders recognize its importance in achieving their strategic objectives. The purpose of a strategic retreat is very simple: You want to live to fight another day. Recall the most

important rule of strategy, Rule 1 (Be a Leader). The mark of a good leader is the ability to recognize when the battle is lost or cannot be won.

An excellent example of strategic retreat is Harley-Davidson in the late 1980s. Harley-Davidson was the last of the American manufacturers of "hogs," or big motorcycles. In fact, it owned the big bike market, with an 80 percent market share. However, because it failed to follow Rule 4 (Know Your Playing Field), Harley was unprepared for the significant segment retreat that was occurring as recreational riders replaced serious bikers. Instead of the 1000+ cc machines, recreational riders were choosing smaller, more manageable, and safer motorcycles and motorbikes. The good news for Harley-Davidson was that it owned the big bike market. The bad news was that this market was shrinking.

Harley-Davidson, once a proud leader, followed a retreat strategy and appealed to the federal government for tariff protection and direct loans and guarantees as it entered Chapter 11 bankruptcy proceedings. Harley used the time and resources to regroup and launch a new assault into the marketplace. It repaid the federal government loans a year before they were due (an unheard of feat) and has reemerged as a major player in the motorcycle market.

A similar example of strategic retreat can be found by looking at Chrysler Corp. Under the leadership (Rule 1) of Lee Iacocca, Chrysler also sought government assistance while focusing on what it did well (Rule 7: Focus, Focus, Focus) and what the market wanted (Rule 3: Get and Stay Close to Your Customer). With government bail-out funds available, Chrysler went from bankruptcy to a serious competitor.

How did Iacocca accomplish this? First, he recognized that he could no longer engage the Big Two and the Japanese auto manufacturers on their turf—the essence of retreat. Next, he used the government funds to concentrate his forces at the

Harley-Davidson owned the big bike market

263

The retreat of P&G Citrus Hill

point of attack (Rule 8). Specifically, Chrysler offered longer warranties ("We build them better, so we back them better") and concentrated on the family minivan market, the yuppie station wagon.

Not unlike GM and Ford, Chrysler had gotten into trouble by ignoring the rules of strategy. And it got out of trouble by recognizing the primary rule of strategy: good leadership. In fact, things went well until Iacocca became involved in the Ellis Island project. Did the demands of this important philanthropic undertaking cause Iacocca to lose his focus temporarily and fail to maintain his objective (Rule 7) as it related to Chrysler? What do you think?

Even flamboyant designer Calvin Klein recognized the value of a strategic retreat. When his company experienced serious setbacks, Calvin Klein retreated from a full-line manufacturing company to a licensing operation. In his own words, Calvin Klein said, "We've gone through a difficult period. We're not all the way there yet, but we've developed a real long-term strategy to grow our business."[3] While choosing a retreat strategy, Calvin Klein Inc. recognized that short-term pain is a prerequisite to achieving long-term stability and success. Obviously, leadership (Rule 1) is critical to this strategy.

What about the retreat of P&G's Citrus Hill orange juice from the market in September 1992? It isn't often that the No. 3 brand in a $3 billion category simply drops out and leaves $210 million in annual sales up for grabs.[4] An obvious question is: Why did P&G retreat from this market? An even more obvious answer: It was losing money to the two heavily resourced leaders (Seagram's Tropicana and Coca-Cola's Minute Maid), which collectively owned almost 60 percent of the market.

P&G recognized that despite its calcium-laden flanking attempt, it would not be able to generate a reasonable return in this market. Was there disappointment over quitting? We think so. Do you think some marketing people, among others, lost their jobs be-

cause of this market failure? Again, we believe this to be the case. Was this withdrawal a good decision? Here we have no doubts. P&G is now able to focus its attention (Rule 7) and concentrate its human and financial resources (Rule 8) in markets where a positive return is more likely than in the highly concentrated orange juice market.

Similarly, Quaker is running up the white flag on Snapple after only two years—and after paying $1.6 billion for it. Despite discontinuing a dozen drinks, making labels less confusing and adding a 32-ounce plastic bottle, which has led to the disposal of some of the obsolete glass bottles and paper labels, the brand lost millions of dollars in 1995, during a summer best remembered for record heat. In 1996, Quaker gave away free bottles of Snapple —to no avail. In the fall of 1996, Quaker announced that it planned to sell Snapple—at a substantial loss.

Quaker realized several things: First, the so-called New Age beverage category became somewhat saturated. Second, Snapple, which originally held the iced tea umbrella, tried to become the New Age provider—offering every imaginable option. Third, Coke and Pepsi exercised their marketing strengths via Nestea and Lipton, respectively. And finally, Quaker recognized that the Snapple drag may well pull under its very successful Gatorade. Although painful to admit defeat, the sale of Snapple will allow Quaker to live to fight another day.[5]

Also consider the classic retreat undertaken a couple of years ago by Sears. The company literally withdrew from the marketplace when it closed its doors for 48 hours while preparing to launch a new defensive strategy. Sears, where America used to shop, reentered the market with "every day is a sale." Its retreat strategy was designed to signal Wal-Mart and K-Mart, the competitors that Sears used to dominate, that volume and share losses would no longer be tolerated. Nevertheless, Sears' reentry strategy, based on a tactic of low prices, has failed to stop the bleeding.

Running up the white flag on Snapple

Never entering the initial contest

Pricing is not a good strategic option, unless your organization has earned or enjoys a functional cost advantage—something Sears has never really had. However, the strategy of retreat and the signal to Wal-Mart and K-Mart that Sears would no longer tolerate market share losses made good sense.

Bypass

If retreat is withdrawing from the field of battle to be able to fight another day, then bypass is never entering the initial contest. Bypass, like most avoidance strategies, requires the marketer to minimize the impact of ego in strategic decision-making. Bypass strategy signals to the big market competitors that you will sit this one out.

Again, the highly competitive and very intense nature of most Americans tends to belittle those who seem to be "afraid" to fight. When confronted with attacks on your ego, don't forget the words of Sun Tzu. Remember that in a market-driven organization, it is long-term profit—not volume or market share—that is the barometer of success.

Who do you think is the largest manufacturer of private-label photographic film? Kodak? Fuji or Polaroid? Surprise: It is 3M. 3M makes a considerable amount of the photographic film sold in supermarkets, drug stores and mass merchandisers. 3M doesn't have a fabulous Kodak Hawaiian Revue that it can take its clients and customers to see. Nor does it enjoy seeing its name in the sky on a blimp circling stadiums, like Fuji. It doesn't even have the satisfaction of giving picture takers the instant gratification provided by a Polaroid snapshot. All 3M has is the profit generated by being the largest manufacturer of private-label film. Enough said!

Speaking of 3M's foray into the film market, private label represents an increasingly popular avoidance approach for markets dominated by large, power-wielding firms. During the last quarter of 1992, private label accounted for 18.4 per-

cent of all units sold in grocery stores. In addition, dollar sales of private label grew 3.2 percent compared with the period a year earlier—twice the growth rate of national brand rivals.[6] This trend continues as the 20th century draws to a close.

Private label, in effect, is the ultimate bypass strategy. And premium private label, represented by Canadian-based Loblaw's President's Choice, provides the umbrella for a market-focused manufacturer of consumer packaged products to capture market share from the branded manufacturers and earn substantial profits.

Private label as a bypass strategy is not simply making a me-too product and putting a retailer's label on it to compete with the big boys. While many organizations have been successful by doing just this—giving consumers more value by offering the same benefits as the branded alternative at a lower price—the real bypass opportunities may be found by combining bypass and flanking strategies.

Examples of such combinations would include chocolate chip cookies with 29 percent more chocolate chips, pasta sauce with 25 percent ground sirloin, flavorful key lime pie and even a private label garlic-flavored dog biscuit designed to repel fleas. How about that for a unique bypass flanking strategy? In fact, President's Choice Decadent Chocolate Chip Cookie was ranked No. 1 over such name-brand competitors as Nabisco's Chips Ahoy! and Pepperidge Farms by *Consumer Reports* magazine.[7]

Some very successful marketers will make and distribute these and other need-satisfying offerings. They won't have their own show or their name in lights. They'll just collect more toys in their quest to see if the one with the most toys does, in fact, win.

An example of an individual quietly collecting more toys is Leonard Pearlstein, chairman, CEO and founder of Confab Co., the largest U.S. private-label maker of feminine hygiene and incontinence products. While total sales of feminine hygiene

Combining bypass and flanking strategies

"I can't tell"

products rose only 2 percent in 1992, private-label sales rose 26 percent. Confab has almost 90 percent of the business (Rule 8—Concentration). Pearlstein knows what it takes to be successful in a bypass strategy—that is, never talk like a big-name brand leader and rarely talk publicly about your strategy (Rule 6—Surprise). Recently, when interviewed about future Confab plans, Pearlstein disclosed little with the expression, "There are other things on the horizon I can't tell."[8]

Another example of a solid bypass strategy comes from Marvin and Helene Gralnick. In 1983, they founded a small specialty women's clothing store— Chico's FAS, referred to in the trade as the "Un-Gap"—on a shoestring budget and a great strategy. The Gralnicks avoided Gap-filled regional malls, where there was too much price competition and the stores were too conventional. Instead, they opened stores in suburban and resort shopping centers, where people were more relaxed about prices. How are they doing? Today, Chico's FAS has 124 stores and sales revenues have reached $60 million.[9]

John Kluge, the owner of Metromedia Co., provides another example. He is known for purchasing declining businesses, turning them around and then selling them at their peak. His success appears to come from his boldness and decisiveness—two very important attributes of a leader. Metromedia is now the fifth-largest long-distance carrier in America, with $400 million in annual revenues.[10] However, it has a long way to go before overtaking No. 3 Sprint, which has annual long-distance revenues of $5.7 billion.

Kluge's announced strategy, an apparent violation of Rule 6 (Surprise), is to bypass the residential long-distance market and the big business market. Instead, he will flank the leaders by offering cheaper long-distance service to small and mid-size businesses. By concentrating on these markets, he avoids the expense of consumer advertising that would push up rates in the increasingly commoditized residential market. In addition, he is avoiding a direct confrontation with the giants,

who compete for the Fortune 1000 business.

Apparently, Kluge recognizes the extent to which the leaders, for whatever reasons (ego or profit), will aggressively defend their territory. While it seems he is almost un-American in sitting out the head-to-head battle with AT&T and MCI, in reality, he is choosing the field of battle that best suits his strengths and minimizes his weaknesses.

Lull to Sleep

There are two ways to cook a frog. One method is to put the frog into the boiling water. However, frogs, like most animals (including man), would jump from the scalding cauldron. The second method, which illustrates the lull-to-sleep avoidance strategy, is to put the frog into a pot of room-temperature water and slowly turn up the heat. The change in temperature is so gradual that the frog is literally lulled to sleep and eventually boiled to death.

The key to success in this avoidance strategy is to have your plan executed and your objectives achieved before your competitors are aware of what has happened. This is accomplished by entering the market with no fanfare, no full-page newspaper or television advertisements, and no press releases heralding your offering. Again, egocentric leaders and most company executives usually are uncomfortable with such an approach.

Examples of the lull-to-sleep strategy include Ramen noodles, Aldi Stores and Citrus World. As noted previously, Ramen noodles quietly entered the U.S. dry soup market and initially captured almost 20 percent before the leaders responded. Could the leading U.S. soup manufacturers have forgotten or ignored Rule 5 (Know Who You Are Playing Against)? Were they surprised, or did they just ignore the attempts of the Japanese to enter their domain? Was it a lack of vigilance or the failure to post a lookout that caused the significant erosion of market share? Or did the success of the market leaders lead to the complacency that we

Choosing the field of battle

Aldi is employing a lull-to-sleep strategy

have warned all leaders to guard against?

Initially, Ramen noodles had little advertising and the lowest shelf space in the soup aisle. It provided little in the way of the trade support that Lipton, Campbell and Knorr give to the channel intermediaries. Nevertheless, it now enjoys almost 20 percent of the dry soup market. Does success leave clues? You bet!

The U.S. Aldi Stores are privately owned by Germany's $21 billion (estimated worldwide revenues) Aldi grocery chain, which accounts for 13 percent of all consumer food purchases in Germany. A 13 percent share of consumer food purchases by a single chain is unheard of in the United States. And, in fact, Aldi is a small player by anyone's standards in this country, with 1992 sales of $1.2 billion.

Although its position in Europe is indisputable, what's so great about Aldi in the United States? Aldi is employing a lull-to-sleep strategy. It engages in no advertising, not even in telephone directories. It does not build stores in costly shopping centers, preferring instead blue-collar, immigrant or low-income neighborhoods. Its stores are considerably smaller, with stock of only 600 items—when the acceptable minimum in most stores is more than 10,000 items.

Aldi limits staff and does not accept checks or coupons. Despite today's passion for customer service, an Aldi shopper could starve to death waiting for an employee to answer a question. And perhaps the unkindest cut of all is that it requires customers to bag their own groceries in bags brought from home.

How are they doing, you ask? Brothers Theo and Karl Albrecht are reluctant to discuss their strategy and tactics (Rule 6—Surprise). Why let competitors in on a good thing? Further, grocery store consultant Jerry Pinney describes Aldi as "a hidden giant." And the Albrechts would just as soon keep it hidden.

But how are they doing? Their net U.S. profit mar-

gins as a percent of sales are nearly double the grocery store industry average. Aldi's sales are estimated at $350 per square foot. This compares extremely well against the $275 per square foot posted by well-run, full-line grocers like Winn-Dixie.[11]

The Albrechts, who are worth around $5 billion, have gotten the attention of food manufacturers and marketers on both sides of the Atlantic. If you review the particulars of the Aldi brothers' strategy, you will notice that they appear to pay painstaking attention to the rules of strategy, while their U.S. counterparts seem to disregard these guidelines either selectively or totally. There should be no question as to why some in the American food trade have labeled Aldi "The Silent Killer."

When a little-known farmers' cooperative called Citrus World Inc. started to market its own brand of pasteurized orange juice, it looked like an improbable player in the $3 billion juice market. While the two giants—Seagram Co., owner of Tropicana, and Coca-Cola Co., with its Minute Maid line—fought each other, the executives at Citrus World's corrugated-metal-tacked-onto-drab-white-stone headquarters, quietly moved into the race. In the words of beverage industry consultant Tom Pirko, "It's a funny kind of horse race. Here's Tropicana's jockey looking over his shoulder, and Minute Maid is cracking the whip, and up on the outside comes this co-op." Citrus World spent just $12.5 million on ads in 1995, while Coke spent $100 million on Minute Maid. The results: Citrus World knocked Minute Maid out of the No. 2 spot in the rapidly growing market for "premium," or pasteurized, not-from-concentrate orange juice. Guess who is no longer "little-known"?[12]

Guerrilla

In guerrilla warfare, the leader of the defending organization often laments that the guerrillas won't "stand and fight." While some military strategists consider guerrillas to be cowardly barbarians,

"The silent killer"

Demoralize the competition

those who understand the rules of strategy recognize that if the underresourced guerrillas were to stand and fight, they would be destroyed by the organization possessing the superior resources.

In a marketing context, the guerrilla strategy is not intended to engage directly. Instead, the ultimate aim is to demoralize the competition. It is hoped that the demoralized victim of a guerrilla strategy eventually will decide that remaining in a particular market is not worth the costs. Usually, the market selected is not of primary importance to the leaders.

The American War for Independence was won not because the British were thrashed on the field of battle. Rather, the British leaders perceived that the resource drain associated with continuing the war until victory could be achieved was not worth the price.

But there is no doubt that the people to bring guerrilla strategy to the forefront were the Vietnamese. They won a war based almost exclusively on a guerrilla strategy. And they did it by following the rules.

First and foremost among the rules followed by the Vietnamese was understanding the environment. They understood the playing fields and their respective opponents (Rules 4 and 5). They spent as much time as any army on painstaking intelligence. They didn't have satellites or spy planes, but they did have intelligence. They also had surprise (Rule 6). Key to success in the guerrilla strategy is to always begin with a surprise.

Now, it may surprise you that the Vietnamese always followed Rule 10 (Advance and Secure), or at least the first part of Rule 10. The Vietnamese always took the offense first. They started every battle. They had to. It was clear that in a "fair fight," they would lose. Tanks beat rifles every day. So they had to pick a battle they could be assured of winning. The same goes for marketers: You pick the time and place of the battle; take the offense.

But one variation of the guerrilla strategy is that it suggests a violation of the second part of Rule 10. It suggests that you shouldn't secure. In fact, what makes this strategy so different from others is that once the enemy regroups from your surprise and initiates a counteroffensive, you retreat. Never (note: never) stand and fight. Take your gains, take your short-term successes, retreat and look for the next place to fight. It's hard for most of us to do this, because we want to stand and crow after our victories. A non-guerrilla fighter, after taking a few market share points from the competition, needs to follow Rule 10 and secure its position. However, the guerrilla fighter never secures.

One factor critical to success with a guerrilla strategy is the competition's lack of respect for you. The American military establishment didn't think an army that walked on old tires for sandals and ate only rice would be a formidable foe. The United States had no respect for the Vietnamese army. This was something that became a significant weakness and made the guerrilla strategy viable.

We can tell you that when Nissin introduced Ramen noodles—those "cheap" dry soups, displayed in heaps on the bottom of supermarket shelves—Campbell's executives ridiculed the product and demonstrated little respect for Nissin. Look at what Campbell's sells today!

A recent example of guerrilla marketing comes from an industry not always perceived as market-oriented: banking. Retail bankers tend to be more risk-reduction-focused than market- or customer-focused. Consider the 1992 merger of BankAmerica (BofA) and Security Pacific. Analysts predicted that this new $187 billion giant would crush the competition.

When BofA announced the closing of 450 branches (a violation of Rule 6—Surprise), the smaller banks saw a once-in-a-lifetime opportunity. BofA announced what it was and was not going to defend, and the guerrilla bankers developed a strategy to

Initiated against a competitor's fringe

capture customers who were finding banking with BofA a lot less convenient. Dennis A. Shirley, marketing director for First Interstate Bank of California, actually said, "We're using tactics that border on guerrilla marketing."[13]

Tactics ranged from billboard ads that screamed, "Lost your sense of Security?" to setting up card tables on the sidewalk across the street from BofA branches that were closing to sign up new customers. Marketers also promoted free checking accounts for senior citizens, since BofA dropped a similar program. These tactics had a profound impact. Bank of Fresno's deposits increased 19 percent and Redlands Federal's deposits grew 12 percent since they launched their respective guerrilla strategies.

This strategy works best when initiated against a competitor's fringe, rather than its core businesses. In other words, attacks in remote corners of an adversary's market will not be as strongly defended as an assault on a major market area.

Additional examples of a little guy that has been harassing the big guys come from Drypers, the diaper company. Remember how it tortured P&G and Kimberly-Clark (KC) by addressing the retailers' need for a perceived loss leader (value to the customer) that didn't actually lose money (see Chapter 8). It has continued its guerrilla attacks against the two leaders, who together control more than two-thirds of the $3.6 billion domestic diaper industry.

While other small companies—including Carolina Royal Disposables and Pope & Talbot—went under or were bought out, Drypers survives. How? By continuing to attack the leaders with small technological innovations that really mean something to parents. It began with putting space for labels on diaper packages so parents could mark them with their babies' names. Then came Drypers' "perfume-free" diaper, which convinced lots of moms that little Billy's bottom deserved better (although perfumes used to cover the smell of glue

are perfectly safe). Now Drypers is back with a new, premium diaper that contains baking soda to stop those nasty odors. We bet P&G and KC wish they could dispose of this strategy-fouling upstart.[14]

Another very effective use of guerrilla strategy was by a small dog food company. It couldn't afford to go head-to-head against the leader, Purina, since it was only a tenth of that company's size. But it was satisfied with a 3 percent market share, year in and year out. So the small dog food company decided to use a guerrilla strategy. It found markets that had a fair amount of regular marketing activity—e.g., coupons and advertising—just enough for each competitor to hold its existing share.

The guerrilla strategy was to increase the marketing support in only one major city. It would spend more on advertising and trade promotions in a very concentrated fashion (Rule 8). The result was that, for a short period of time, its sales would increase. Let's say, for the sake of discussion, that the company actually increased sales by 33 percent—from a 3 percent share to a 4 percent share. Not bad. But how much did the leader's share decline, assuming all the gains came from the leader? Maybe only one share point was surrendered out of 65 percent. Keep in mind, this loss was limited to one market. Do you think the executives at Purina came out of their seats when this happened? Most likely no, and they probably attributed this small market share loss to normal market fluctuations. Now, each month, the guerrilla company was making 33 percent gains, while the leader was losing less than 2 percent of its base market share.

Soon, the leader discovered that it had been systematically losing a share point each month. No doubt the poor regional manager who had been crying about the new offensive was finally heard by the powers that be. A Purina response was launched to put the upstart back in its place. And that's exactly how the upstart behaved. It stopped all the marketing, fell back in line and accepted a

Diversionary strategies are simply decoy thrusts

3 percent share of the market—in that city. But the entire process began anew in another city, in another region, at another time.

Diversionary

Diversionary strategies are simply decoy thrusts designed to get the competition to defend somewhere other than where you are really planning to launch an attack—or to divert the competition from assaulting your core market.

In World War II, the Germans failed to meet the Normandy invasion with full force. The Germans were led to believe that General Patton was going to strike farther north. Similarly, most strike forces of any kind—land, sea or air—normally deploy decoy tanks, ships or airplanes in advance of the primary assault group.

While Rule 5 (Know Who You Are Playing Against) is important in all of the avoidance strategies, it is particularly critical to the success or failure of a diversionary strategy. This strategy requires that you have intimate knowledge of the strength and weaknesses of your competitors. More importantly, you must be able to predict the nature and degree of the competition's response to your foray into its markets.

Sometimes, to win wars, you have to avoid battles or retreat and regroup. A number of different lesser known and used avoidance strategies were introduced in this chapter. The next chapter is devoted to the most popular of all avoidance strategies: niche strategies.

Chapter 18 Clues

- Remember the goal is to win wars, not just battles.

- Know when to withdraw to fight another day.

- Don't let your ego get in the way of your strategy.

- Don't stand and fight someone capable of destroying you.

Chapter 19:

AVOIDANCE STRATEGIES,

PART TWO—NICHE

STRATEGIES

The previous chapter discussed marketing strategies that let you take on the big guys by avoiding the fight. That makes great sense, because you usually can't win by going head-to-head with them.

However, many of these avoidance strategies are passive, as in a "take what you can get" strategy or a "lay low and wait" strategy. These tried-and-true strategies can be very effective when used in the right situation. But avoiding a fight can have an aggressive aspect, as well.

A niche strategy is the most aggressive of the avoidance strategies. It requires that you find a very specific "segment," or niche, in the mass market that is not being served—or served well—by the "shotgun" marketer, then do a better job of addressing the needs of that niche.

You may have already heard of niche strategies by other names, such as micromarketing, micromerchandising, regional marketing or precision target marketing. Regardless of the name applied, this is a strategy of winning the marketing war by serving the customer better than anyone else and, in so doing, avoiding a face-to-face confrontation with heavily resourced giants.

A subset of the market

Niche Marketing Is Not About Being Small

Some who hear about niche marketing as a strategy rule it out because they don't want to be small. However, we know of companies that employed niche strategies with both large and small potential markets.

The issue with niche marketing is finding a group of consumers who are being asked to compromise because the mass-marketed product is geared toward the *average* customer.

The objective of the niche marketer is to find a group of customers and not simply satisfy them, but delight them. This means providing products and services that precisely meet their needs. The point is to recognize that there are no longer markets for products and services that everyone likes a little—only products and services that some people like a lot.

You may say, "Wait a minute! This is what all marketing is about—delighting customers." True, but logic dictates that when a marketer serves a heterogeneous group, some members are going to be less satisfied than others. The niche marketer tries to identify group members with homogeneous needs, so that when he or she determines how to delight just one, he delights them all. The marketer must be satisfied with providing the product to a subset of the market—but sometimes that subgroup can be quite large.

A look at the hotel industry provides us with an example of large subgroups. Here is an industry that, for a long time, didn't really consider customers' needs. Like many other retailers, hoteliers believed that market share could be increased by either spending more on advertising or by finding a better location. Of course, you know what happened to profits in order to get the extra share points—they went down. Advertising is expensive, and "better" locations obviously are more expensive than "average" locations.

Marriott, however, would not accept the paradigm

that share growth necessarily meant lower profit. It would not accept the hotel paradigm that growth could be achieved only by convincing people to compromise what they want in a hotel. Marriott changed the industry by picking off the niches in the market—and it picked big niches.

Marriott looked at who was not being best served by the traditional mass-market-oriented hotels. One unsatisfied group consisted of guests who stay in the hotel for extended periods of time. These guests want a more home-like environment, with a separate living room, dining room, kitchen and bedroom. Therefore, Marriott created Residence Inns. Also, there are guests who use their hotel rooms as their mobile offices to conduct business, so Marriott introduced Marriott Suites. On the other hand, the overnight business traveler does not need a townhouse or professional office setting. Instead, he wants a clean uncluttered room with an informal restaurant on-site (or good room service). A lounge singer is not necessary. So Courtyard by Marriott became the new offering. Fairfield Inn by Marriott was just the ticket for the family vacationer or the per diem business traveler who desires an inexpensive, clean overnight room with few amenities. Meanwhile, Marriott Hotels was repositioned to serve the downtown business traveler who wants to be near his or her appointment or the conventioneer who needs meeting room space or catering services. Each hotel targets a specific market. Each hotel has a very specific customer in mind.

Apparently, Marriott is not finished focusing on specific segments. In 1996, it announced it was planning to build 150 economy-priced hotels focusing on the growing—but still underserved—extended-stay market. This as-yet-unnamed budget version of a Residence Inn appears to be targeted to people who are temporarily displaced from their home environments and do not enjoy the benefits of corporate lodging reimbursement.[1]

Who is the nation's biggest rental car company? That's easy, right? Hertz.

Create and own a market

Wrong. The biggest of all is Enterprise Rent-a-Car. Barely heard of it? It's okay; most frequent flyers have never come near an Enterprise office. And that's just fine with Enterprise. While Hertz, Avis and lots of others were cutting one another's throats to win a point or two of the "suits and shorts" market from business and vacation travelers at airports, Enterprise invaded the hinterlands with a completely different strategy. Enterprise located its operations in local neighborhoods, within 15 minutes of most people in America. Its approach is astoundingly simple: It aims to provide a spare family car if your car has been hit, or has broken down, or is in for routine maintenance.

How has Enterprise done by attempting to create and own a market, rather than seeking a share in a larger, competitor-filled environment? Profits have increased 25 percent to 30 percent each year for the past 11 years. Perhaps the best testimonial to Enterprise's niche strategy comes from Frank Olson, the fiercely competitive Hertz CEO, who concedes he "missed a big opportunity" by letting Enterprise run away with the "replacement" business.[2]

Want another example? How about American Express? While the green card is its major source of business, it added a gold card, platinum card, Optima card, corporate card and purchasing agent card. Each card was targeted to a niche with very specific needs in mind, which were different from all the others.

No Average Customer

If you are to employ a niche strategy, one of the first facts you must accept is that there is no such thing as a typical or average customer. You must reverse the traditional segmentation process of breaking down the whole or mass market into smaller segments. Instead, concentrate on building up your niche by satisfying one customer at a time.

A niche marketer will go to the market and find

one customer who is not being satisfied by the traditional offerings or one customer who could be better satisfied. Then, the niche marketer creates a product that uniquely satisfies this one customer. Finally, the marketer determines whether there are enough people with similar unsatisfied needs to make it profitable to market the product.

Who would pay $3,500 for a refrigerator? Enough people to make Sub-Zero's Jim Bakke exceedingly prosperous. Bakke calls his product "refrigeration furniture." Normal refrigerators stick out and are ugly. Sub-Zero developed the concept of built-in refrigerators to cash in on the growing market for classy custom kitchens. It is a market that Sub-Zero dominates, with a hammerlock 70 percent share—much to the dismay of General Electric and Whirlpool, both of which have been trying for years to crack the high-end market. While it makes up only 1 percent to 2 percent of the 8.5-million-unit refrigeration market, Sub-Zero generates about $135 million in sales. That's a lot of cold cash for something little more than a steel and plastic box that blows cooled air around.[3]

Consider the case of Konica photographic film, which we previously discussed. Konica would have had a hard time going head-to-head against the Kodaks or Fujis of the world. Let's face it: When it comes to film, Kodak is Goliath. So Konica searched for a customer who was not being totally satisfied by the giant's film. In the process, Konica found that many people who take pictures are very infrequent users of cameras and know little about what type of film to use. It also found out that many of these same people take pictures of their babies. So Konica developed "Baby Film," specifically designed for indoor photography of babies. If you were an infrequent photographer and knew nothing about film speed or other characteristics, a film called "Baby Film" would cry out to you from the shelf. It was exactly what you were looking for.

Of course, Kodak and Fuji sell many times more film than Konica, and the big companies would say that Konica's Baby Film has only a small share

"Refrigeration furniture"

Kodak isn't crying too much

of the market. This is no doubt true. But the niche strategy was not a strategy to take over the No. 1 position in the photographic film market. Rather, it was a way to enter the market, sell film and make profits without going head-to-head with the giants. The objective was a profitable market entry without the potential of death.

Could Kodak go after the baby film market and take it from the niche marketer? Sure, but how would the new film fit within the total marketing philosophy of Kodak? It would be difficult for that company to create a "me too" product and keep the integrity of the remainder of its line. Congratulations, Konica.

Guess what? Kodak isn't crying too much about this missed niche, because it came out with its own niche product that fit within its existing marketing philosophy. Kodak has found that some amateur photographers are very serious about photography, yet they cannot really afford the super-high-quality, high-cost film that professionals use. So Kodak introduced the "Gold Line" for the serious amateur who knows what to ask for.

What's common to the two film examples? A very specific customer was targeted and apparently satisfied, thereby making it difficult for the competition to enter these small but profitable market segments.

Sustainable Longer

While we know that no strategy is attack-proof, the advantage obtained by a good niche strategy is sustainable longer than many of the other strategies. By finding a market that is small enough to have common (uncompromised) needs, it becomes less attractive for the competition to attack.

Remember the Lipton example of encirclement of the dry soup market. One of the advantages of the small markets for alternative dry soup products was that there wasn't enough room in each of the markets for two players, and the defender had the advantage. Even if the attacker did win the battle

for one of the niche markets, it would be spending significantly more than the defender to get share in a small market. In general, the big guys have better, more productive uses for their funds than going after niche markets that are already occupied.

Another reason the niche position is sustainable longer is that the mass marketers often must change their entire strategy to compete with a niche player. Mass marketers are telling everyone this product is for him or her. As soon as they start saying "except for this group," the overall strategy is weakened.

In addition, many mass marketers are slow to change their attitudes toward the value of the "mass." They look at the strategy of Konica, which appears to be satisfied with a small piece of the total market, and they scoff. Why settle for a piece of the pie when you can have it all?

Of course, as you know, the mass marketers usually don't "have it all," and their quest for greater shares of the mass market provide great advantage to the niche marketer. Eventually, these people come around and recognize their folly. More and more mass marketers are realizing that it is niche or be niched. But it is a slow learning process, and nobody said that mass marketers were very smart.

Incremental Sales, Not Cannibalism

Another advantage of the niche marketing strategy is that it enables the marketer to have a better defense in each of the niches, rather than one single defense for the entire market. It is less susceptible to attack.

Look at Gerber baby food. It found that mothers like to use the same brand of baby food they started with. Gerber also discovered that babies just starting on baby food do not eat a full jar. The niche product, Gerber's First Foods, was developed for the infant just starting solid foods. It was baby food in smaller jars. What a great niche product—

America West went after an uncontested market

not really large enough for a competitor to attack as a major product category. But the nicher not only gets the incremental sales (because First Foods meets the needs of the baby), it also starts the mothers on the Gerber line. Niche marketing at its best!

How Different Are the Niche Products?

One of the key issues in niche marketing is the cost of creating a product for each market. Twenty years ago, niche marketing might not have been possible, but with today's technology, one can produce greater variety at lower costs. Flexible production now makes it possible to achieve lower costs than previously possible while manufacturing a variety of products.

America West took advantage of the difficulty other major airlines would have in rearranging their schedules to defend an attack on different takeoff and landing times. America West went after an uncontested market, the late-night flyer. While other airlines have gone to sleep for the evening, America West is starting its busiest time of day. It has created a niche by going after price-conscious vacationers who don't mind late flights, or business people who need to get there, even though the pilots of the major airlines would rather sleep.

Talk about successfully avoiding the competition: Only 23 percent of America West's schedule competes with low-cost rival Southwest, and only 5 percent competes head-to-head with Shuttle by United. As CEO William Franke said, "We have proven we have a niche. The issue is our ability to grow the niche."[4]

Obviously, operations people are never very happy about serving marketers' needs for varied products. The mark of a good operations engineer is low unit costs. Many of the best operations people in companies became vice presidents because they ran a "tight" factory and kept costs down. However, regardless of the internal pressure to make standardized products, it is now possible to change

over factories to new products faster—and therefore cheaper—than ever.

For example, it used to take Toyota *eight hours* to change over the bolt maker in the factory. Today, Toyota has the bolt maker changeover time down to one minute (no mistake: one minute). Likewise, Mitsubishi Heavy Industries reduced the changeover time on its eight-arbor boring machine from 24 hours to three minutes.[5]

What was once an impossible operation is now possible.

In fact, niche strategies often do not require major product changes, only small product changes. And, in some cases, no physical product changes are required. Simply repositioning is enough.

Another example is the over-the-counter drug maker Bayer. It came out with a variety of aspirin products designed for specific problems—backache, headache, PMS, etc. Picture the shopper who enters the drugstore with a terrible backache. He scans the shelf for some pain reliever and sees regular aspirin and Bayer Select for backaches. Which do you think will be more attractive to him? Usually, whenever you solve a specific problem rather than a general problem, you're ahead.

How different are the various formulations of Bayer Select? We are not qualified to interpret the back of the box. However, from a production point of view, there is not much difference at all. In some cases, it is a different dosage of the same medicine; in others, there are additional medicines. But the changes from a production point of view are small.

The real key to niche marketing success is this: If the consumer with a backache believes that Bayer Select for backaches is better for his pain, he will pay more for the product. People will pay more for products that do a better job of meeting their needs. Plain and simple!

Look at what Du Pont did with Kevlar, a very strong fiber with a variety of applications—from bridge

Solve a specific problem

The market continued to grow dramatically

cables to bulletproof jackets. Rather than sell the general product characteristics, Du Pont developed specific promotional pieces for each of its potential uses and discussed how the product fits those specific needs. It doesn't matter how small the market, Du Pont needs only to determine how the existing product satisfies these needs and create a sales presentation for that specific use. (This is where desktop publishing has changed the promotional opportunities for companies, as well— often allowing them to cost-effectively customize promotional materials for a single client.)

Small But Growing

Another advantage of niche strategies is that, occasionally, a small market will grow and become a significant market in and of itself. What a great position to be in! You establish a relationship with customers by doing a better job of serving their needs than anyone else, and more and more people fall into your niche.

Look at P&G's Pampers. When the product was planned, it was targeted to the market of people who were traveling or not in a position to wash dirty cloth diapers immediately. Originally, because most people with young babies stayed at home, this was something of a niche strategy. But the world changed. People are on the go more and more, and the occasion for Pampers' use has increased. Furthermore, the advantage of disposability, even at home, was recognized, and the size of the market continued to grow dramatically. Who was in the driver's seat from day one? Who was the market leader from the day the category was first measured? Right, P&G!

The same is true for a host of products, especially kids' products. How much money have toothpaste companies made on toothpaste for kids? Here was a classic niche situation. The mass-marketed product had to satisfy everybody—dads, moms, kids, grandparents, etc. But one group—kids—didn't like the mint flavor. When was the last time you

heard a kid ask for mint? Kids chew bubble gum; they don't eat after-dinner mints. So, make bubble gum-flavored toothpaste for kids. Initially, this was a small market. However, not only did the kids' toothpaste market grow, but so did the market for kids' mouthwash, toothbrushes and even dental floss. What started out small became big.

Sometimes growth comes from unexpected places. Look at Carnation's Coffeemate. Carnation made its product more attractive by adding flavors, such as hazelnut. If Carnation had captured extra sales from people who wanted some flavor in their coffee, it would have had a good niche product. In fact, many of the people who wanted some flavor wanted a variety of flavors. Instead of one container of Coffeemate on the shelf, they bought three or four containers.

Some would say this growth in sales was just a "one-time boom" or a boom until the inventories were filled, resulting in the same replacement rate. Perhaps this is true, but how many companies would scoff at a one-time boom?

The Key to Niche Strategies

Read through the above examples again. You'll see one theme over and over: Niche marketers understand customers. They have to be close to the customers and know their concerns and needs. They must know that their needs are not being fulfilled.

In virtually every case, a customer experience led to the niche strategy. In the case of Gerber First Foods, it was the 800 customer hotline. It picked up on the fact that mothers were calling to ask if they needed to refrigerate the opened but uneaten portions of baby food, and how long they could be safely stored. Responding to customers' needs led to the successful new product.

In the John Grisham bestseller *The Firm*, evil lawyers realize that the hero is spying on them because he uses an office photocopier excessively. In real life, though, many corporations have little idea how much their employees use company copy

A well-organized, complete database

machines. Such ignorance spells opportunity for Equitrac Corp., a niche company that focuses on "cost recovery." In America's accelerated drive to slash costs, Equitrac helps clients use photocopiers and other office equipment more efficiently. By focusing on solving a problem in an area so narrow that a big company has given little thought to it, the savings to the client and the rewards to Equitrac are surprisingly large. For the fiscal year ending February 28, 1992, Equitrac's reported revenues were $27.5 million, up 16 percent from the previous year.[6]

Another example of using a niche strategy is Largo stores. Jewel T stores of Chicago discovered that many of the people who returned after wintering in Florida complained that they had not been able to get typical Midwestern foods in the Florida supermarkets. So Largo was created—a supermarket in Florida that specialized in products that were popular in Chicago. Listening to what makes your customers unhappy can lead to great niche possibilities.

Get the Information You Need

If you intend to use niche marketing as an avoidance strategy, be sure to have all the information you need before you start formulating the strategy. One striking factor about niche marketing is that it requires significantly more data on markets and products.

As one executive said, "We realized that once we got into niche marketing, we didn't have as much information as we needed. The more information we had, the better we could target market to customers."[7]

We know that every marketer cries that he or she doesn't have enough information, but the niche marketer is totally lost without a well-organized, complete database. If you are even thinking about using niche strategies, start building your database immediately.

One final thought on the need to have an action-

able database to be an effective niche marketer was best stated by Vince Gennaro of PepsiCo. He said, "There is now significant room for a forward-thinking company to gain a competitive edge by making a commitment to information systems."[8]

Before You Begin

"Niche marketing is totally different from mass marketing. If you try to approach niche marketing from a mass marketing point of view, you are going to fail," according to one executive.[9]

Begin by wiping out the concept of an average customer. Think about the market in terms of individuals with unmet needs whom you intend to delight. If you talk about the average customer in your meetings, you might not be ready for niche strategies.

Think profits. Niche marketing often costs more—but, generally, it reaps bigger profits. A study of profitability by market size conducted by PIMS (Profit Impact of Marketing Strategy) reported that the average return on investment from markets with more than 1 billion members was 11 percent, while the average ROI in markets of under 300 million was 27 percent.[10]

Why is this so? Because even though you might spend a little more to create a niche product to delight a smaller group of customers, they probably will be willing to pay more for it. No one in his or her right mind would pay more for a product that is exactly like a cheaper one. However, almost every person will pay marginally more for a product that delights him or her. Look to spend more and make more.

A Passing Parade

Niche marketing might sound pretty good as a way to win the marketing wars against the big guys. But keep in mind that it's a passing parade. Just when you think you have the market figured out, it changes. You can be standing on the street at

Willing to pay more for it

There are no average customers

exactly the best spot there is to watch the parade. But it is also the spot where you can't see anything once the parade passes you by. Niche marketers must keep moving with the parade or be left at the curbside.

Those of you who want to start with niche strategies may want to check out a book written exclusively on the subject of niche marketing: *Making Niche Marketing Work*, published by McGraw-Hill and written by Robert Linneman and our own John Stanton.

Chapter 19 Clues

* Think focused, not small.

* Find out what really delights your target market ... and give them what will delight them.

* Remember, there are no average customers.

* Remember, there are no longer markets for goods, services and ideas that everyone likes a little. There are only markets for goods, services and ideas that some people like a lot.

Chapter 20:

IF NOT OUR RULES, WHAT RULES?

Our objective in writing this book was to help the reader become a better strategic marketer, not simply a better-educated marketer. To help you reach this easy-to-say, not-quite-so-easy-to-achieve objective, the text focused on three components that are critical to generating successful clues.

First, we reviewed the concepts and philosophies governing marketing, marketing strategy, and the evolution of marketing and strategy, and we positioned (differentiated) our approach to marketing strategy.

Second, we presented our strategic philosophies, heuristics and rules designed to enhance your strategic decision-making.

Finally, we outlined a variety of marketing strategies based on our rules and an assessment of the prevailing market conditions. In applying each of the strategies, we highlighted key rules that must be adhered to and introduced examples of organizations that have succeeded—and some that have failed—in following the rules or adopting a particular strategy.

Our Approach to Marketing Strategy

Simply stated, marketing strategy is the process of employing your organization's strengths relative to the selected playing field and competing players to solve the target market's problems better than anyone else.

Not even running in the same race

To implement this process successfully, we discussed several inviolate (i.e., ignore or violate at your own risk) rules that marketing strategists must follow. Many of these rules represent clues that military generals have adhered to for centuries. Other rules have been garnered by observing successful corporate generals. Still others reflect the findings of our research and consultancies.

Knowing the rules is necessary—but not sufficient—in order to realize strategic marketing success. Not only must you know and follow the rules presented, you must understand the strategic philosophies (attack, defend or avoid) available to organizations. In addition, you must understand the particular options available once you have selected a philosophy.

Marketing is a race without a finish line. You don't win in marketing; you just keep from falling behind. Winning would suggest that the contest is over. In marketing strategy, the goal is to lead where we think it counts most—namely, in the minds of your customers as reflected by profitable business. However, leading does not necessarily mean that you must have the dominant market share. In fact, sometimes you can lead the profit race by being second or third in market share—and sometimes you can lead by not even running in the same race as the so-called leaders.

Even with the approach we have recommended in this book, marketing strategy is still extremely difficult to develop and execute. Each of the rules and strategies requires careful analysis and research to ascertain if it fits your organization and its environment. However, the good news is that once you understand and develop your strategy, its value to you in decision-making is priceless. Your marketing strategy is what gives you license to make any and all marketing decisions.

Every time you make a tactical decision, every time you consider a new opportunity, ask yourself this question: Is the anticipated action on strategy? If the answer is *yes*, then proceed. However, if the

response is *no*, you have two simple options: One, don't do it. Two, change your strategy. It is economic suicide to take action that is counter to your strategy.

Decisions to pursue new markets, take advantage of opportunities or change tactics—such as price decreases or advertising increases—are simplified because you have a barometer against which you can measure the strategic appropriateness of your actions. No longer will you be affected by the "ad hocracy" malaise, in which every decision of every day is judged on its own merits, without regard to its strategic consequences.

Remember, strategy ends at corporate headquarters and tactics begin at the customer's door. Our foot soldiers (sales and service representatives) will win the war for us if we have a plan that makes the war winnable, a plan that follows the rules.

Our Strategic Philosophies, Heuristics and Rules

Recall that the particular strategy selected by an organization reflects the organization's philosophical orientation. If the prevailing philosophy of the organization is offensive, then the thrust will be to attack the competition. If, however, the organization's governing philosophy is defensive, then the objective will be to stop the attack. Finally, some organizations prefer neither to attack nor defend. Instead, they wish to avoid any direct engagement. Not surprisingly, we have labeled this philosophy avoidance.

Regardless of the philosophy governing your competitive entry into the marketplace, we did recommend a few very basic rules of thumb. Since these heuristics appear to be so simple and straightforward, they are not given the attention accorded the rules of strategy. However, even these seemingly intuitive, very broad guidelines are frequently ignored—often with catastrophic consequences. Remember this trio:

Intimately know the customer

- Big fish eat little fish.

- More people are better than better people.

- Better resources and strategy will beat better products.

The balance of this section introduced and developed the 10 rules of strategy. The rules are briefly restated as follows:

1) **Be a Leader**. Without a leader (a preacher of vision and a lover of change) your chances of achieving strategic success are severely reduced. This is the most important rule.

2) **Know What Is Under Your Umbrella**. Find out what problems the marketplace gives you permission to solve. Critically assess your company's strengths and weaknesses, noting potential opportunities and threats. Don't be a cheerleader in this exercise. Be an untiring, unwavering pathologist.

3) **Get and Stay Close to the Customer**. One could argue that this rule, not Be a Leader, should be first in importance. If you don't intimately know the customer, which of his or her problems need solutions and how you are perceived by the market, then your chances of strategic success are *zero*. Look, listen and learn.

4) **Know Your Playing Field**. Constantly scan the environment (social, cultural, economic, legal, technological and political). Knowledge of the playing field exposes opportunities and uncovers potential land mines.

5) **Know Who You Are Playing Against**. Know in detail everything possible about each of your competitors—strengths, weaknesses, orientation toward competing, tendencies, etc. Don't be out-intelligenced.

6) **Surprise**. Surprise is the flip side of what you know about your competitors. It is what they don't know about you. Surprise is not just se-

crecy; it is doing the unexpected.

7) **Focus, Focus, Focus**. Another way of expressing this rule is: Maintain your objective. Don't lose sight of your vision, strategy and what problems you solve for the market.

8) **Concentrate Your Resources**. It's not total resources that count. Rather, it is the resources you employ at the point of attack. Also, you should concentrate your strengths against your competitors' weaknesses.

9) **Be Mobile**. In short, this rule is about change. Not only must you realize the need to change, but you must be able to change. The premise underlying this rule is that it is hard to hit a moving target.

10) **Advance and Secure**. Regardless of your strategic philosophy, to take or maintain the lead in anything, you have to move forward at some point. Even the leader who chooses a defensive strategic alternative recognizes that defending works very well in the short run. Eventually, everyone will catch up to or surround you. At some point, you need to move forward and change; however, this corollary also reminds us of the need to have a safe haven, in the event that you stumble or fall.

If you want to be a good marketer, understand the rules. If you want to be a better marketer, follow the rules.

If Not Our Rules, What Rules?

Throughout the text, we have presented and reinforced our rules of strategy. Often, the reinforcement took the form of the clues at the end of each chapter. We recommend that you return to these clues on a regular basis and attempt to implement each over a particular time period. Challenge the clues. Add your own clues.

As for the rules, make sure you use some rational basis for making critical strategic decisions. Perhaps you disagree with some or all of the rules we

Thou shalt or thou shalt not

have included. That's okay. Find some rules that you think will work better for you than our rules. What is not okay is to ignore the rules. What is unacceptable is to proclaim that marketing strategy is art in its purest form and therefore devoid of rules. Don't mistake the creativity of the output with the organization of the process. Abstract artists and symphony composers still have rules.

Coaches and managers of teams—from Little League to the professional leagues—follow rules. Military leaders religiously post the order of battle. And, speaking of religion, can you name an organized religion that does not have its own set of rules? Think of the greatest rules of them all: the Ten Commandments.

Your rules don't have to be prefaced by *thou shalt* or *shalt not* something. But the effect must be the same. You must have a standard of excellence to assist you in your decision-making and to help you assess the merits of your decisions.

Worksheet 12 is basically a blank sheet of paper for you to craft your own rules. Incorporate some or all of ours, borrow from others as necessary, and add your own. But have a set of rules!

Remember that professionals, on occasion, may choose to violate the rules, while amateurs simply don't know or ignore the rules. Be the consummate professional. Post your rules for all to see and learn from. You'll soon discover that success does, in fact, leave clues. And soon, we will be citing you and your organization—and the clues you've left to your success. Good luck!

Chapter 20 Clues

* Have a set of rules you understand.

* Have a set of rules you believe in.

* Follow them.

ENDNOTES

Chapter 1

1. Scott McCartney, "Competitors Quake as Southwest Air Is Set to Invade Northeast," *Wall Street Journal*, October 23, 1996, pp. A1, A15.

Chapter 2

1. Tom Peters, *Speed Is Life, Get Fast or Go Broke*, video, 1992.

2. "How to Listen to Customers," *Fortune*, January 11, 1993, p. 77.

3. George Stalk Jr., David K. Pecaut and Benjamin Burnett, "Breaking Compromises, Breakaway Growth," *Harvard Business Review*, September/October 1996, pp. 131-139.

4. Fergal Quinn, *Crowning the Customer* (Dublin: The O'Brien Press, 1990), p. 70.

5. "National Business Hall of Fame: Sam Curtis Johnson," *Forbes*, April 5, 1993, p. 110.

6. Robert Linneman and John Stanton, *Making Niche Marketing Work* (New York: McGraw-Hill, 1992), p. 29.

7. Laura Bird, "Beyond Mail Order: Catalogs Now Sell Image, Advice," *Wall Street Journal*, July 29, 1997, p. B1.

8. Kathleen Kerwin, "GM Warms Up the Branding Iron," *Business Week*, September 23, 1996, pp. 153-154.

Chapter 3

1. Kenichi Ohmae, *The Mind of the Strategist* (London: Penguin Books, 1982), p. 92.

2. Gene Walden and Edmund O. Lawler, *Marketing Masters* (New York: Harper Business, 1993), p. 128.

Chapter 4

1. B.H. Liddell Hart, *Strategy* (New York: Prager Publishers, 1967), p. 337.

2. "The Big Squeeze," *Snack World*, June 1993, p. 62.

3. Peter F. Drucker, "The New Game," *Bottom Line Personal*, March 30, 1993, p. 7.

4. Geraldine Williams, "High Performance Marketing: An Interview with Phil Knight," *Harvard Business Review*, July/August 1992, p. 27.

5. Geoffrey Smith, "Reebok Is Tripping Over Its Own Laces," *Business Week*, February 26, 1996, pp. 62-66.

6. Gretchen Morgensen, "Denial in Battle Creek," *Forbes*, October 7, 1996, pp. 44-46.

7. Linda Grant, "Where Did Snap, Crackle and Pop Go?" *Fortune*, August 4, 1997, pp. 223-226.

8. Martin Friedman, "The Day the Last National Brand Died," *New Product News*, January 8, 1994, pp. 12-13.

9. Susan Pulliam, "Retailers Find New York Opening's Flash Often Followed by Stock-Price Crash," *Wall Street Journal*, January 25, 1996, p. C1.

Chapter 5

1. Carl Von Clausewitz, *On War* (Princeton: Princeton University Press, 1976).

2. Al Reis and Jack Trout, *Marketing Warfare* (New York: McGraw-Hill, 1986).

3. Gerald A. Michaelson, *Winning the Marketing War* (Lanham, Md.: Abt Books, 1987), p. XV.

Chapter 6

1. T.R. Phillips, *Roots of Strategy* (Harrisburg, Pa.: Stackpole Books, 1985), pp. 401-442.

2. Sun Tzu, *The Art of War* (New York: Oxford Unversity Press, 1963).

3. "Mary Kay's Lesson in Leadership," *Fortune*, September 20, 1993, pp. 68-77.

4. Larry Donnithorne, *The West Way of Leadership: Honor Is the Language We Speak* (New York: Currency/Doubleday, 1993).

5. "All Eyes on Gerstner to Cure Ills," *USA Today*, March 29, 1993, p. B1.

6. Alex Taylor III, "The Man Who Put Honda Back on Track," *Fortune*, September 9, 1996, pp. 92-100.

7. Donnithorne, op. cit.

8. "How to Murder the Competition," *Fortune*, February 22, 1993, p. 87.

9. "Be Bold or Fail," *USA Today*, September 7, 1992, p. 10B.

10. Kenneth Labich, *Fortune*, July 22, 1996, pp. 80-88.

11. "Crises Require Bold Action," *USA Today*, November 7, 1992, p. 9B.

12. Linda Grant, *Fortune*, June 24, 1996, pp. 24-25.

13. Dana Wechsler Linden, *Forbes*, August 28, 1996, pp. 44-46.

14. Douglass Lavin, "Robert Eaton Thinks 'Vision' Is Overrated," *Wall Street Journal*, October 4, 1993, p. 1.

15. *Business Week*, September 30, 1996, pp. 119-125.

16. Tom Peters, *Thriving On Chaos* (London: Pan Books, 1987), p. 70.

17. Carol Hymowitz and Gabriella Stern, "Taking Flak," *Wall Street Journal*, May 10, 1993, p. 1.

18. Bruce Posner, "Targeting the Giant," *Inc.*, October 1993, pp. 92-94.

19. Michael J. Silverstein, "Innovators Have Edge in War of the Brands," *Advertising Age*, August 9, 1993.

20. Ibid.

21. "Kellogg Seeks Truce," *Wall Street Journal*, October 5, 1992, p. 8.

22. Patricia Sellers, *Fortune*, April 29, 1996, pp. 130-136.

Chapter 7

1. Laura Bird, "Marketers Sell Pen as a Signature of Style," *Wall Street Journal*, November 9, 1993, p. B1.

2. Kevin Goldman, "John Hancock's Olympics Ads Sell 'Trust'," *Wall Street Journal*, February 15, 1994, p. B2.

3. Patrick M. Reilly, "Where Borders Group and Barnes & Noble Compete, It's a War," *Wall Street Journal*, September 3, 1996, p. A1.

4. Tim Smart, "Can Xerox Duplicate Its Glory Days," *Business Week*, October 4, 1993, pp. 56-58.

5. *Not by Jeans Alone*, PBS Video, 1983.

6. Charles McCoy, "Microsoft Focuses on Fun and Games," *Wall Street Journal*, October 1, 1993, p. B1.

7. Ibid.

8. Bill McDowell, *Advertising Age*, September 23, 1996.

9. *Business Week*, August 26, 1996, p. 31.

Chapter 8

1. John Huey, "Managing in the Midst of Chaos," *Fortune*, April 5, 1993, p. 40.

2. Kathleen Devey, "Sales of Private-Label Goods Keep Rising," *Wall Street Journal*, October 5, 1993, p. B12.

3. Ibid.

4. "How to Listen to Customers," *Fortune*, January 11, 1993, p. 77.

5. Greg Steinmetz, "Health Insurers Try to Put on a Friendly Face," *Wall Street Journal*, October 10, 1993, pp. B1, B4.

6. Huey, op. cit., p. 41.

7. "Sears: Thinking Small Helps Retailing Giant Rebound," *Atlantic City Press*, October 7, 1993, p. E1.

8. Alex Taylor III, "The Man Who Put Honda Back on Track," *Fortune*, September 9, 1996, pp. 92-100.

9. Rahul Jacob, "Beyond Quality and Value," *Fortune*, Autumn/Winter 1993, p. 8.

10. Ibid.

11. Ibid.

12. Bruce Posner, "Targeting the Giant," *Inc.*, October 1993, pp. 92-94.

13. Gabriella Stern, "P&G Gains Little from Diaper Price Cuts," *Wall Street Journal*, October 28, 1993, p. B12.

14. R. Lee Sullivan, "Diaper Guerrillas," *Forbes*, July 1, 1996, pp. 58-59.

15. Susan Caminiti, "A Star Is Born," *Fortune*, November 29, 1993, pp. 44-47.

16. Bruce Horovitz, "The Quest for Cool," *USA Today*, September 4, 1996, p. 1B.

17. "Hands On, Every Employee a Service Rep," *Success Inc.*, October 1993.

18. Harold Lloyd, "Someone Is Trying to Tell You Something," FMI Conference, Chicago, 1993.

19. "Where Service Is Right," *Fortune*, April 24, 1993.

Chapter 9

1. R.L. Wing, *The Art of Strategy* (New York: The Aquarian Press, 1988), p. 163.

2. Meg Cox, "Town and Country Lowers its Brow a Notch," *Wall Street Journal*, March 25, 1994, p. B1.

3. Wendy Bounds, "Fuji Tries to Develop All-American Image," *Wall Street Journal*, October 7, 1996, p. B2.

4. Jeffrey Kutler, "Reed Says Tech Revolution Won't Happen Overnight," *Wall Street Journal*, September 20, 1996, p. C2.

5. Keith Naughton et al., "Revolution in the Showroom," *Business Week*, February 19, 1996, pp. 70-76.

6. Sun Tzu, *The Art of War* (New York: Oxford University Press, 1963).

7. "Does Competitive Intelligence Pay Off?" *Potentials in Marketing*, September 9, 1993, p. 48.

8. Tom Hals, *Philadelphia Business Journal*, August 23-29, 1996, p. 3.

9. "Corporate Spies Snoop to Conquer," *Fortune*, November 7, 1988, pp. 68-76.

10. Kevin Goldman, "FCB Bumps Ayer as AT&T's Top Agency," *Wall Street Journal*, November 22, 1993, p. B6.

11. Kenichi Ohmae, "Getting Back to Strategy," *Harvard Business Review*, November/December 1988, pp. 149-156.

12. Gerald A. Michaelson, *Winning the Marketing War* (Lanham, Md.: Madison Books, 1987).

13. John Holusha, *New York Times*, March 20, 1996.

14. Mike Pehanich, "Hershey Foods: Hugs, Kisses, and Quality Commitment," *Prepared Foods*, October 1993, pp. 28-36.

15. William Carley, "How Honeywell Beat Litton to Dominate Navigation-Gear Field," *Wall Street Journal*, September 20, 1996, p. 1.

16. Lucette Lagnado, "Oxford to Create Alternative Medicine Network," *Wall Street Journal*, October 7, 1996.

17. "Champagne Is a Drink, Not a Smell," *Forbes*, January 31, 1994, p. 193.

18. Bart Ziegler and Don Clark, "Microsoft Gives Technology Away to Beat Rival," *Wall Street Journal*, October 3, 1996, p. B1.

Chapter 10

1. "How to Murder the Competition," *Fortune*, February 22, 1993, p. 90.

2. Stuart Elliott, "The Media Business," *New York Times*, January 22, 1993, p. D2.

3. "Buffet Controls Geico," *Minneapolis Star Tribune*, August 26, 1995, p. 1D.

4. Kate A. Kane, "LifeUSA's Number One Policy — Speed," *Fast Company*, August/September 1996, pp. 22-24.

5. "Subaru Has a Lot Riding on Its Impreza," *Wall Street Journal*, February 26, 1993, p. B1.

6. Kevin Goldman, "Volvo Seeks to Soft-Pedal Safety Image," *Wall Street Journal*, March 16, 1993.

7. Kambiz Foroohar, "Chip off the Old Block," *Forbes*, June 17, 1996, pp. 48-49.

8. "Pepsi Returns to Original Focus: Its Profitable Younger Generation," *Wall Street Journal*, January 22, 1993.

9. "Lands' End Looks for Terra Firma," *Business Week*, July 8, 1996, p. 128.

10. "Why Things Are So Sour at Borden," *Business Week*, November 22, 1993, p. 78.

11. Ibid.

12. Gerald A. Michaelson, *Winning the Marketing War* (Lanham, Md.: Madison Books, 1987).

13. Elizabeth Jensen, "A Wiser Fox Refocuses on Young Adults," *Wall Street Journal*, October 16, 1996, p. B1.

14. Patricia Sellers, "Sears: The Turnaround Is Ending; The Revolution Has Begun," *Fortune*, June 9, 1997, pp. 106-118.

15. Phyllis Furman, "Sam & Libby's Big Slide," *Advertising Age*, February 14, 1994, p. 123.

16. "Turning Up the Gas at Burger King," *Business Week*, November 15, 1993, pp. 62-66.

17. Ibid.

Chapter 11

1. T.R. Phillips, *Roots of Strategy* (Harrisburg, Pa.: Stackpole Books, 1985), p. 401.

2. Gerald A. Michaelson, *Winning the Marketing War* (Lanham, Md.: Madison Books, 1987), p. 32.

3. B.H. Liddell Hart, *Strategy* (New York: Meridian, 1991).

4. Al Ries, "The Discipline of the Narrow Focus," *Business Strategy*, p. 3.

5. Robert Frank, "PepsiCo Critics Fear Glass Is Half Empty," *Wall Street Journal*, September 30, 1996, p. C8.

6. "Pepsi's Eateries Go It Alone," *Fortune*, August 4, 1997, p. 27.

7. Al Ries and Jack Trout, *22 Immutable Laws of Marketing* (New York: Harper Business, 1992), p. 70.

8. Al Ries and Jack Trout, *Positioning: The Battle of the Mind* (New York: McGraw-Hill, 1986).

9. Al Ries and Jack Trout, *22 Immutable Laws of Marketing*, op.cit.

10. "The Big Squeeze," *Snack Food World*, June 1993, 4-6.

11. Dan McGraw, "Salting Away Big Profits," *US News & World Report*, September 16, 1996, p. 71.

12. Seth Lubove, "We Have a Big Pond to Play In," *Forbes*, September 13, 1993, pp. 216-224.

13. Sally Goll Batty and Richard Gibson, "In Latest Flip-Flop, McDonald's Orders Up New Agency," *Wall Street Journal*, July 30, 1997, pp. B1, B2.

14. Phillips, op. cit.

15. Michael Verespej, "How the Best Got Better," *Industry Week*, March 7, 1994, p. 27.

16. Lori Bongiorno, "It's Put Up or Shut Up Time," *Business Week*, July 8, 1996, pp. 100-102.

17. "Rolling Rock's Mug Runneth Over," *Business Week*, June 1, 1992, p. 76.

18. "Making Fans on Talk Radio," *Inc.*, December 1993, p. 162.

19. Lori Kessler, "A-B Benefits from Regional Approach," *Advertising Age*, February 27, 1994, pp. 48-49.

Chapter 12

1. Gerald A. Michaelson, *Winning the Marketing War* (Lanham, Md.: Madison Books, 1987), p. 89.

2. Mary Ellen Kuhn, "Weight Watchers: 1992 New Products Company of the Year," *Food Business*, February 8, 1993, p. 15.

3. "Quotes of the Day," *Food Business*, March 8, 1993, p. 43.

4. Louise Lee, "Upward Mobility," *Wall Street Journal,* February 7, 1996, p. A1.

5. Thomas J. Peters and Robert H. Waterman Jr., *In Search of Excellence* (New York: Harper & Row, 1982).

6. Susan Warner, "Rite Aid Posts a Loss, Plans to Sell Chains," *Philadelphia Inquirer,* March 29, 1994, p. D1.

7. "How To Get Focused Again," *Fortune,* January 24, 1994, p. 85.

8. Eric Shine, "The Squawk Over Boston Chicken," *Business Week,* October 21, 1996, pp. 64-72.

9. Louise Lee, "Boston Chicken Decides to Trim Appetite for Expansion," *Wall Street Journal,* June 26, 1997, p. B4.

Chapter 13

1. Lori Bongiorno, "It's Put Up or Shut Up Time," *Business Week,* July 8, 1996, pp. 100-102.

2. Patrick Reilly and Richard Turner, "Disney Pulls Ads in Tiff with Time," *Wall Street Journal,* April 2, 1993, p. B1.

3. Ibid.

4. "National Business Hall of Fame: S.C. Johnson," *Fortune,* April 5, 1993, p. 110.

5. "Aiming at Both the High and Low Markets," *Fortune,* March 22, 1993, p. 89.

Chapter 14

1. Dana Canedy, "Slates Pants: A Marketing Strategy of Little Left to Chance," *New York Times,* October 9, 1996.

2. "What's in a Name?" *Financial World,* September 1, 1992, p. 45.

3. Stephanie Strom, "Speedo Maker Drops Line of Skiwear," *New York Times,* October 4, 1996, p. D3.

4. Kevin Goldman, "Lee Aims at Bigger Targets: Pudgy People," *Wall Street Journal,* January 27, 1993, p. B7.

5. Pat Sloan and Jennifer Lawrence, "Olay Bath Bar Makes Splash," *Advertising Age,* August 2, 1993, p. 9.

6. Gabriella Stern, "Brand Names Are Getting Steamed Up to Peel Off Their Private-Label Rivals," *Wall Street Journal,* April 21, 1993, p. B1.

7. Craig Torres, "Investor's Loyalty to Brand Name Companies Fades," *Wall Street Journal,* April 6, 1993, p. B1.

Chapter 15

1. Yumiko Uno, "One New Beer, Three New Ad Campaigns," *Wall Street Journal,* September 17, 1996, p. B1.

2. Laura Bird, "TV Ads Boost Nestle's Infant Formulas," *Wall Street Journal,* March 30, 1993, p. B1.

3. Len Strazewski, "Direct Sellers Defy Odds," *Advertising Age,* November 9, 1992.

4. "From Frozen Dinners to Styling Gels," *Wall Street Journal,* February 3, 1993, p. B1.

5. John Greenwald, "Autos: Toyota's Red, White and Blue Look," *Time,* October 7, 1996, pp. 73-74.

6. Valerie Reitman, "Diaper Firm Fights to Stay on the Bottom," *Wall Street Journal,* March 20, 1993, p. B1.

7. Michael McCarthy, "Sports Drink 10-K Tries Different Pitch to Win Market Share From Gatorade," *Wall Street Journal,* March 19, 1993, p. A5.

8. "MCI Is Coming Through Loud and Clear," *Business Week*, January 25, 1993, p. 84.

9. "Ford Tunes into the MTV Generation," *USA Today*, March 29, 1993, p. B5.

10. "Tetley Hopes to Reshape the Tea Market," *Wall Street Journal*, February 17, 1993, p. B1.

11. *Business Week* September 2, 1996 page 72-73, Did you say Sprint was No. 1? by Peter Elstrom

12. "Compaq: Turning the Tables on Dell," *Business Week*, March 22, 1993, p. 87.

13. Norm Alster, "Penny-Wise," *Forbes*, February 1, 1993, p. 48.

14. Richard Gibson, "Michelina's Frozen Entrees Trip Up Giants," *Wall Street Journal*, September 21, 1993, p. B11.

15. "VISA Volleys for Market Share," *Business Week*, September 27, 1993, p. 46.

16. Christopher Power, "How to Get Closer to Your Customers," *Business Week/Enterprise*, 1993, p. 44.

Chapter 16

1. Robert L. Simison, "Mercedes to Shake Up Its Product Policy," *Wall Street Journal*, January 28, 1993, p. A10.

2. Krystal Miller and Timothy Aeppel, "BMW Zooms Ahead of Mercedes-Benz in World-Wide Sales for the First Time," *Wall Street Journal*, January 20, 1993, p. B1.

3. Ellen Neuborne, "Catalog's End Just Might Be the Beginning," *USA Today*, January 26, 1993, p. B1.

4. Patricia Sellers, "Sears: The Turnaround Is Ending; The Revolution Has Begun," *Fortune*, June 9, 1997, pp. 106-118.

5. "Pan Am Name Sells for $1.3 Million," *USA Today*, December 3, 1993, p. B2.

6. "Look Who Learned About Value," *Fortune*, October 18, 1993, p. 75.

7. Shelly Branch, "McDonald's Strikes Out with Grownups," *Fortune*, November 11, 1996, pp. 157-162.

8. James C. Abegglen and George Stalk Jr., *Kaisha: The Japanese Corporation* (New York: Basic Books, 1985), p. 48.

9. William Carley, "How Honeywell Beat Litton to Dominate Navigation-Gear Field," *Wall Street Journal*, September 20, 1996, p. 1.

10. Gary Strauss, "Price Cuts Designed to Woo Back Smokers," *USA Today*, April 5, 1993, p. B8.

11. "The Smoke Clears at Marlboro," *Business Week*, January 31, 1994, p. 76.

12. Susan L. Hwang, "Kraft Puts the Cheese Market in Ferment," *Wall Street Journal*, March 16, 1993, pp. B1, B7.

13. Christopher Palmeri, "Joe Three Fights Back," *Forbes*, November 22, 1993, p. 46.

14. Bart Ziegler and Don Clark, "Microsoft Gives Technology Away to Beat Rival," *Wall Street Journal*, October 3, 1996, p. B1.

15. Jolie Solomon, "Not in My Backyard," *Newsweek*, September 16, 1996, pp. 65-66.

16. "Even Philip Morris Feels the Pull of Gravity," *Business Week*, February 15, 1993, pp. 60-62.

17. Richard Gibson, "McDonald's Tries Bigger Burger to Beef Up Dinner Menu," *Wall Street Journal*, March 24, 1993, p. B1.

18. Richard Gibson, "Attention Wal-Mart Shoppers: You Want Fries With That?" *Wall Street Journal*, July 25, 2997, p. B6.

19. Matt Murray, "Rx for Pharmacies: Bigger Line of Products and Services," *Wall Street Journal*, September 12, 1996, p. B2.

Chapter 17

1. Laura Bird, "Detergent Industry Spins into New Cycle," *Wall Street Journal*, January 5, 1993, p. B1.

2. "Makers of Personal-Care Products Hope to Clean Up with Brands for Children," *Wall Street Journal*, January 28, 1993, p. B1.

3. Valerie Reitman, "P&G Uses Skills It Has Honed at Home to Introduce Its Brands to the Russians," *Wall Street Journal*, April 24, 1993, p. B1.

4. "IBM Mainframe Chief: We Goofed," *USA Today*, February 10, 1993, p. B2.

5. Patrick M. Reilly, "Where Borders Group and Barnes & Noble Compete, It's a War," *Wall Street Journal*, September 3, 1996, pp. A1, A8.

6. Linda Grant, "Gillette Knows Shaving—and How to Turn Out Hot New Products," *Fortune*, October 14, 1996, pp. 207-210.

7. Joseph Pereira, "Early Coupon Campaign by Toys 'R' Us May Spark Price War Among Discounters," *Wall Street Journal*, October 29, 1993, p. B1.

8. "Pepsi's Future Becomes Clearer," *Business Week*, February 1, 1993, p. 74.

9. Ibid.

10. Timothy D. Schellhardt, "Tossing Its Head at P&G, Helene Curtis Styles Itself No. 1 in the Hair-Care Market," *Wall Street Journal*, November 19, 1992, p. B1.

11. David Craig, "Carnival's Ship May Be Coming In," *USA Today*, April 27, 1993, p. B3.

12. Gary Strauss, "Private-Label Heroes Lift Image," *USA Today*, November 26, 1993, p. B4.

13. Linda Grant, "Gillette Knows Shaving—and How to Turn Out Hot New Products," *Fortune*, October 14, 1996, pp. 207-210.

14. Paulette Thomas, "OfficeMax Sees Opportunity in Plight," *Wall Street Journal*, September 11, 1996.

15. "Extending a Bit Too Far," *USA Today*, April 19, 1993, p. C1.

Chapter 18

1. Sun Tzu, *The Art of War* (New York: Oxford Unversity Press, 1963).

2. Ibid.

3. Teri Agins, "Shaken by a Series of Business Setbacks, Calvin Klein Inc. Is Redesigning Itself," *Wall Street Journal*, March 21, 1994, p. B1.

4. Eben Shapiro, "Tropicana Squeezes Out Minute Maid to Get Bigger Slice of Citrus Hill Fans," *Wall Street Journal*, February 4, 1993, p. B1.

5. Jennifer Waters, "Snapple Giveaway Fails to Heat Up Summer Sales," *Advertising Age*, October 7, 1996, p. 32.

6. Kathleen Deveny, "Private Label Items Buffet Brand Loyalty," *Wall Street Journal*, March 9, 1993, p. B1.

7. Gary Strauss, "Private-Label Heroes Lift Image," *USA Today*, November 26, 1993, p. B4.

8. Amy Balan, "Using Private Labels, Firm Has Made a Name for Itself," *Philadelphia Inquirer*, November 22, 1993, p. C1.

9. Zina Moukheiber, "The Un-Gap," *Forbes*, September 9, 1996, pp. 44-45.

10. "The Millstones at Metromedia," *Business Week*, March 1, 1993, pp. 68-71.

11. Marcia Beres, "Bag Your Own," *Forbes*, February 1, 1993, p. 70.

12. Yumiko Ono, "A Pulp Tale: Juice Co-op Squeezes Big Rivals," *Wall Street Journal*, January 30, 1996, pp. B1-B5.

13. Larry Armstrong, "Golden State Warriors," *Business Week*, February 8, 1993, p. 116.

14. R. Lee Sullivan, "Diaper Guerrillas," *Forbes*, July 1, 1996, pp. 58-59.

Chapter 19

1. Bruce Orwell, "Marriott to Provide Long-Term Guests a New Economy-Priced Hotel Option," *Wall Street Journal*, February 13, 1996, p. B6.

2. Brian O'Reilly, "The Rent-a-Car Jocks Who Made Enterprise #1," *Fortune*, October 28, 1996, pp. 125-128.

3. Joshua Levine, "Cool!," *Forbes*, April 8, 1995, p. 98.

4. Scott McCartney, "America West Has Turned Nighttime into Flight Time," *Wall Street Journal*.

5. Robert Linneman and John Stanton, *Making Niche Marketing Work* (New York: McGraw-Hill, 1992).

6. Jeffrey A. Tannenbaum, "Entrepreneurs Thrive by Helping Big Firms Slash Costs," *Wall Street Journal*, November 10, 1993, p. B2.

7. Robert Linneman and John Stanton, op. cit.

8. Vince Gennaro, "The Future of Regional Marketing," Lucrative Regional Marketing Strategies Conference, April 12, 1989.

9. Robert Linneman and John Stanton, op. cit.

10. Robert Buzzell and Bradley T. Gale, *The PIMS Principle: Linking Strategy to Performance* (New York: The Free Press, 1987), p. 3.

WORKSHEET 1:

LEADERSHIP STATUS IN MY ORGANIZATION

A leader need not possess all of the traits listed below, but he or she must at least have some of them. An organization must have all the traits of leadership resident in the management team.

1) What have I done to demonstrate leadership?

2) What have my associates done to demonstrate leadership?

 Who did it?

3) What have I done to demonstrate my robustness?

4) What have my associates done to demonstrate robustness?

Who did it?

5) What have I done to demonstrate risk taking?

6) What have my associates done to demonstrate risk taking?

Who did it?

7) What have I done to demonstrate my competitiveness?

8) What have my associates done to demonstrate their competitiveness?

Who did it?

9) What have I done to demonstrate my boldness and decisiveness?

10) What have my associates done to demonstrate their boldness and decisiveness?

Who did it?

11) What have I done to demonstrate my opportunism?

12) What have my associates done to demonstrate their opportunism?

315

Who did it?

13) What have I done to demonstrate grace under pressure?

14) What have my associates done to demonstrate grace under pressure?

Who did it?

15) What have I done to demonstrate innovativeness?

16) What have my associates done to demonstrate innovativeness?

316

Who did it?

Worksheet 2:

What Business Am I Really In?

1) What do I make?

 I satisfy people who needs
 the new such smokehuas, people running out of
 staple milk, bread, impulse eaters

2) What do I believe my customers are buying?

 theve buying thing / come convenant

3) What do my customers *say* they are buying?

 M

4) What problems do I uniquely solve for my customers?

 saving time

5) What do my associates think our customers

are buying?

They make this custome
And special
comfort levels

6) What is my equivalent of "selling hope"?

WORKSHEET 3:

TEST FOR POTENTIAL NEW PRODUCT/SERVICE IDEAS

1) Can I do it?

2) What makes me believe I can or can't do it?

3) Will the target market give me permission to do it?

4) What makes me believe it will give me permission?

5) Will competition allow me to do it?

6) What makes me think competition will allow me to do it?

7) Does it fit my strategic objectives?

8) What makes me think it fits my strategic objectives?

9) Can I make money?

10) What makes me think I can make money do-
ing it?

WORKSHEET 5:

KNOW THE ENVIRONMENT

Change Area	What is the nature of the change	What is the trend?	What is the impact?	What is the opportunity?
Legal				
Political				
Technological				
Economic				
Cultural				
Social				
Demographic				
Other				
Other				

11) What is the single biggest advantage indirect competitor C has over you?

12) What is the single biggest advantage you have over indirect competitor A?

13) What is the single biggest advantage you have over indirect competitor B?

14) What is the single biggest advantage you have over indirect competitor C?

WORKSHEET 7:

HOW DO YOU SURPRISE THE COMPETITION?

1) How can you use your offering (product, service, etc.) to surprise?

2) How can you use distribution to surprise?

3) How can you use advertising to surprise?

4) How can you use product positioning to surprise?

5) How can you use promotion to surprise?

6) How can you use price to surprise?

7) How can you use personnel to surprise?

8) How can you use financing and terms of sale to surprise?

9) How can you use the sales force to surprise?

10) How can you use packaging to surprise?

11) How else can you surprise the competition?

12) What is the single most unexpected tactic you could use?

WORKSHEET 9: CONCENTRATE YOUR RESOURCES

1) Have you actually shifted resources from concentrating everywhere to concentrating on the objective discussed in Worksheet 8?

2) How have you concentrated your resources on the objective discussed in Worksheet 8?

3) How have you concentrated the sales effort?

4) How have you concentrated the advertising effort?

5) How have you concentrated the promotional effort?

6) How have you concentrated the distribution effort?

7) How have you concentrated the training effort?

8) How have you concentrated the pricing effort?

9) How have you concentrated the product development effort?

10) How have you concentrated the product positioning effort?

Worksheet 10:

Are You Mobile?

1) What have you changed to keep from being a sitting target?

2) Where has the company been mobile? (Be specific.)

In strategy? _____

In markets? _____

In tactics? _____

WORKSHEET 11:

ADVANCE AND SECURE

1) Identify three recent advances by your organization.

Advance 1: _____

Advance 2: _____

Advance 3: _____

2) For each advance, indicate what would have happened if that offensive action was a total failure.

Advance 1: _____

Advance 2: _____

Advance 3: _____

3) For any failed outcome above, was your company at extreme risk?

Advance 1: _____

Advance 2: _____

Advance 3: _____

4) What can you change to reduce risks if you fail?

Advance 1: _____

Advance 2: _____

Advance 3: _____

WORKSHEET 12:

MY RULES OF STRATEGY

1) _____
2) _____
3) _____
4) _____
5) _____
6) _____
7) _____
8) _____
9) _____
10) _____

INDEX

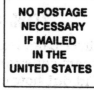

BUSINESS REPLY MAIL

FIRST-CLASS MAIL PERMIT NO. 73996 LOS ANGELES CA

POSTAGE WILL BE PAID BY ADDRESSEE

SILVER LAKE PUBLISHING
2025 HYPERION AVE
LOS ANGELES CA 90027-9849

BUSINESS REPLY MAIL

FIRST-CLASS MAIL PERMIT NO. 73996 LOS ANGELES CA

POSTAGE WILL BE PAID BY ADDRESSEE

SILVER LAKE PUBLISHING
2025 HYPERION AVE
LOS ANGELES CA 90027-9849